Fashion Drawing Course

Fashion Drawing Course

From Human Figure to Fashion Illustration

Juan Baeza

promopress

ACKNOWLEDGEMENTS

To our Father, source of all beauty, creativity and life.

To Oscar Senonez, who inspired me to do this project.

To my father and Gonzalo Morales, for proofreading and typing.

To César Rodríguez, Guillermina Brandauer, Florencia Repetto and Lucas Maíz for generously posing as models for this book.

To Alejandra León for her contributions to and correction of chapter 6 in relation to the subject of textiles.

To Dana Jiménez and Daniel Fernández for their photographs and sessions.

To all my students, who helped me to grow and formed the basis of this work, which is aimed at them.

To Mariel and Lucas.

I dedicate this book to my mother and grandpa Baeza, who encouraged me to draw.

Fashion Drawing Course
From Human Figure to Fashion Illustration

Original title:
Figurín de moda
Del dibujo de la figura humana
a la ilustración de moda

Translator: Tom Corkett
Models: César Rodríguez, Guillermina Brandauer;
Lucas Maíz and Florencia Repetto

ISBN: 978-84-15967-06-4

© Drawings, Juan Baeza
© Photographs, Dana Jiménez and Juan Baeza
© 2014 Guillermo Kliczkowski
© 2014 Promopress

Promopress is a brand of:
Promotora de prensa internacional S.A.
C/ Ausiàs March 124
08013 Barcelona, Spain
Tel.: +34 93 245 14 64
Fax: +34 93 265 48 83
Email: info@promopress.es
www.promopress.es
www.promopresseditions.com
Facebook: Promopress Editions
Twitter: Promopress Editions @PromopressEd

First published in English: 2014

Cover design/revision of layout design:
spread: David Lorente

Printed in China

CONTENTS

PROLOGUE

The human figure for the designer

It is the interesting approach taken by Juan Baeza, which stems from his background and experience in teaching the drawing of the human figure, that makes this book an extremely useful tool for designers.

Beyond fashion trends, society nowadays is more individualistic, and contemporary creativity is based on the freedom of recombining. In this context, what stands out is the importance of independent design, which is characterized by offering solutions based on a personal style and inspiration, without following the trends that are imposed from the fashion production centres. Each discipline serves the particular needs of its subject of study. In clothing and textiles, proximity to the body demands a special way of working. Clothes are designed to be displayed using the body and, therefore, must respect the body's topology and the movements and twists it makes. The value of a designer is mainly measured by the sum of his or her ability to understand the idea behind the object and his or her ability to design—that is, his or her ability to translate that idea into reality.

The development of a project is comprised of a number of individual steps that are systematized in a sequence that moves towards the solution sought and whose purpose is to make the project take form.

That form—the what—is impersonal, while the design—the how—is the designer's. Designing involves a process of prefiguration, genesis and organization of form—that is, a formal process of production. To achieve this objective it is necessary to optimize all available resources, and it is here that the exercise of drawing the human figure becomes essential.

In this work the author presents a systematization of the objectification of the real, the physical and the constructive into a visual translation through drawing; it is capable of generating two-way communication, in which the drawing becomes a prefiguration of the real and not a mere representation of reality. Among the many merits of this book what stands out is the theoretical and conceptual support that is present throughout its pages and that translates into the development of an organic and harmonious system where every aspect and every part has its purpose relative to the others. It forms a valuable whole that is much more than the sum of its parts and that will be most useful for students and professionals.

Susana Saulquin
Former Course Director of the DIyT / FADU-UBA

INTRODUCTION

Human figure drawing for designers

It is worth clarifying that the study we will undertake in this book is of the human figure for design purposes and not simply of the human figure in general.

The specific work of the fashion designer requires a perception, an understanding and a development that are not the same as those of a visual artist; both what he or she is looking for and his or her purposes are different.

In the visual arts and drawing, different representations of the human body are a source for the artist's expression. In design, however, the body is the beginning and the end; it is the structure and foundation of the garment. It is important to understand that the human body is a natural form that is the result of a process of functional adaptation and that has emerged out of a huge set of functions, capable of moving in space-time and expressing itself through movement.

This book is therefore not a manual on drawing the human figure, but a method for designers to learn to draw (and understand) the human body that will wear with their designs.

Representation and preview

In the process of inventing or innovating, the designer will encounter images of a possible though as-yet undefined reality that projects into the future, a mental (or rather phantasmal) image. It is a reality in preparation, which lacks concrete realization and material form: a virtual reality.

As a result, traditional drawing of the human figure (for example, the live model) it is not enough, since it *re-presents*—that is, it presents once more, in two dimensions, an existing object. In clothing design it is very difficult to interpret the human body only through live-model drawing or copying its outward appearance at skin level. Rather, its anatomy must be studied and understood in terms of a form that is rational, mechanical, organic, dynamic, sensual, beautiful, desired, forbidden, unique, and so forth. It has to be memorized and its possible movements, volumes and tensions calculated to be able to generate patterns and garments that are functional and comfortable. The fashion designer must recreate from memory not only a human body in motion, but also the relationships that exist between it and the material and form of the garment, and be able to present this information in a drawing (which is not a *re-presentation*, since it does not already exist).

The designer must be in possession of this information and creatively synthesize it when designing.

It is not advisable for design students to be trained only in visual perception and the representation of objects located in space-time (our real dimension). They should also, and more importantly, practice the immediate presentation (drawing) of an intellectual and creative reality—that is, one that exists in neither space nor time, but is based on a knowledge of the properties and behaviour of the subject matter.

In other words, the designer must learn to draw what exists in his or her mind as if it existed in three dimensions.

Doing so has economic benefits, since creating a preview of something that has no material form saves resources used in designing and producing a prototype. But it also makes it possible to link together the real, conceptual and visual levels so that the visual level can be used as a preliminary creative and expressive tool for design whose results can then be transferred into a system for construction. Through drawing the material form can be discovered in advance.

Moreover, beyond expressive and creative issues, drawing fulfils a crucial function in design: information.

Innovation and tradition collide when a design is produced; in general this is thought to occur in an inexorable way. It would seem that designing and producing were opposites, like *thinking* and *doing*. That is why every day we see confrontations between architect and builder, graphic designer and printer, or fashion designer and patternmaker, among other examples. Here the designer's drawing can provide understanding and clarity for both parties. The ability to communicate an idea through different types of drawing greatly facilitates understanding innovation (through, for example, diagrams, blueprints, sketches, accuracy, and so on). In addition, drawing narrows the possibilities of misinterpretation by the producer, saving resources and avoiding the need for clarifications.

Finally, it is important to emphasize the persuasive function that drawing has. The drawing of a human figure is already in itself a discourse, with its iconicity, pose, colour, face and expression being not only informative, but also having a persuasive value that influences the client to approach it from an emotional level. Mastering the expressive resources of drawing also results in a good presentation of the proposed design.

About this book

This book is not intended as a compendium of human anatomy. There are books of excellent quality for that purpose, and it is recommended that the reader gets hold of a small reference collection on the subject, to collate information and make better use of the contents of this work. It is also worth developing a portfolio of graphic and photographic documentation on anatomy and other topics that are covered in this volume.

This book aims to teach the designer the complexities of the dressed and dynamic human figure, and also includes a somewhat specific lexicon, and therefore its language might be somewhat technical. However, my desire is to be as clear and direct as possible, to avoid complications and to express myself with the simplicity that I owe to the beginner-level students I usually teach, from whom I have learned so much and of whom I am so fond.

structure

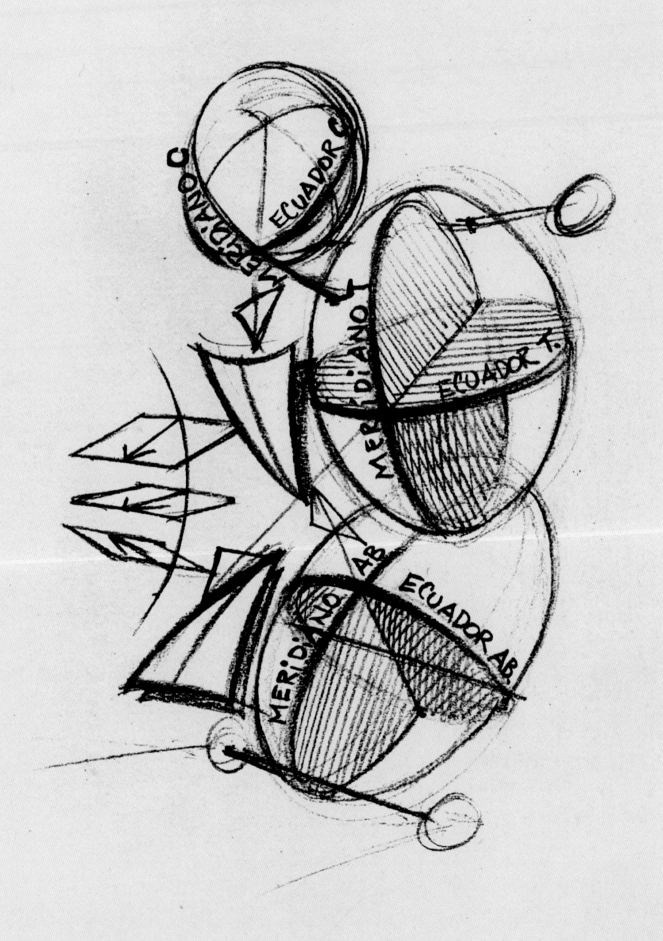

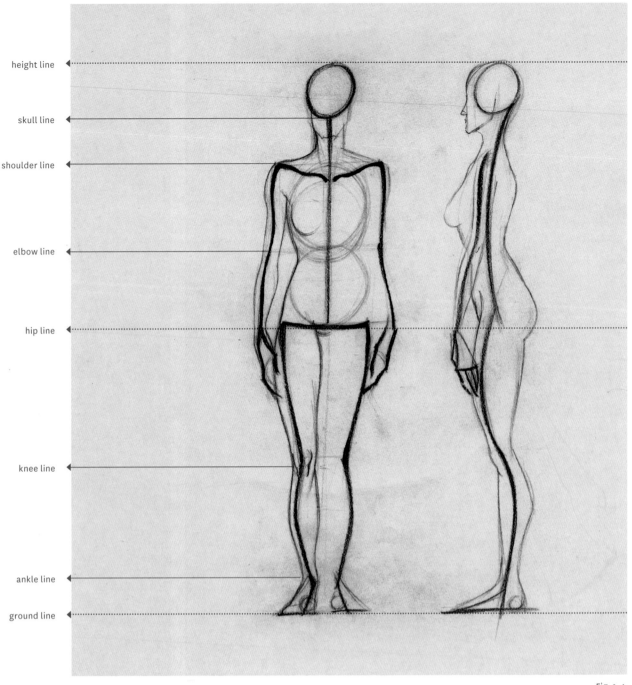

height line

skull line

shoulder line

elbow line

hip line

knee line

ankle line

ground line

Fig. 1 ▲

The harmony or **harmonic system**

The human body is an organic form, a complex, proportional system in which all parts relate to each other and to the whole. Although any part of the body can become a unit of measurement, no one alone represents the essence of the human form, and trying to understand the body by taking one part as a reference is to lose sight of the relationship between the parts and the whole. To master drawing of the human figure it is necessary to understand the relationships of shape, size, position and density between the elements of structure and those of movement. This is not difficult if we know which structural elements are the main ones and which are the secondary ones and we can place them into a whole in relation to the other components. Our eyes do not find it difficult to locate medians (midpoints) in particular segments. From these points we can develop many elements of the skeletal structure. Some examples: the trochanter line (at the head of the femur), better known as the "lower hip," is at exactly the halfway point of the total height of the body. The knees are in the middle of the leg (femur, tibia and foot). The elbows are located at the middle of the distance between the shoulder line and the pubic symphysis

(the lower part of the pubis, the groin), and the same applies to many other parts of the body that are in the middle between others. We can identify halves, quarters and eighths; interestingly, it is these measures that lead to the harmonic complexity of the human body. (Fig. 1)

It should be pointed out that any proportional norms that we use will be a subjective generalization of the immense variety that the human gene pool contains. This clarification is important in defining *styling* and *realism*, as well as the type of generalization or the model to emulate.

As a result it seems necessary for me to note that the norms that we will use or the model to which we refer have a pedagogical function. Their goal is to start us drawing and understanding the human schema, and, subsequently, the specificities of gender, age, build, and so forth, which will be left for a second volume. Our model is based on *normal* proportions in the statistical sense of the word, a regularized system that has the goal of facilitating the understanding of the reader who wants to learn to draw the human figure.

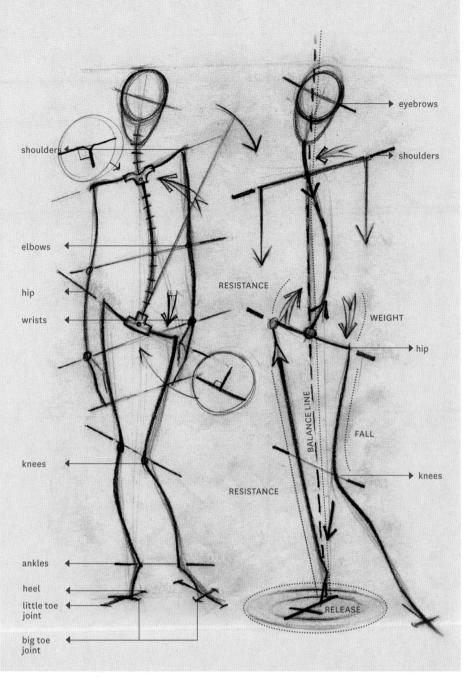

Fig. 2 labels:

shoulders
eyebrows
shoulders
elbows
hip
wrists
RESISTANCE
WEIGHT
hip
knees
BALANCE LINE
FALL
RESISTANCE
knees
ankles
heel
little toe joint
big toe joint
RELEASE

▼ Fig. 2

Draw these lines as fluidly as possible. Focus on expression rather than body shape.

Contrapposto

▼ Fig. 4

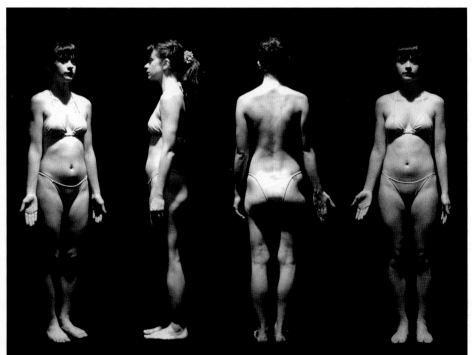

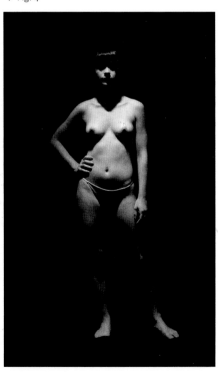

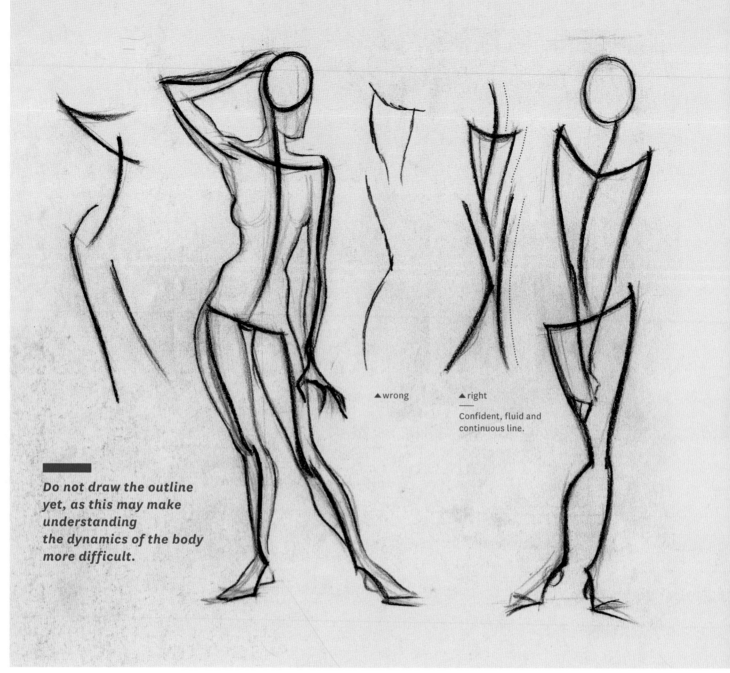

▲wrong

▲right

Confident, fluid and continuous line.

Do not draw the outline yet, as this may make understanding the dynamics of the body more difficult.

The outline is for guidance; you should not draw it / Fig. 5 ▲

Initial structural drawing
or kinetic structure

This initial structural drawing, which we shall call the *kinetic structure*, has the goal of creating a continuous line, "the line of beauty" characteristic of natural organisms. Moreover, as fundamental as acquiring a fluid stroke is structuring the figure according to its own dynamics, understanding the principles of bipedal posture, *contrapposto*, and the balance of a person who is standing, often on the point of falling, and always in a state of delicate, agile and emotive movement. The application of these aspects makes it possible to draw a kinetic and expressive figure that is difficult to achieve through other methods (for example, starting with the complexity of the contours), as they produce a very synthetic abstraction of the human structure that is within the abilities of beginners. It is very important to start from here: do not skip this part of the learning or the corresponding practice. It is a good starting point that will save frustration later, since it will help you to free up your hand and practice with a manageable amount of items, with minimal but precise proportion and line information.

Remember
You are not yet ready to work on the outline; do not incorporate it until you have achieved correct proportions and an understanding of the lines and how they move.

Learning Materials
To practice this part it is advisable to use magazines or other photographic material. Please note that the photos should be of thin women in underwear or a swimsuit or naked, with an adequate contrast of light that allows the lines of movement associated with the skeletal and muscular form to be discovered.

14

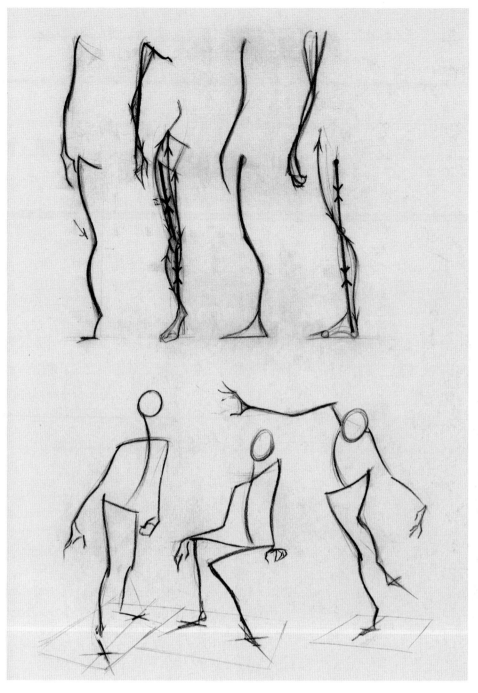

Do not forget that what we are aiming for at the moment is to develop your strokes based on the dynamics of the pose you draw.

▼ Fig. 6

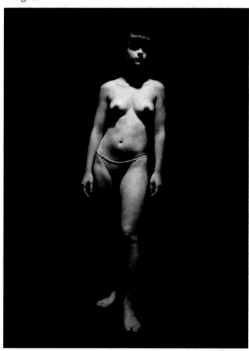

Start your practice with frontal poses; once you have understood and assimilated them, continue with different poses, though for now without foreshortening.* Do not include joints yet. What we are looking for at this stage is to develop strokes, and drawing joints would disrupt the movement of the arm as it draws. The whole arm –fingers, wrist and elbow– and shoulder work to generate a line. Draw on a medium-sized sheet of paper such as A4, using the full length of the sheet for each of the poses.

Use a 4B or 6B pencil that lets you glide over the page quickly, smoothly and steadily. Do not produce a "furry line" (a line consisting of short and successive lines, a product of drawing only with finger movements) but instead make one long line, even if this is difficult to do. Remember that the purpose is to polish your movement, your ductus, and not to create an attractive drawing, something which in any case results from having a good stroke, among other things.

Do a large version of your own signature (take up a whole sheet) and analyse the speed at which you make it, with how much confidence and the differences in pressure and continuity. You will see that you are able to achieve good line and that your ductus is more confident than you thought. Translate this fluidity to your drawing, and try to draw as though you were doing your signature: the confidence of your signature comes from it continuously being your mark for years –that is to say, you have a lot of practice in signing things.

* The object's viewpoint, perspective.

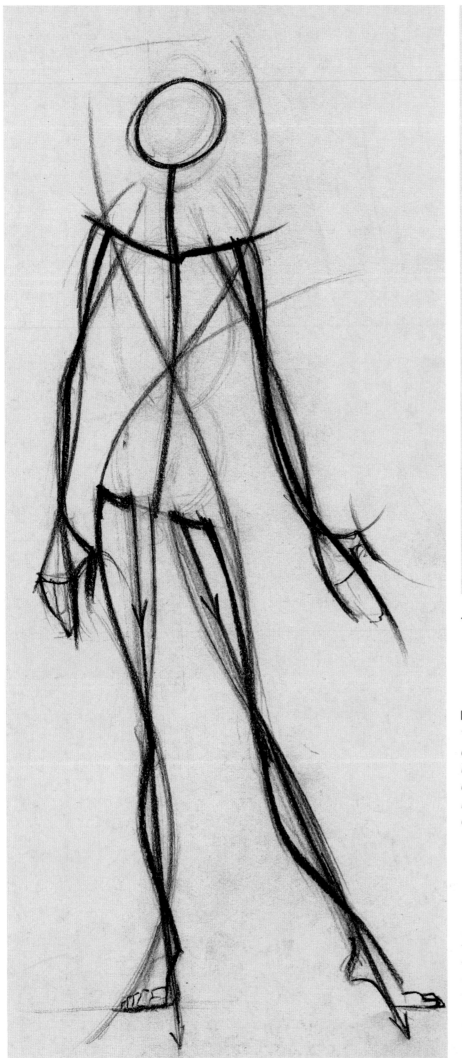

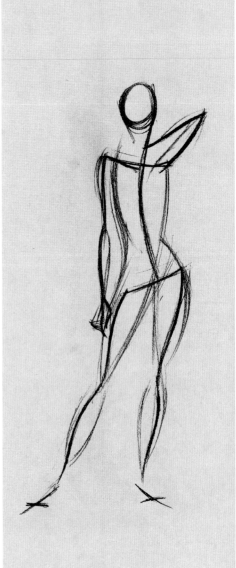

◀ Fig. 8

The goal is not to make an anatomical drawing, but to understand that the outline and structure should have rhythmic continuity and be expressive.

Now the outlines appear as fluid and dynamic lines that complement the structural lines. The idea is not yet to draw in an anatomical way, but to understood that the outline is dynamic when the structure is too. Here the outlines are somewhat intuitive; they are not being drawn consciously or with a knowledge of musculature.

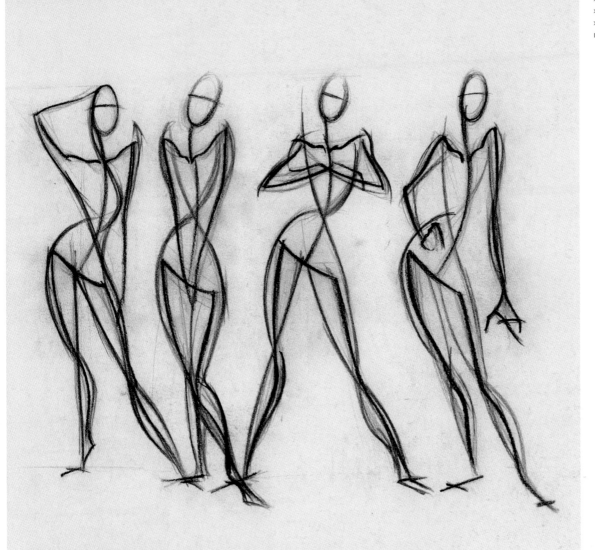

◀ Fig. 9 and 10
—
› dynamic outline
› tensions and forces
› continuous lines with
 no defined end

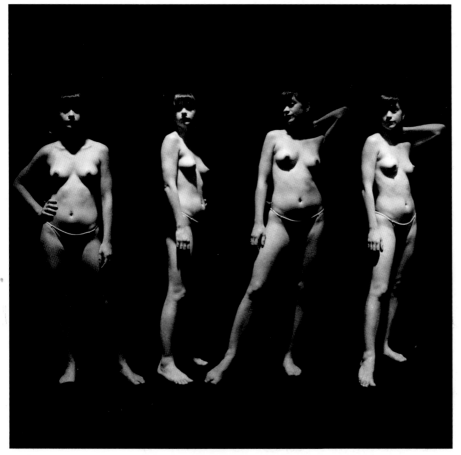

◀ Fig. 11
—
Practice these poses.
First work on the
structure and then
dynamic outlines.

When you practice, try to focus on what
you are producing. Fully develop three
poses and then correct them from the
first to the third, three or four times per
pose. Always think and correct only what
you know how to correct. If something
seems wrong but you do not know why,
leave it and study it later. Trying to cor-
rect things now would be acting blindly
and not correcting.

17

Structural **volumes**

After plenty of practice on kinetic structure, when you can see that your stroke is continuous and expressive and that you are correctly interpreting poses and their energy, attitude, proportion and harmony, it is time to add a new element: volume.

However, volume here should not be understood in terms of light and shadow, but in terms of geometry; and not in terms of perception, but in terms of its morphological constitution and the reason for it.

Imagine a transparent sphere with a meridian and an equator seen from exactly in front (1).

We will see two lines, one vertical and one horizontal.

Now, if we lightly rotate the sphere on a vertical axis (2), we will see the vertical straight line become a narrow ellipse that also develops vertically. The ellipse becomes wider as we continue rotating, until it follows the same outline as the sphere, that is, the circumference of the sphere when seen from the side. The same thing will happen to the horizontal line if we rotate on a horizontal axis (3). We will call these two circumferences that go around the sphere the *meridian* –which runs vertically– and the *equator* –which runs horizontally– since their function is similar to the lines of the same name found on a globe.

Now, if we rotate the sphere first in one direction (V) and then in another (H), we get two ellipses (4). After observing this behaviour we can see that by drawing these ellipses we can define:

a | The direction in which these volumes are facing.
b | The viewpoint from which these volumes are observed.
c | The front and back of the object.

One of these takes the object as a reference (a) and corresponds to its location in space, while the other is based around the subject (b) and refers to the place in space where the object is observed. It is important to understand this concept to discern the point of view of the observer and the position of the object, which will help us to conceive of the sheet as a three-dimensional space.

Volumes in perspective

Practice these examples of volumes and planes in perspective to simulate a three-dimensional space on paper. We will not go into more depth on the issue of perspective here, since we will continue to see it in practice throughout the construction of the figure in motion, but the student should learn about it through a book on the subject.

In the case of depth the key is to discern and complement the observer's viewpoint in relation to the position of the observed object. By this I mean that, for example, if a person was hanging upside down from the ceiling we would see them from below, but the view we would get would be a top view (as though we were seeing them from above). Both concepts are complementary and inseparable: the eyes see from one position, but the position of the object is independent of the subject.

It is also necessary to be aware that each volume has a geometric constitution that we must understand so that we can properly draw it in three dimensions.

Draw planes that look as though they are squares, completing their heights and their diagonals; then draw ellipses within these parallelograms (our intelligence will understand the drawing as circumferences within squares, even if our eyes do not tell it that). From these continuous and rounded ellipses, construct cylinders whose more closed or more open ellipses will determine a different perspective; the more circular the ellipse, the shorter the straight lines forming the length of the cylinder, while the most narrow ellipses are connected with the longest straight lines. You will find the same thing in arms and legs: keep this in mind when the time comes to draw them in perspective.

Fig. 13a ▶

Rectangular planes

Fig. 13b ▶

Perspective of circles

Fig. 14 ▶

Spheroids in different positions

Fig. 15 ▶

Cylinders in different positions

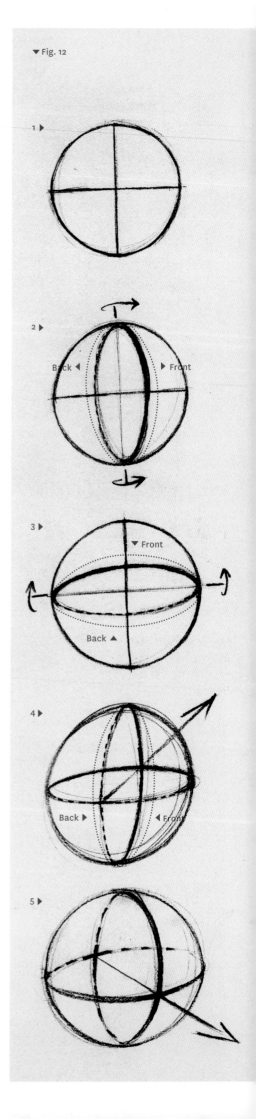

▼ Fig. 12

▼ Fig. 14

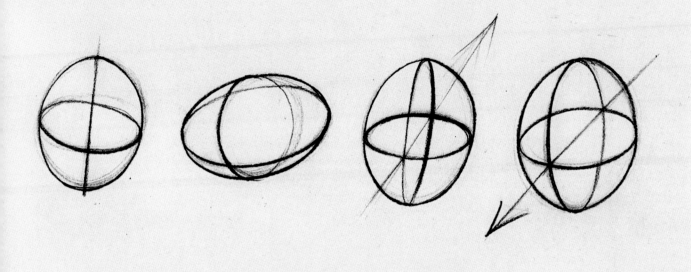

▼ Fig. 13a

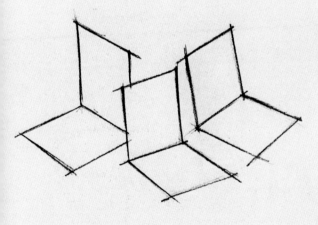

▼ Fig. 15

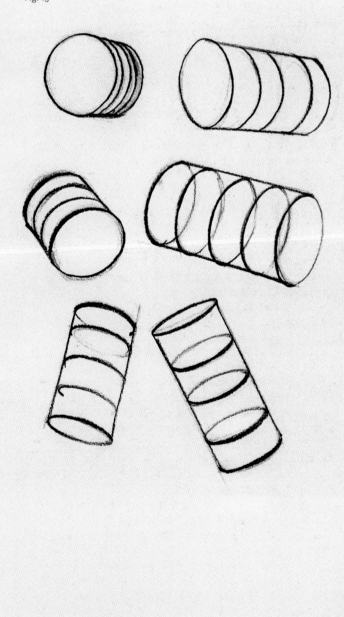

▼ Fig. 13b

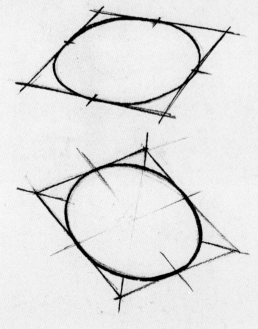

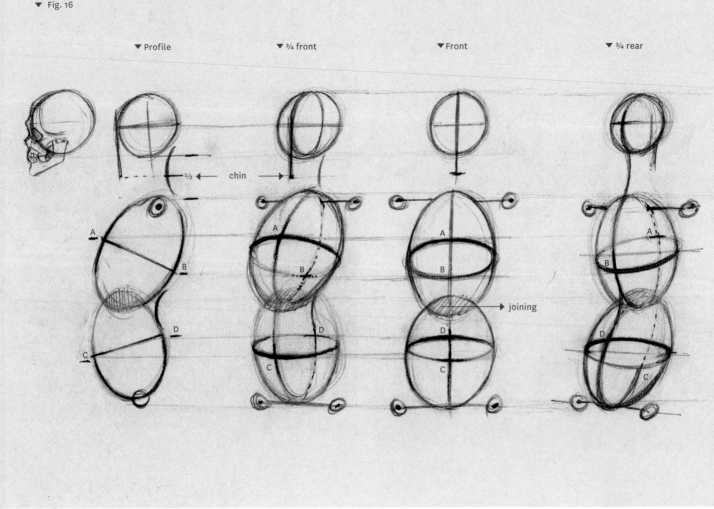

The three structural blocks

To the kinetic structure we were previously making we will now incorporate three volumes that are also structural. One is for the cranium –that is, the ideal spherical volume that constitutes the cranium– without the maxilla or mandible (the neck will therefore be very long because of the mandible being missing). One is an ovoid form that constitutes the rib cage, and the other, which for the moment is identical to the previous shape, makes the abdominal volume.

These circles and ovoids must be quickly and fluidly drawn, without paying too much attention to technical accuracy. They serve to establish the perspective and form the starting point of the musculature and, therefore, the outline, but above all, they order these items within a particular perspective, as we have seen in the introduction above, doing so with slightly varying proportions according to the gender, age and build of the figure we want to represent.

It is important for the chest and abdomen volumes to fit together, and for the ribs to be fairly close to the hip.

▲ Fig. 16

Perspective of the three main blocks
—
A › Sternum.
B › Back.
C › Pubis.
D › Sacrum-coccyx.

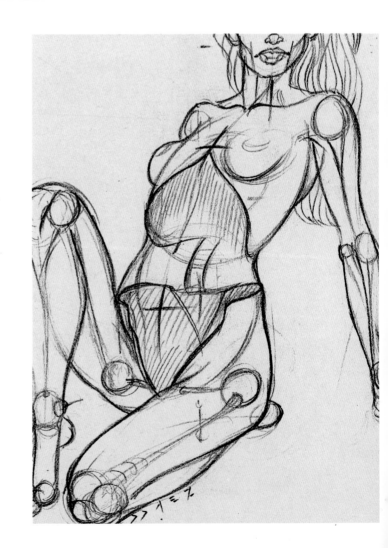

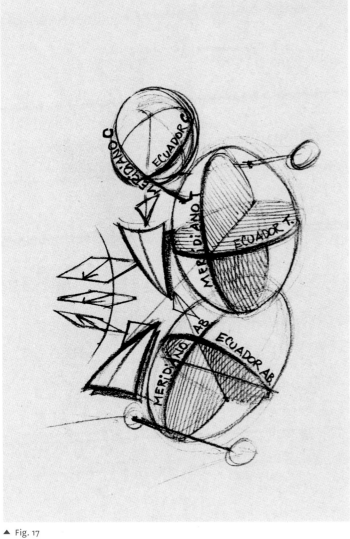

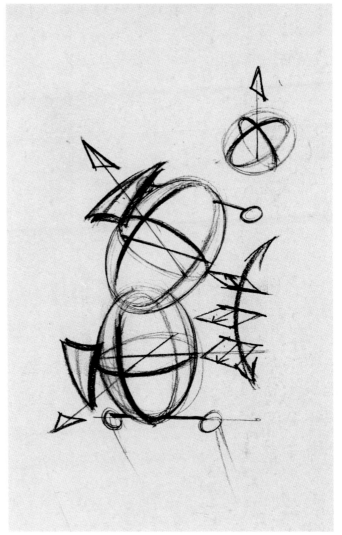

Fig. 19 ▼

Movements of the structural blocks

Fig. 17 ▲

Hunching (contraction)

Fig. 18 ◀

Stretching (extension)

Fig. 19 ▶

Torsion

Each block or structural volume is connected and articulated at the spinal column, so they move independently. This means they have different perspectives, and herein lies the secret of a dynamic, foreshortened pose.

The most typical movements are *hunching* (Fig. 17), *stretching* (Fig. 18) and *torsion* (Fig. 19) as well as lateral contractions.

In the above-mentioned movements, each block has a different position that is determined by the meridians and equators of the ellipses for each structural volume. Each ellipse's equator has an axis that is parallel to:

1 | Cranial ellipse equator: ear line.

2 | Thoracic ellipse equator: shoulder line.

3 | Abdominal ellipse equator: lower hip line.

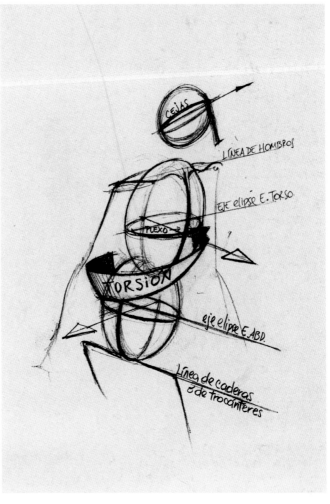

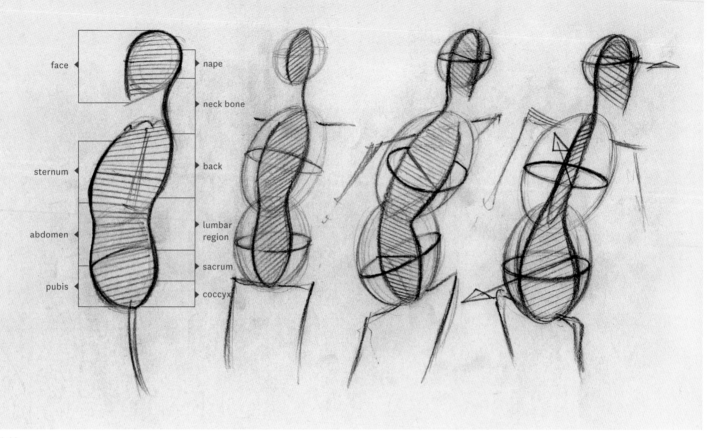

face ◄
sternum ◄
abdomen ◄
pubis ◄

► nape
► neck bone
► back
► lumbar region
► sacrum
► coccyx

▲ Fig. 20

The middle vertical line

These construction lines make up the structure of the human figure. Understanding and being able to draw them is essential: do not leave out this stage of your learning.

The meridians of each block in turn unite to form a middle plane through the trunk and abdomen. But as each volume has a different position, this plane can be subject to torsion, hence the word *torso*.

The meridians conform: (Fig. 20)

› For the cranium, to the middle vertical axis of the face at the front and the vertical middle line of the nape from behind.
› For the thorax, to the sternum in front and from behind the spine.
› For the abdominal volume, to the middle line of the abdomen in front and sacrum-coccyx behind.

In joining the curves at the back we will draw two countercurves that will link the nape and the back at the top (the neck area) and the back and sacrum at the bottom (the lumbar region).

Before you start drawing, get hold of photographs in which you can see the volumes and concepts shown in the drawings here. Draw the outlines and their ellipse equators and meridians over the photos and then make a drawing of the structure on paper.
It will be necessary to repeat this drawing many times, until you achieve fluidity, speed and proportional accuracy.
Do not go to the next stage without first mastering this one and being able to draw it gracefully (that is, with fluidity, speed and accuracy).

Now that we have gained a correct understanding of the structural volumes we will add the synthetic information of the bones that compose them.

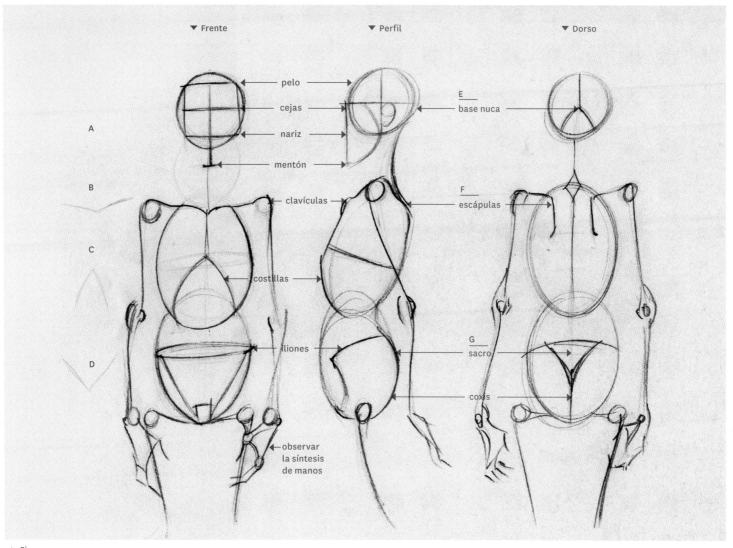

pelo
cejas
nariz
mentón
clavículas
costillas
iliones
observar la síntesis de manos

E base nuca
F escápulas
G sacro
coxis

A
B
C
D

▲ Fig. 21

Fig. 22 ▼

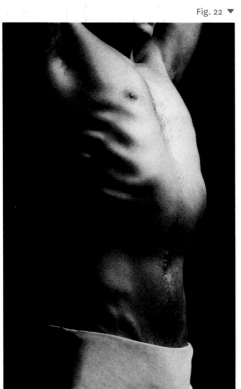

› **Front of the figure** (Fig. 21)

To the cranium we will add the information for the mask that will make up the face, which is composed of three equal sections. The chin is about halfway between the base of the cranium and the shoulder line (A). On the thorax we will draw the clavicles, in a slight "V" from the angle at the upper end of the sternum (in the centre) to the shoulders, which have their own particular curve (B). Where the meridian and equator of the thorax meet a downward "V" marking the ribcage opens up (C).

For the abdomen, the "V" will go from the pubis (the pubic symphysis) to the lateral ends of the equator of the abdomen (D).

› **Back of the figure**

At the cranium we will draw an inverted "V" from the intersection of the meridian of the nape with the equator of the cranium to the base of the cranium (E).

At the thorax, as an analogous element to the clavicles, we will draw the scapulae line (the crest of the shoulder blades), slightly separated from the spine (F). At the abdomen we will draw a "V" that is more closed than the others to synthesize the sacrum and coccyx, a line which coincides with the meridian (G).

The drawing will now provide an approximate synthesis of the figure's skeletal constitution.

23

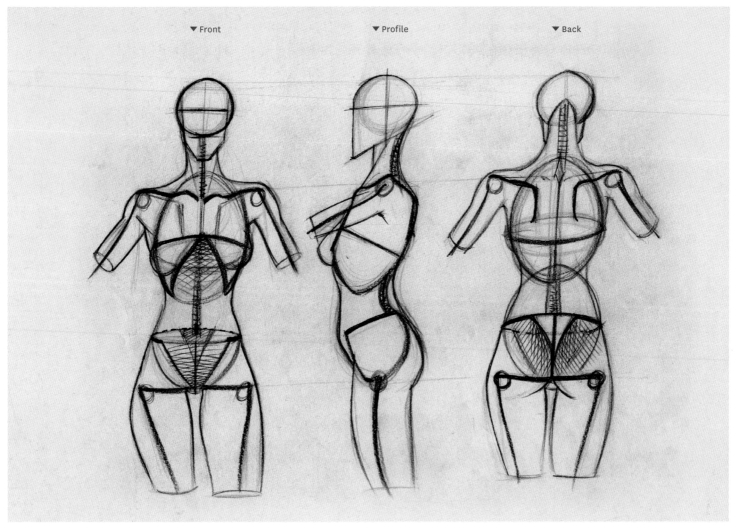

This model gives us a clear idea of the location of the skeleton that we are drawing and how it functions in relation to the anatomical outline.

Imagine the geometric volumes inside the body and you will be able to see how they structure it.

The functioning of the hips is more difficult to understand than that of the other blocks. As you head down from the head to the hips, the blocks lose bone density (reflecting their role of protecting different levels of organs: the brain, respiratory system, the centre of the circulatory system, the reproductive organs) meaning that the abdominal cavity separates from the upper body, that is to say the half above the abdominal equator, and forms a transitional contour, the waist. The equator is the upper hip (the ilia and sacrum bones of the pelvis).

Fig. 23 / Observe these volumes in ▲ the photograph (Fig. 24)

Functioning of the structure in the anatomical outline

▼ Fig. 24

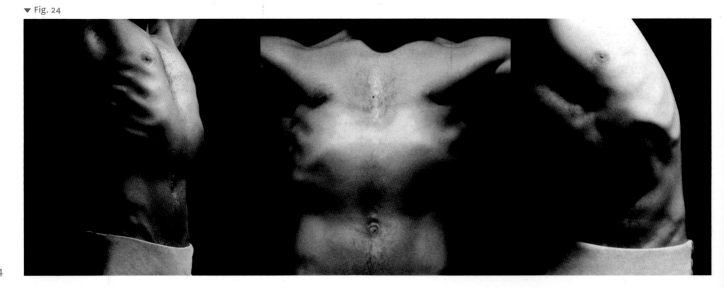

◀ Fig. 26

Functioning
of the hips
inside the body

surplus
space

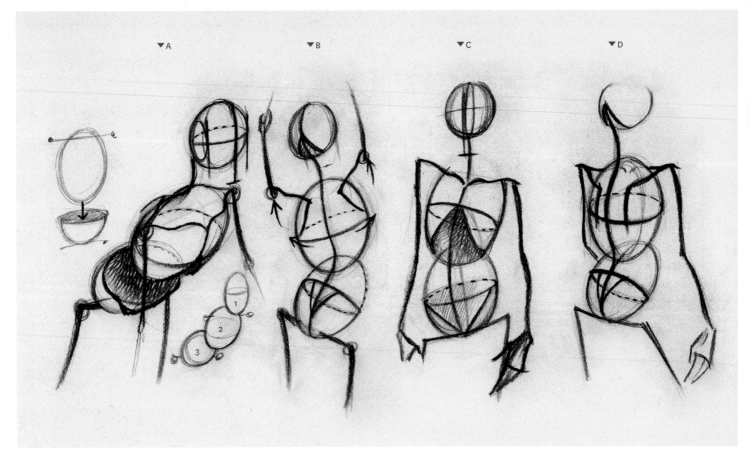

▲ Fig. 28

Poses of the structure / joining points

Fig. 29 ▼

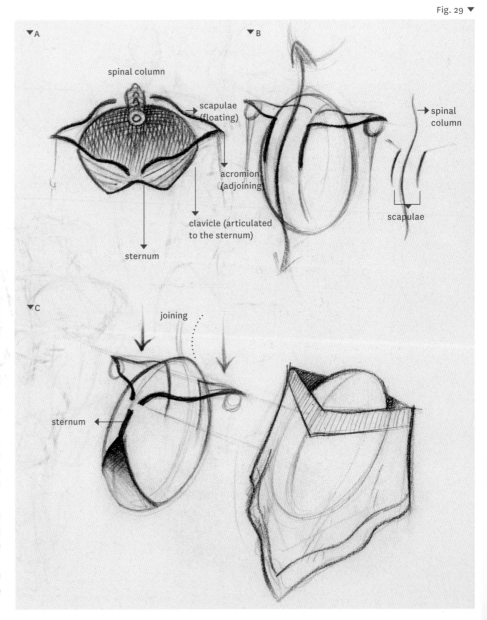

Do a lot of practice on this level of structure, but remember that understanding and representing the volumes, their perspective and the bone details that we have seen are not more important than the dynamics and expression of the pose and the line, which we must understand and master before focusing on volumes and bone synthesis.

Notice how the sense of depth is created with foreshortening: it comes from the juxtaposition of the ovoids that make up the structure. The first thing we see is the volume of the head, which overlaps with the second, the torso, which in turn overlays the third volume in depth, the abdomen (Fig. 28-A).

The idea of space is an interpretation of the human brain, not a perception. What the eye actually perceives is one form cutting into another.

When the shoulders rise, the scapulae turn outwards moving within the rib cage (Fig. 28-B).

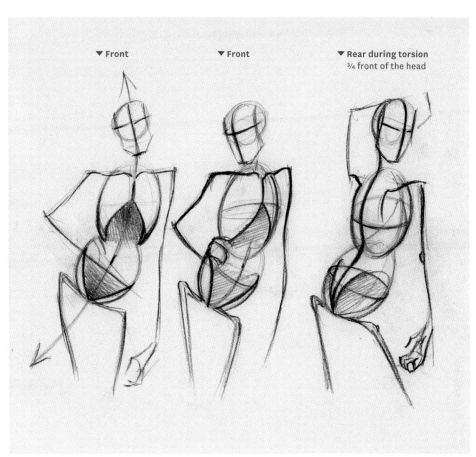

▼ Front ▼ Front ▼ Rear during torsion
 ¾ front of the head

Meeting of the upper limbs with the thorax

The clavicles meet the thorax at the sternum and can only move upwards. They connect to the shoulder blades at an angle called the *acromion* (Fig. 29-A), from where the arm (humerus) comes out. The shoulder blades connect to the ribcage in a more flexible way and give the impression of floating over it.

Structural foreshortening

› foreshortening of the structure
¾ front

› foreshortening of the structure
back view

▼ Fig. 31

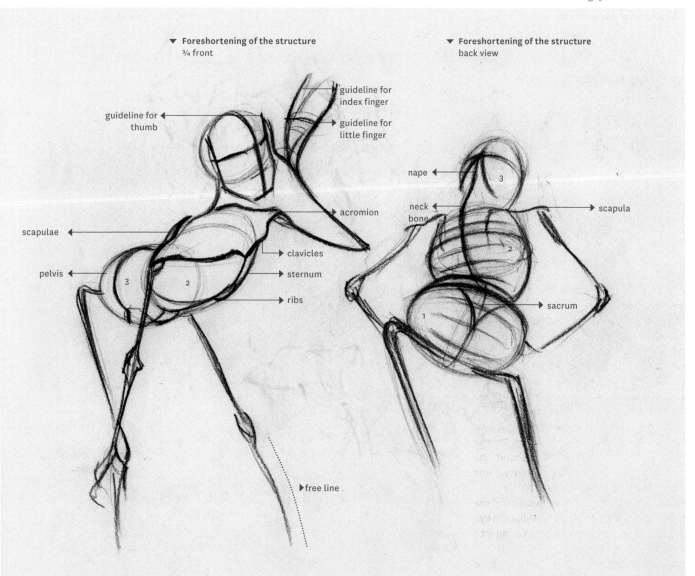

▼ Foreshortening of the structure
¾ front

▼ Foreshortening of the structure
back view

guideline for index finger

guideline for thumb

guideline for little finger

nape

acromion

neck bone

scapula

scapulae

clavicles

pelvis

sternum

sacrum

ribs

free line

27

Structuring of the feet (Fig. 33)

In the case of the foot, as in all previous cases, knowing its structure is essential for constructing and representing it. This structure is made up of two and a half squares that form the length and width of the foot. We draw a middle lengthways line to create the axis of the sole, and at one-third of the length we draw a widthways line to form a cross with the axis of the sole (Fig. 32). This cross emerging from a rectangular plane will give us a very important solution to the problem of feet being planted on the ground plane, which is essential for the figure not to "fly" or "float" above the ground. It is as important as establishing the body's movement lines.

Once we can properly handle the perspective of this cross (or support plane) we will be able to put the circular spherical volumes that structure the form on it:

The sphere *M1* rests on the metatarsal line, followed by smaller ones that represent the start of the other toes, whose size decreases as they progress towards the little toe. We can also imagine it as a hinge that supports the joint of the toes with the foot when it rises up and rests only on the metatarsus (Fig. 34).

The sphere *Cal* rests on the edge of the sole line (sole axis) and forms the heel.

And finally we have the sphere *An* that makes the ankle; it is above and further forward than the heel and is slightly larger than it. The ankle has two small spheres on the sides that form the internal and external condyles (Fig. 33-B).

› The arch

The tarsus and metatarsus of the foot–or instep, as it is often called–can be understood as a curved bridge that connects the ankle sphere with the hinge formed by *M1* (the sphere of the big toe) and subsequent spheres.

But to have more continuity in the drawing we must join everything together with curved and continuous lines spanning from the internal condyle of the ankle to the base of the big toe, and another from the external condyle to the little toe (Fig. 33-C).

› Base of the foot

The sole of the foot consists of a ridge that runs from the base of the heel to the base of the little toe, forming a diagonal volume spanning the entire sole (Fig. 33-A); on the other side we have the metatarsal hinge and a concave volume that we call the *arch*.

Fig. 32 ▶

Diagram of the foot
The opening of the angle and the tilt of the arch and metatarsal lines indicate the perspective.

▼ Sole lines / Fig. 34

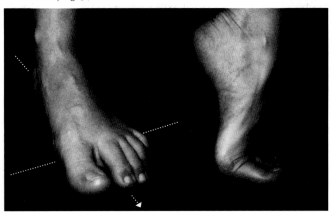

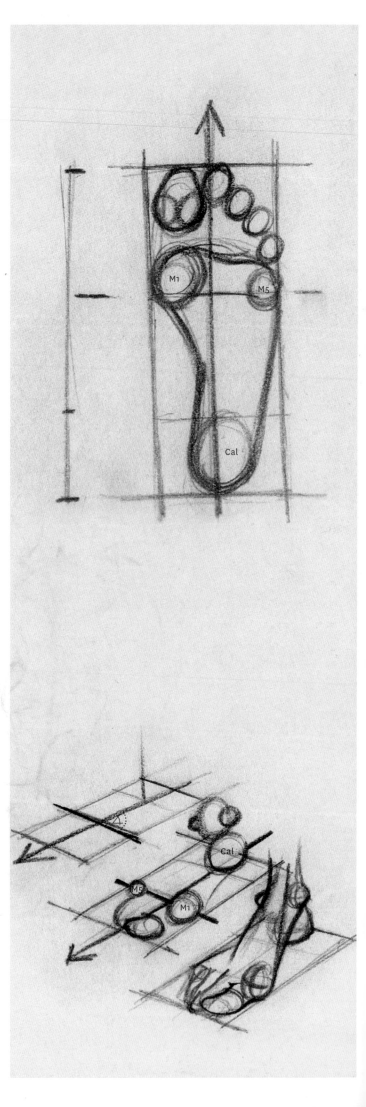

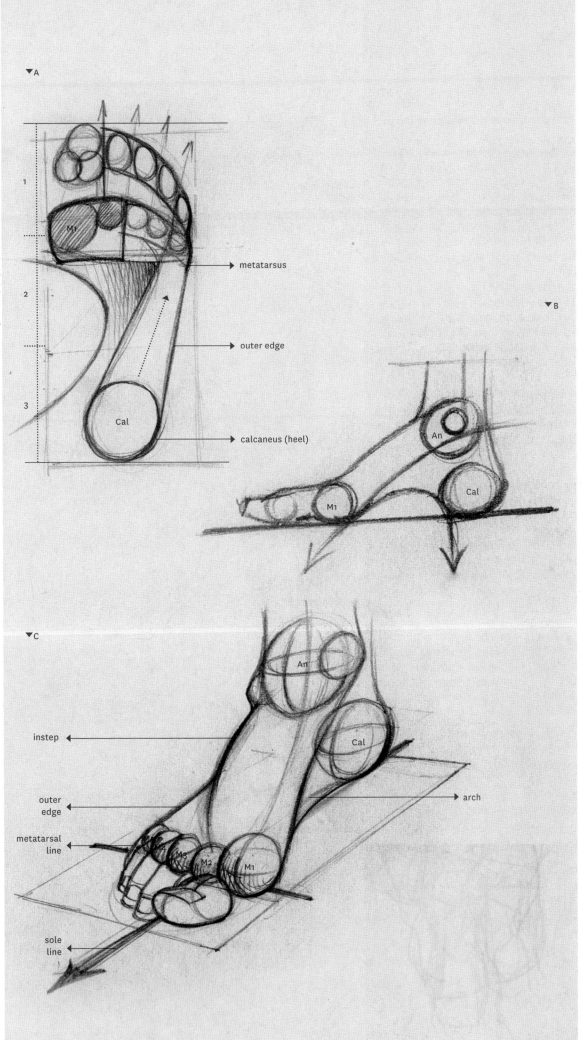

A › View of the sole.
B › Internal profile.
C › Three-quarters frontal.

An › Ankle;
Cal › Calcaneus (or heel);
M1 › Metatarsus (of the big toe). (as per Figs. 32 and 33)

▼A

1

M1

2

→ metatarsus

→ outer edge

3

Cal

→ calcaneus (heel)

▼B

An

M1

Cal

▼C

An

instep →

Cal

outer edge →

arch →

metatarsal line →

M3 M2 M1

sole line →

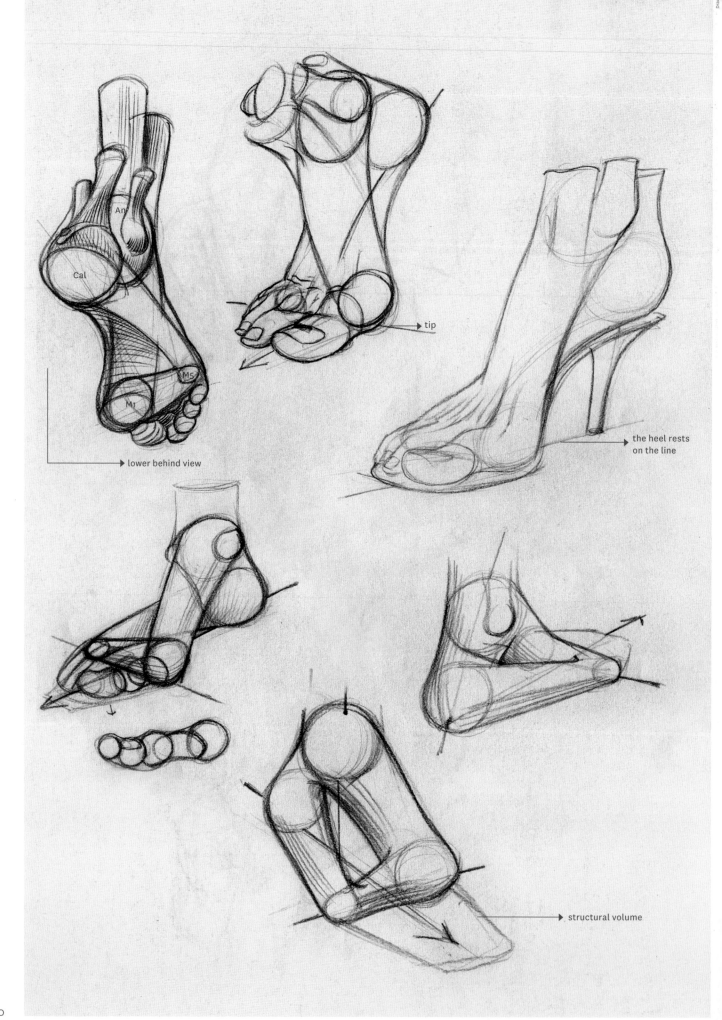

An

Cal

M5

M1

► lower behind view

► tip

the heel rests
on the line

► structural volume

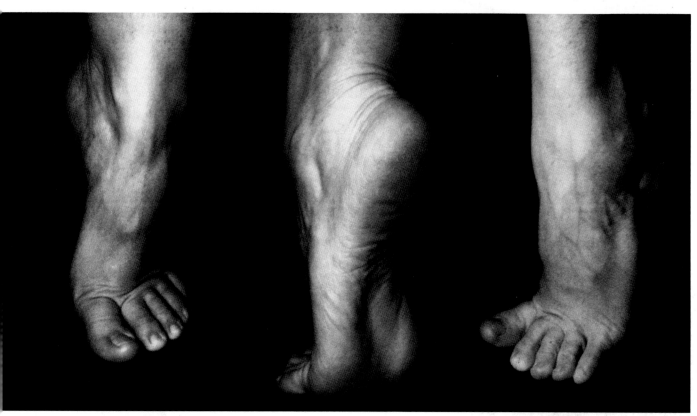

Fig. 37 ▼

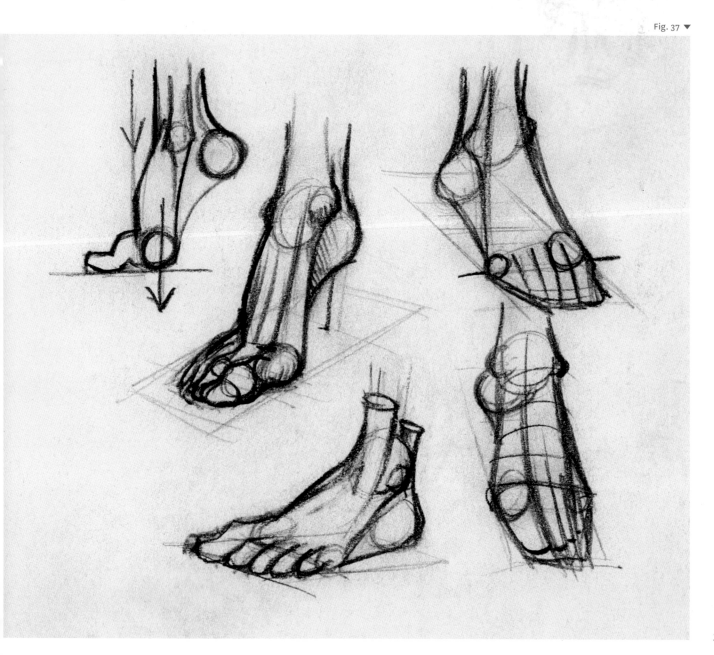

Fig. 39 ▶

**Kinetic structure
of the hands**

Kinetic lines
and proportional
structuring

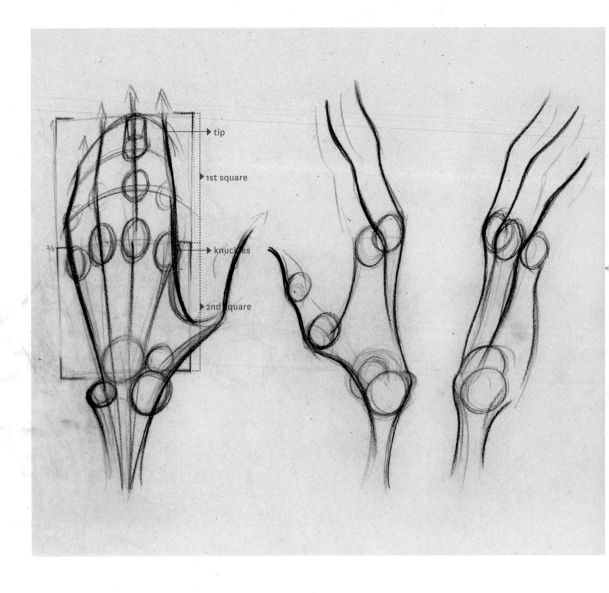

Structuring of the hands (Fig. 39)

The kinetic aspects of the structuring of the hand are very impor-
tant; a hand based on structural volumes will be rigid and have
no expressive grace.

For this reason the index-finger line should be understood as a
continuation of the arm line (Fig. 38); the index-finger line is linked
with the little-finger line and is opposed to the thumb line: these
are the three key directions of the hand. The other two fingers
are only rarely focused on since they are a continuation of the
movement that begins at the index finger and ends at the little
finger. Establishing these three lines will indicate the fanning out
of the five fingers.

Another line of great structural importance is that of the knuckles.
This is a horizontal line that runs perpendicular to the length of the
hand and divides the hand into two equal parts whose respective
limits are the base of the palm, where the wrist ends, and the tip
of the middle finger.

Draw these lines with the greatest possible fluency, with attention
focused on the expression rather than the form, as we did with
the body. You will then add different structural elements that will
help you understand and achieve the shape of the hand.

The volumes to be added to this line structure
will be:

A | Knuckles: These are spheres that
represent the entire joint of the first
phalanges of the fingers with the meta-
carpals; they are aligned according to
the knuckle line.
B | The muscles of the little finger and thumb.
C | The junction plane between the thumb
and index finger.
D | The wrist: a large sphere on the thumb
side of the hand and a small one on the
little-finger side.

Always keep in mind that the fingers
never form straight or parallel lines, but
rather a fan of lines, usually from the
position of the index finger to the little
finger, with the thumb having greater
independence.

Fig. 40 ▼

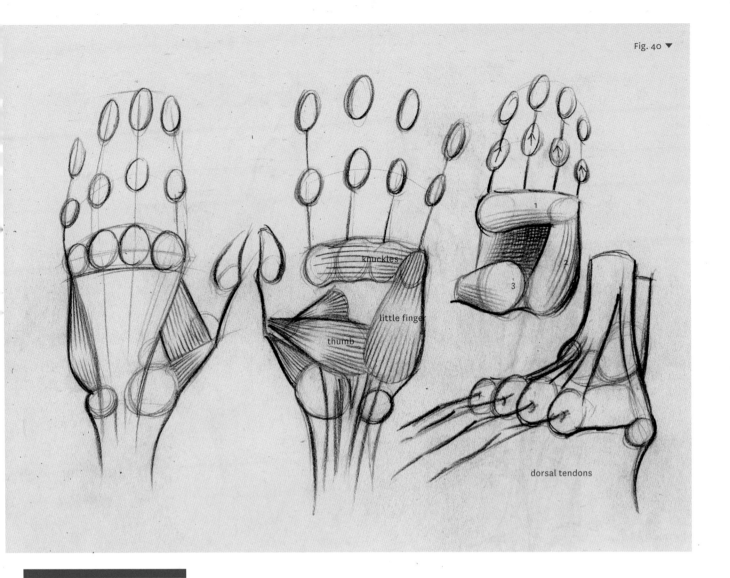

knuckles

little finger

thumb

dorsal tendons

To establish the hand muscles, first practice
the kinetic structure to achieve spontaneity,
then put in the joint spheres, and finally add
the musculature.

▼Fig. 38

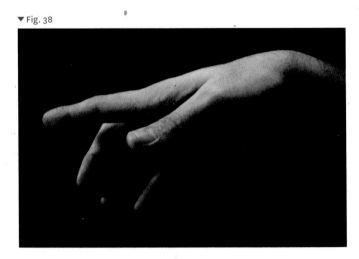

Fig. 38a ▼

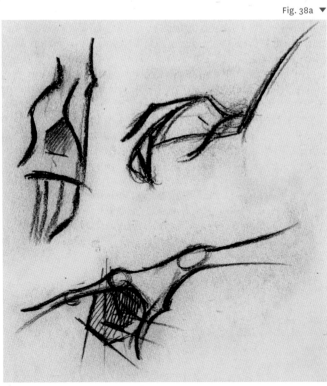

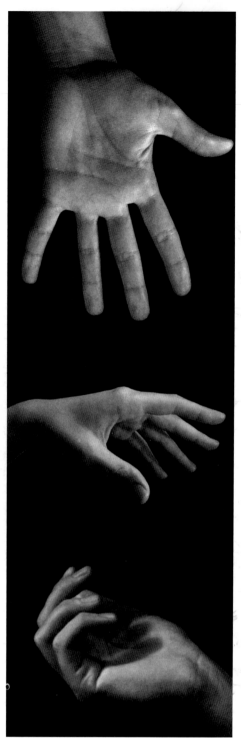

▲ Fig. 41

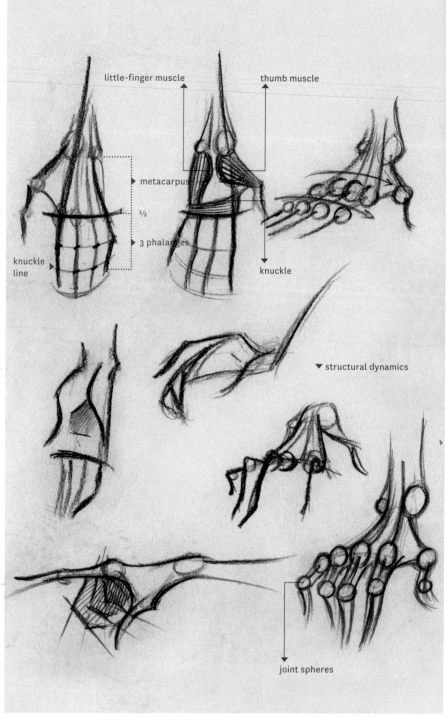

little-finger muscle thumb muscle

metacarpus
½
3 phalanges

knuckle
line

knuckle

▼ structural dynamics

joint spheres

▲ Fig. 42

Fig. 43 ▼

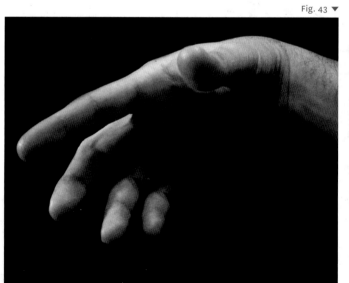

Fig. 44 ▼

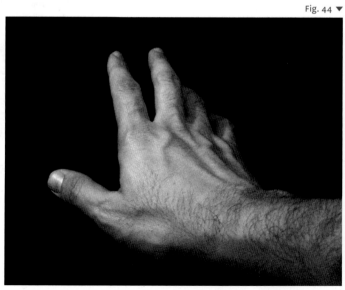

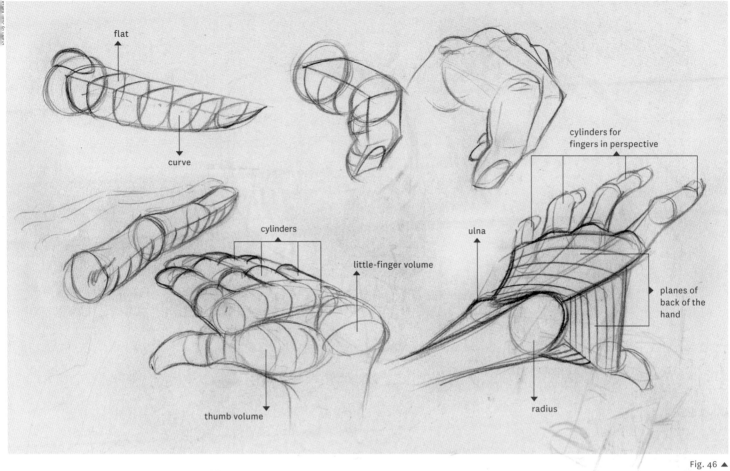

flat

curve

cylinders for
fingers in perspective

cylinders

little-finger volume

ulna

planes of
back of the
hand

thumb volume

radius

Fig. 46 ▲

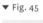

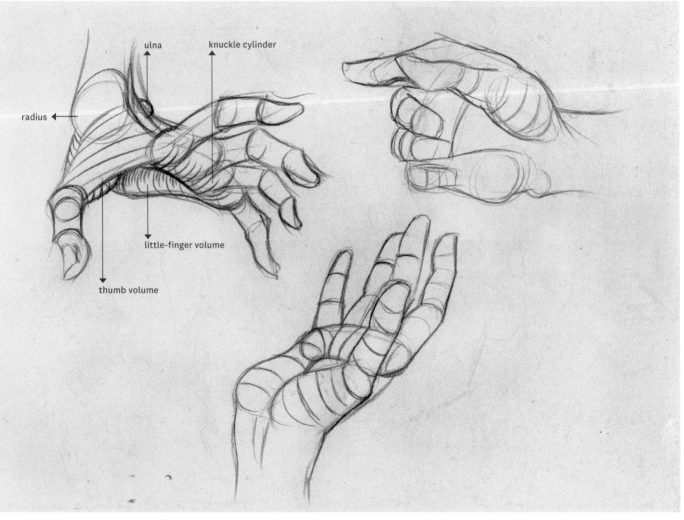

ulna

knuckle cylinder

radius

little-finger volume

thumb volume

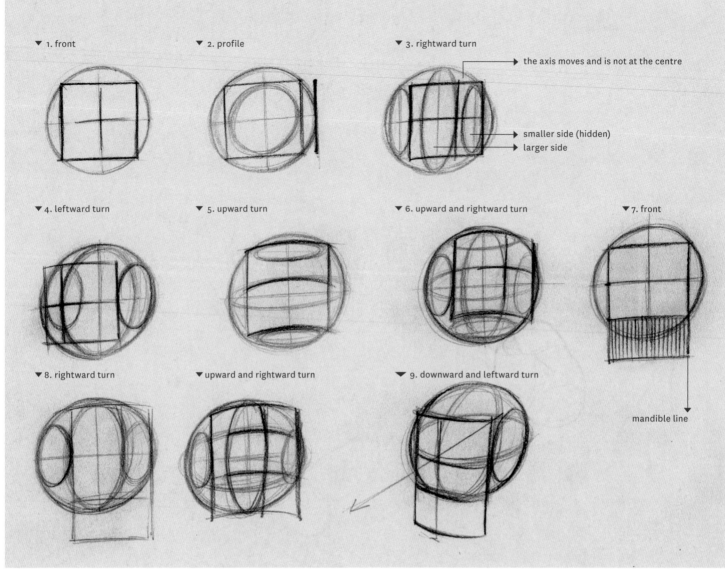

▼ 1. front ▼ 2. profile ▼ 3. rightward turn

→ the axis moves and is not at the centre

→ smaller side (hidden)
→ larger side

▼ 4. leftward turn ▼ 5. upward turn ▼ 6. upward and rightward turn ▼ 7. front

▼ 8. rightward turn ▼ upward and rightward turn ▼ 9. downward and leftward turn

mandible line

▲ Fig. 47

Structure of the face
relative to the head

We will continue the structural study of the human body with the face and head, without yet going into their details and the facial features.

Base square of the face

We will begin by studying the movements of the sphere containing the first components of the face (Fig. 47).

1 | This sphere is the head, to which we attach a flat square on the front. The square is inserted in the circle for the structural cranium and is divided into four equal parts by the cranial meridian and equator lines; the lines mark the hair line and forehead area, the location of the eyebrows and the base of the nose. Seen from the front, the sphere seems to be just a circle with a square inside.

2 | Viewing the volume in profile form we see that the (parietal) sides have the same structure as the front, with the difference that another circle is added, this time contained in the square, and a line with the same height as the square which would be the square for the face.

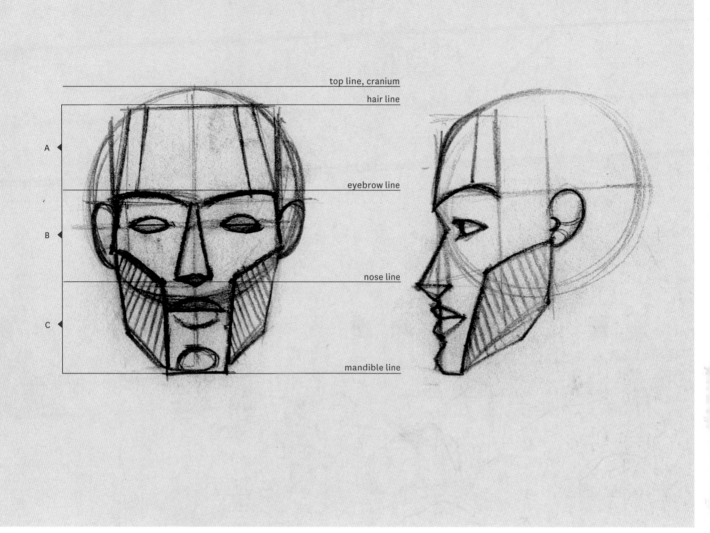

top line, cranium
hair line
eyebrow line
nose line
mandible line

A
B
C

Fig. 48 ▲

Main volumes

3 | If we turn the sphere a little on its vertical axis, we see that the meridian line becomes an ellipse, as we saw earlier. The new element is that on the opposite side to which it turned (or at least from our viewpoint) an ellipse taking the same shape but of half the size appears, making up the side of the head: the temples or parietal areas. If the sphere rotates, the ellipse widens until it turns into a circle in its profile view.

4 | If the head only turns upwards, what changes is the equator line. The limit of the forehead is the edge of the cranium, and the lines marking out the forehead, eyebrows and nose arch in accordance with the curve of the equatorial ellipse.

5 | We now combine the two rotations to achieve a three-quarter profile view.

6 | If to this structure we add half a square to the bottom part we get the mandible line; this line will be parallel to the eyebrow line and will have the same curvature.

The result is a structural mask of the face, divided into three equal parts:

A = Forehead.
B = Eyes-nose.
C = Mandible.

Parts which will move in the same manner as in the cases of the sphere.

Search for photos where you can find what you have seen in the book; mark them at the height of the eyebrows and draw the axis of symmetry in the face: you'll see that they match the parameters that I have written about and drawn here. This will help you understand the perspective of cranial volume with the inclusion of the planes of the face. Do not worry about defining facial features yet; only draw them geometrically. You will look at them in detail later; remember that progressing step by step will avoid unnecessary frustrations.

37

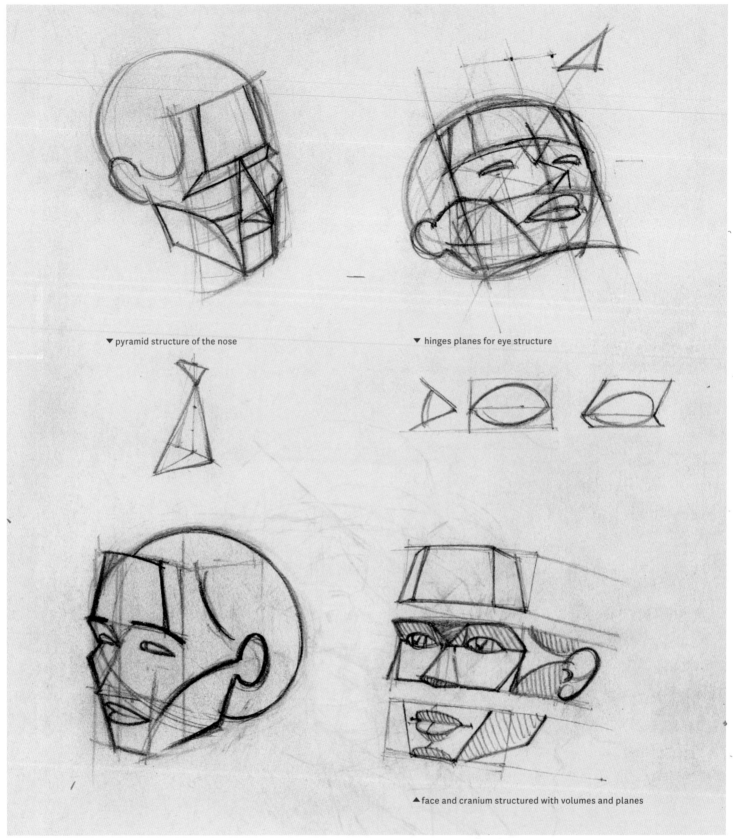

▼ pyramid structure of the nose

▼ hinges planes for eye structure

▲ face and cranium structured with volumes and planes

▲ Fig. 49

More details of secondary planes for the mask

Draw the features as geometric objects without going into details, but be careful to get the location and drawing of the elements correct.

The goal is not to provide detailed facial features, but to understand their structuring volume. Without this understanding, it is useless and counterproductive to define the formal details of the eyes, nose and mouth, as they will be misplaced or malformed.

Fig. 50 ▼

▼ Incorporation of volumes

▼ Nose volumes

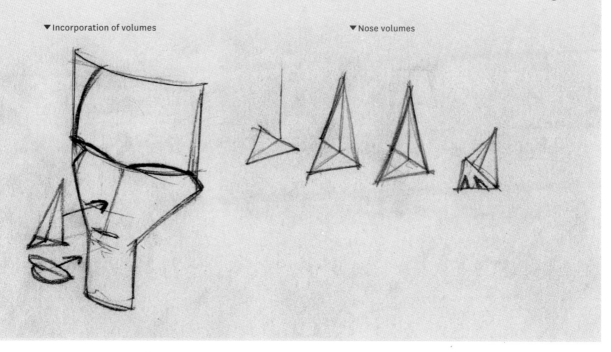

Fig. 51 ▼

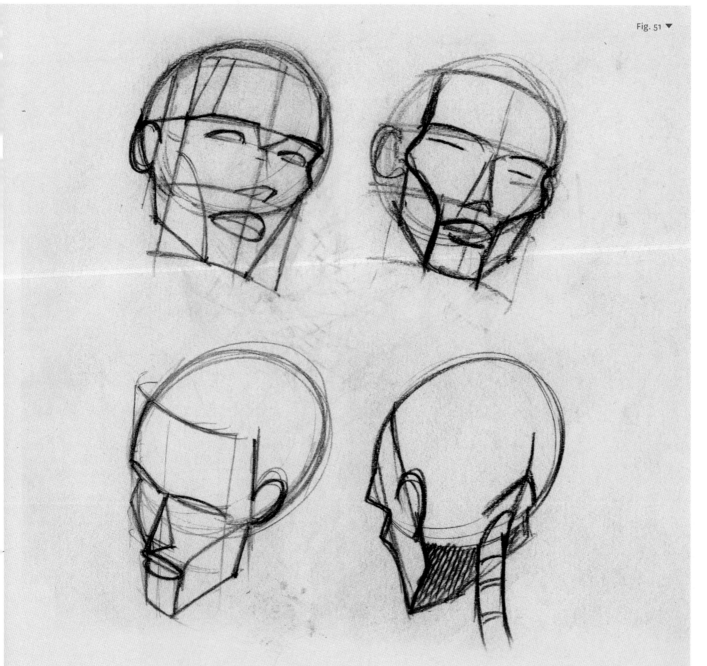

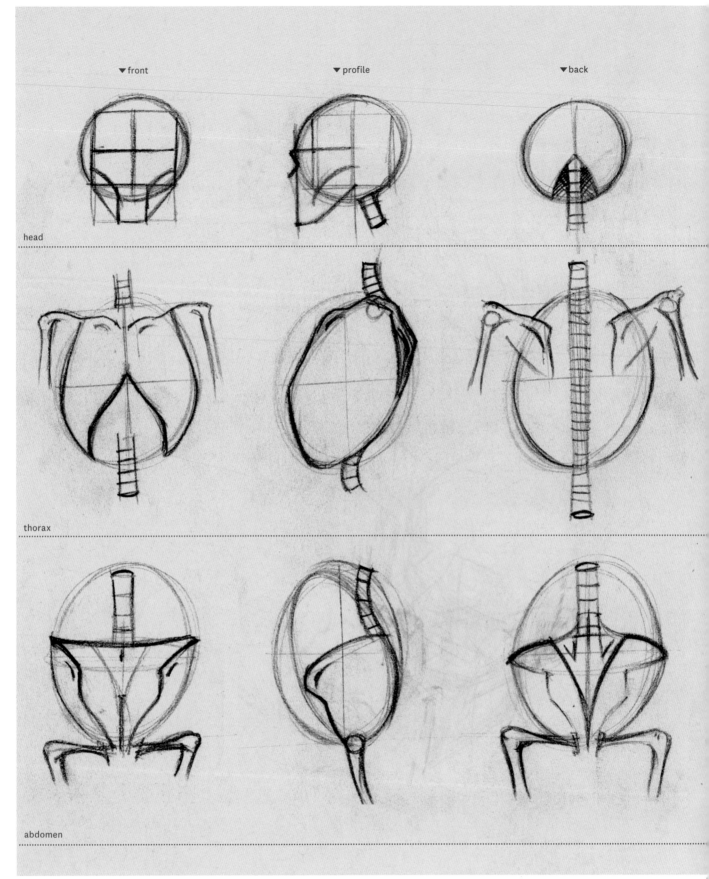

head

thorax

abdomen

▲ Fig. 52

40

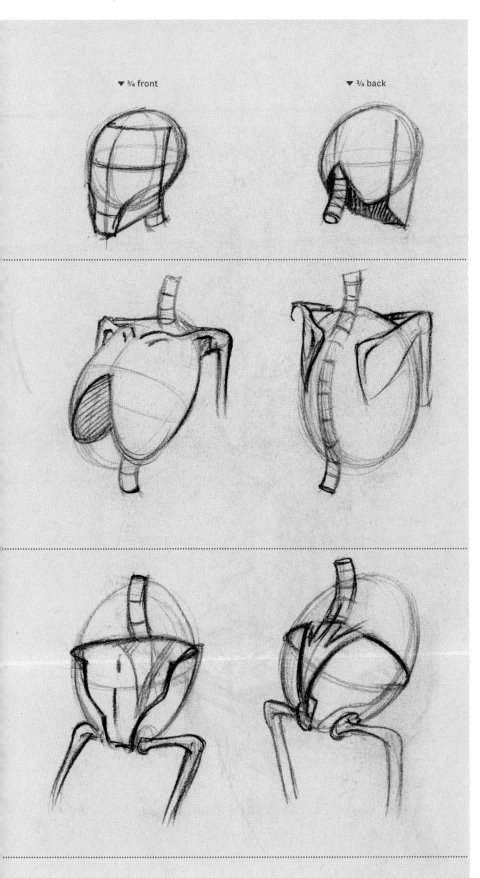

▼ ¾ front ▼ ¾ back

Approximation of the skeleton

We will now go one step further by converting the kinetic structure into a synthesis of bones, that is, a sketch of the bones that allows us to recognize them and serves as a reference for adding the muscles.

Note the incorporation of the face structure and the nape as an inverted "V" into the head.

On the chest we mark out the clavicles, ribs and shoulder blades, while at the hip we will have the pelvis with its iliac crests, the pubis, the sacrum and the coccyx.

———

With a little more skeletal information the volume and kinetic structures become a true synthetic skeleton.

Fig. 53 ▼

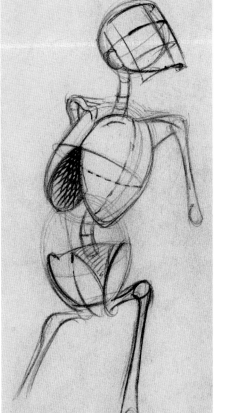

41

Functioning
of the arms

We will now incorporate into the joints spheres that will have the function of:

› Marking out the perspective of the elbows and wrists, which are mobile and always change in terms of their viewpoints.
› Simulating torsion of the arm (through the movements of supination, the thumb facing outwards, and pronation, the thumb facing inward).

Fig. 54 ▶

Diagram of bone synthesis
Alternative cylinder elbow

Kinetic structuring line
Location of bones based on this structuring

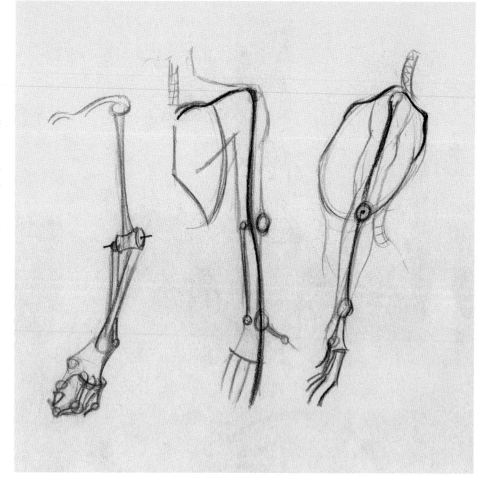

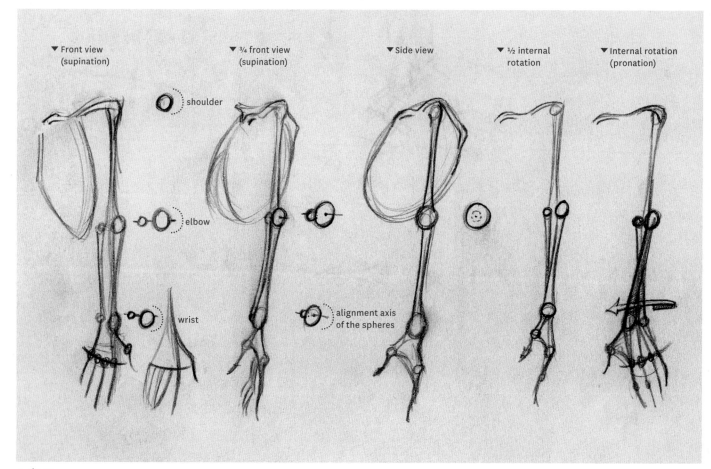

▼ Front view
(supination)

shoulder

elbow

wrist

▼ ¾ front view
(supination)

alignment axis
of the spheres

▼ Side view

▼ ½ internal
rotation

▼ Internal rotation
(pronation)

▲ Fig. 55

Thumb facing outwards / external rotation

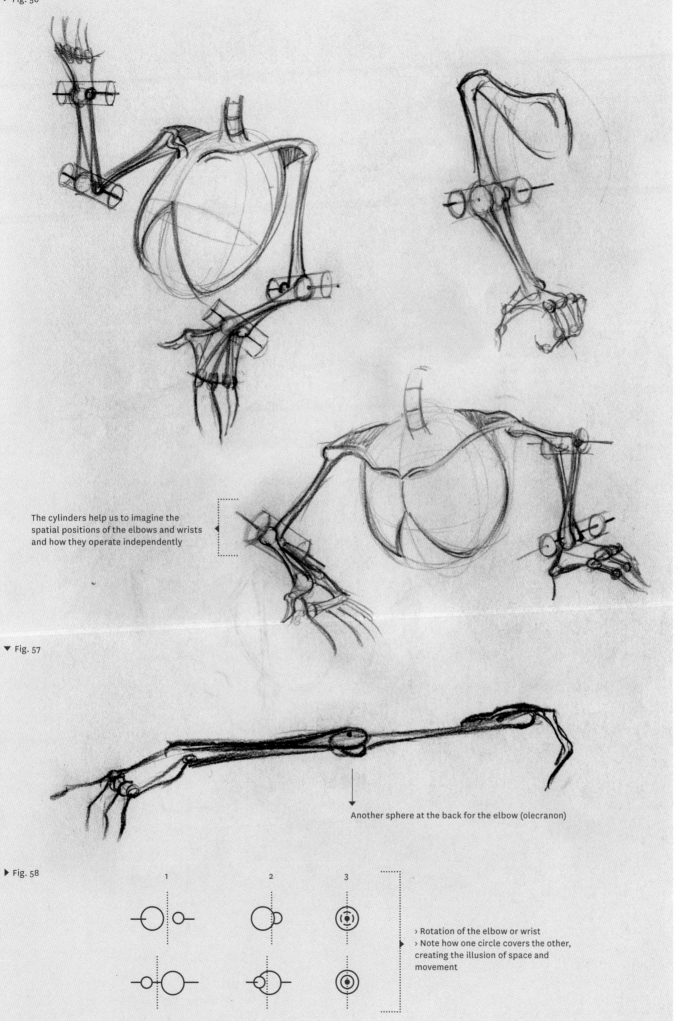

The cylinders help us to imagine the spatial positions of the elbows and wrists and how they operate independently

▼ Fig. 57

Another sphere at the back for the elbow (olecranon)

▶ Fig. 58

1 2 3

› Rotation of the elbow or wrist
› Note how one circle covers the other, creating the illusion of space and movement

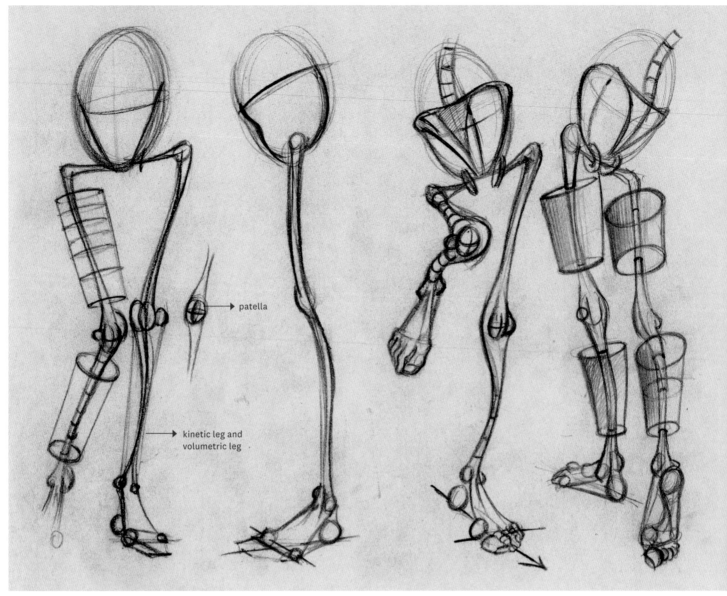

▲ Fig. 59

› The rings or coverings in the drawings are a visual aid to establish the perspective of each jointed section.
› The cylinders serve a similar function and also help to visualize the body's mass.

Fig. 60 ▼

Structure for the legs

We incorporate spheres into the legs at the knees and ankle in a similar way.

The patella is a half sphere that is like a kind of lens, located over two spherical (internal and external) volumes. The use of coverings or rings that you can see on the bones creates the effect of perspective, as with the cylinders we saw previously, and they can be incorporated into both the legs and the arms, though it is more important to add them to the legs because of the body mass they hold.

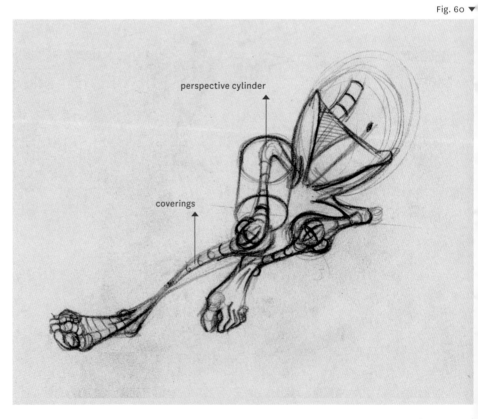

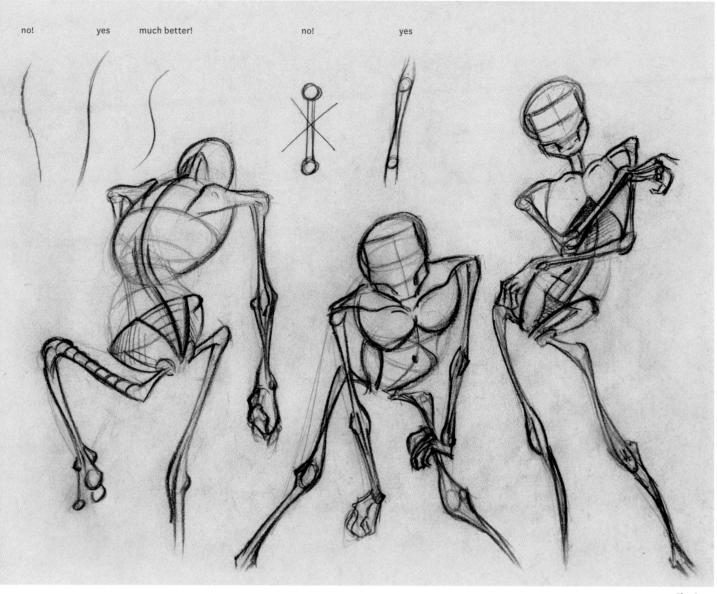

no! yes much better! no! yes

Fig. 62 ▲

▼ Fig. 61

Drawing creation sequence
› The axes and cylinders are explanatory. You can draw and use them to help understand the movements and then erase them.

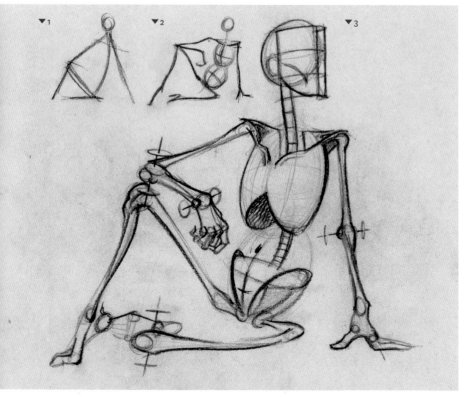

▼1 ▼2 ▼3

Internal structure

This sequence will help you begin to establish the bone structure. First, we do a quick sketch of the geometric axes that exaggerates the stance, then a first establishing of volumes, and then the details.

Although it might not seem like it, the most important steps are the first and second ones, as they create the dynamics, attitude and grace of the drawing.

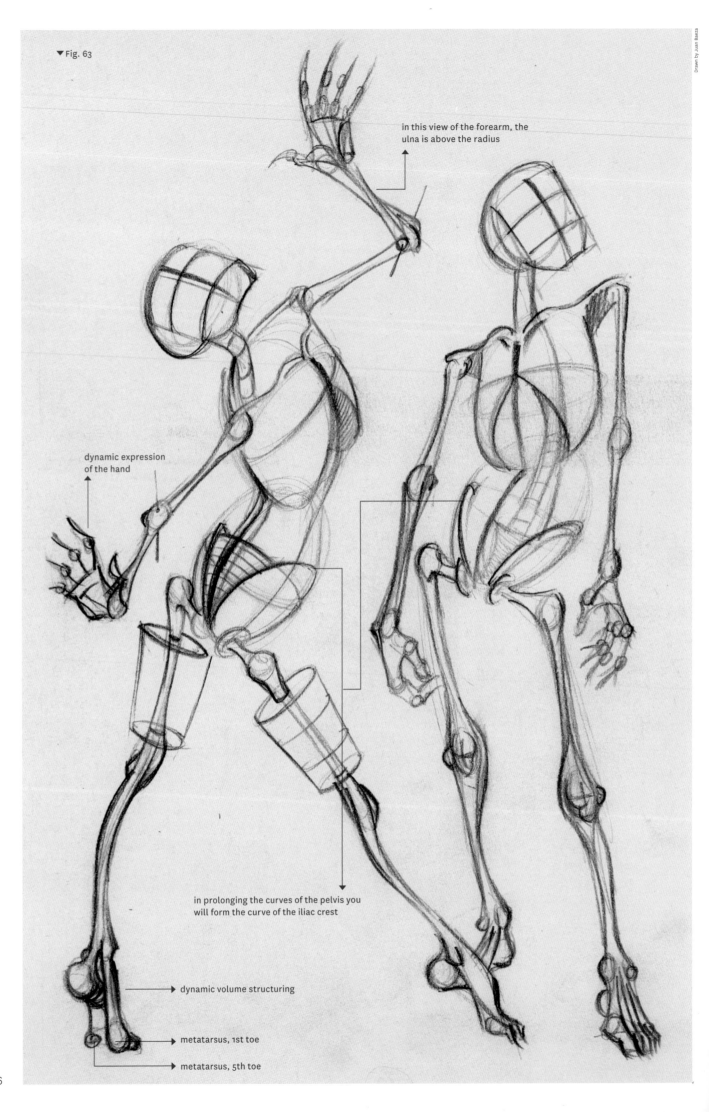

Drawn by Juan Baeza

in this view of the forearm, the
ulna is above the radius

dynamic expression
of the hand

in prolonging the curves of the pelvis you
will form the curve of the iliac crest

dynamic volume structuring

metatarsus, 1st toe

metatarsus, 5th toe

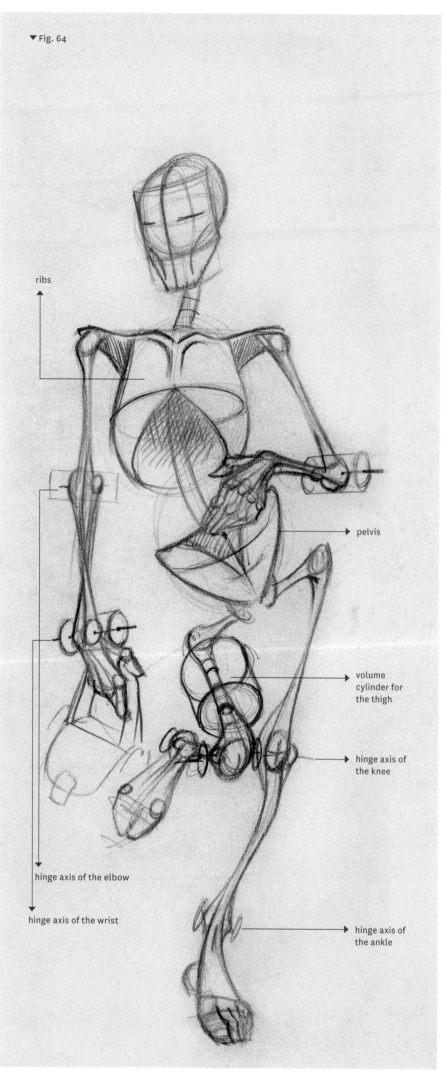

Draw lots of poses in this way, without adding details until you've mastered these elements.

Once we integrate everything we get a dynamic and *three-dimensional* skeletal structure.

ribs

pelvis

volume cylinder for the thigh

hinge axis of the knee

hinge axis of the elbow

hinge axis of the wrist

hinge axis of the ankle

▼1 ▼2

Fig. 65 ▶

Fig. 66 ◀

Look at the gaps: they are
not leftover space but
emerge with the body and
must be harmonious with it.

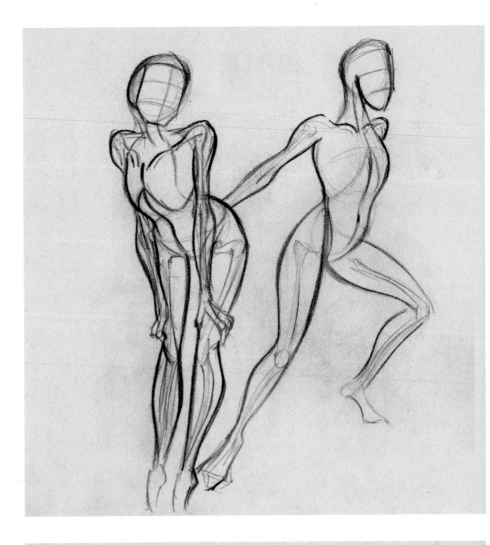

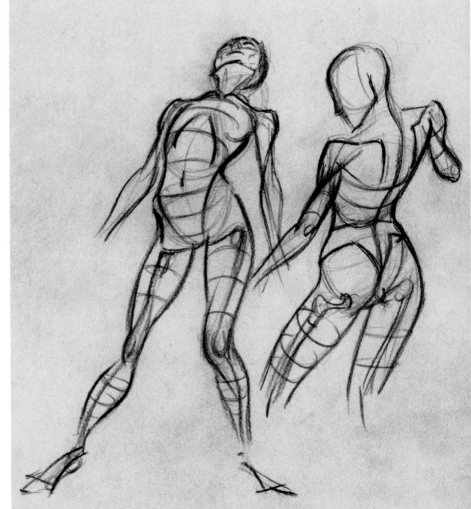

What we see here is a dynamic and intuitive
drawing of the outline of the figure.
This means that it is not yet a product of
a knowledge of muscular anatomy, but of
hand movement simulating the anatomical
contour lines which, with a fast and loose
stroke, cross the kinetic structure of the
skeleton.

I should point out that although I have
tried to hide it in my drawings, the mus-
cle information is already incorporated
(that's cheating!). But it is there as a
guide for those who need a reference.

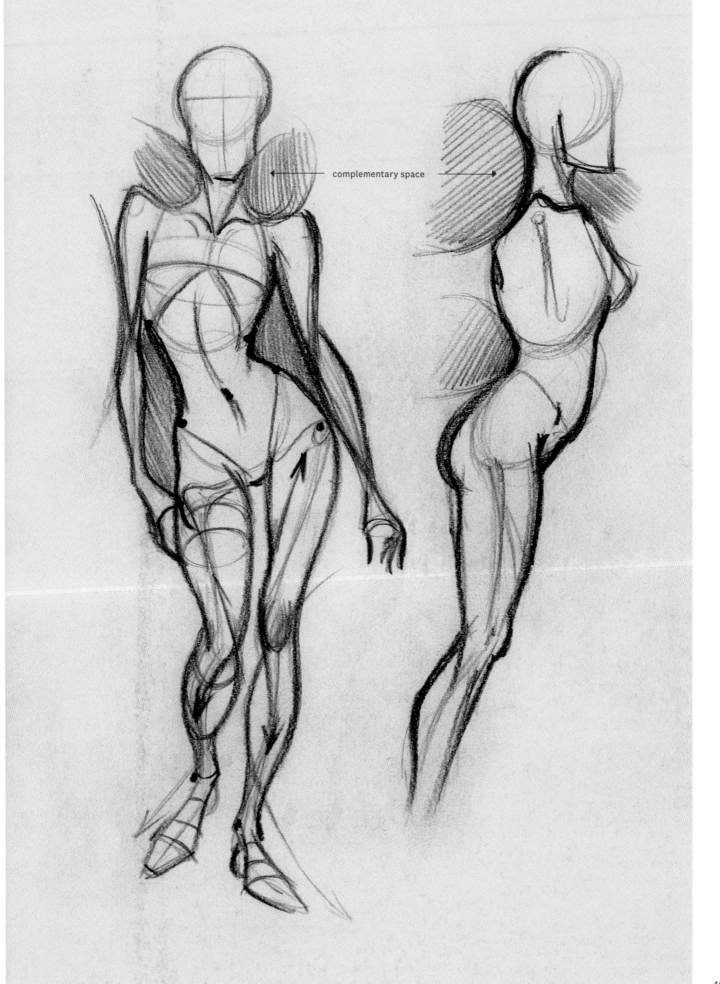

complementary space

musculature

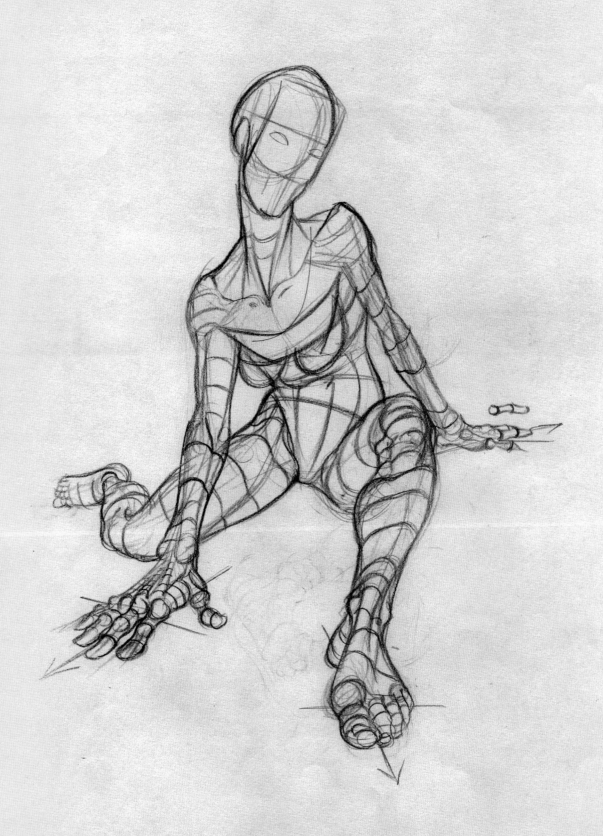

Fig. 69a ▶

Basic functioning of the musculature

› bone
› joint
› insertion
› muscle

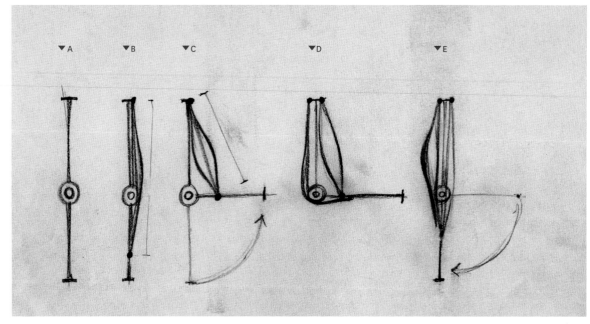

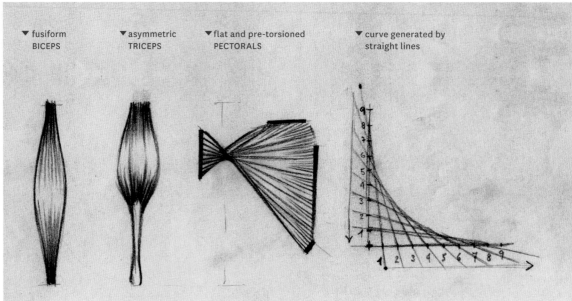

IMPORTANT: Keep in mind that what we will see here is not medical anatomy, and nor is it detailed. It is a synthesis that helps us to understand muscles at a basic functional level. I have therefore used my artistic licence in these drawings; you can compare them with specialist literature or pictures, drawings, diagrams and other readings that can be obtained from a cursory Web search. I often merge the muscles into packages so as to not overly complicate the anatomical detail, and I will not go deeply into names and technicalities that would complicate attaining what is our main goal here: understanding and drawing the form and its basic function. However, I recommend starting the exercise from here, as I have observed that in this way students pick up an understanding of anatomy very quickly, thanks to the order of the main information set out on these pages.

Before drawing the anatomy we need to understand its functional basis. We will greatly reduce the level of information so as to understand the basic logic of the locomotor system and draw it by transposing the *reality* of it into a drawn representation of it (Fig. 69a):

A | Diagram of two rigid sections linked by a hinge-type joint.
B | Addition of a *self-contracting* tensor, which is elongated or in a relaxed state here.
C | When the tensor contracts it shortens in length and causes movement of the rigid sections through the joint.

D | If we want to move it in the opposite direction we add another tensor on the opposite side.
E | A movement in the opposite direction has been added. This is known as an *antagonistic muscle pair.*

This is a very synthetic explanation of how our locomotor system (skeletal muscles) works.
Keep in mind that different functions produce different forms. If we change the way in which the system moves, the resulting muscle form will change; a hinge movement is not the same as a rotating one like those of the shoulders and hips, or that of the spine.
Muscles always obey a linear vector when they tense, like ropes. The curves we see in our body are the result of interwoven muscle fibres following twisting or rotational movements, appearing as a weave of straight lines that form parabolas, as we can see in the pectoral and trapezius muscles.
There are therefore few basic muscle forms, and to save our efforts, I will reduce the forms to three types (Fig. 69b):
Long and fusiform, for general flexor muscles such as biceps or hamstrings.
Straight asymmetric, for the extensor muscles such as triceps and quadriceps, which are antagonists of the previous two. And pre-torsioned muscles such as the trapezius, pectorals, and so on, which move rotational joints.

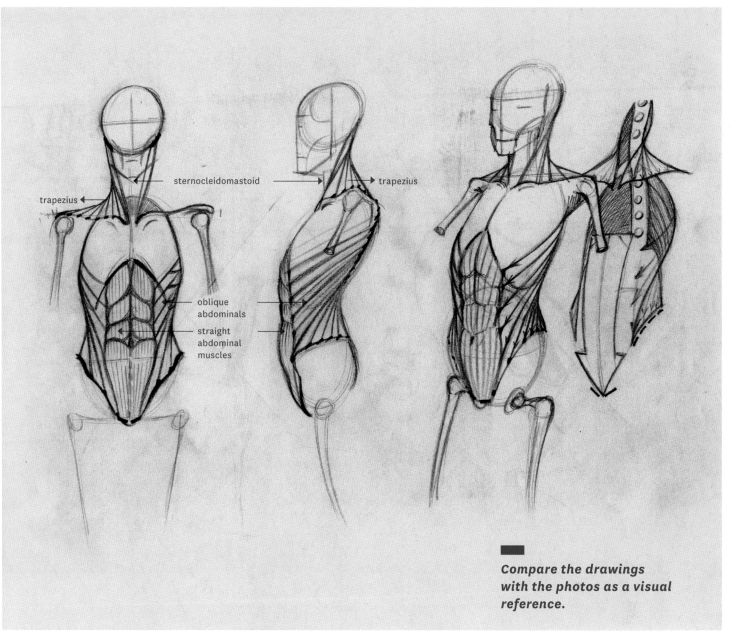

trapezius ←

sternocleidomastoid →

→ trapezius

oblique abdominals

straight abdominal muscles

Compare the drawings with the photos as a visual reference.

▲ Fig. 69c

> abdominals
> sternocleidomastoid
> trapezius

Abdominals
and spinal muscles

We will incorporate the skeletal muscles that move the hip-thorax and thorax-head circular blocks. Here the sternocleidomastoid muscles (SCM) and those neighbouring it and the nearby obliques are analogous, precisely because both move the head and thorax respectively in torsion.

The concept of analogy is very important for memorizing the muscle forms (**Fig. 69c**).

▼ Fig. 68 ▼ Fig. 70 ▼ Fig. 71

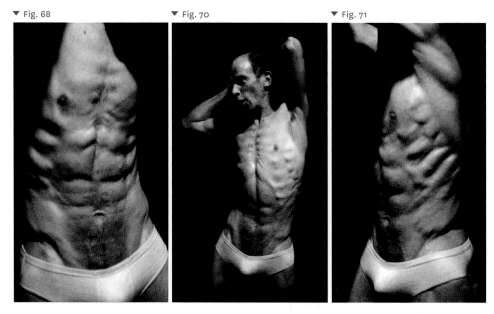

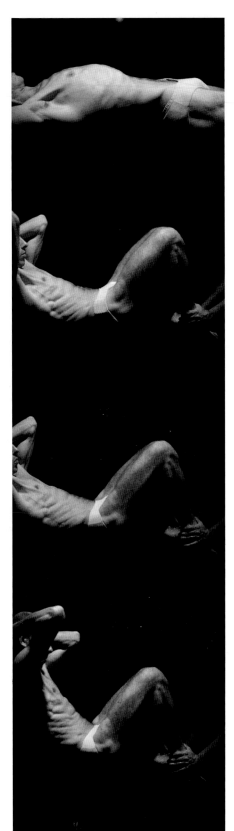

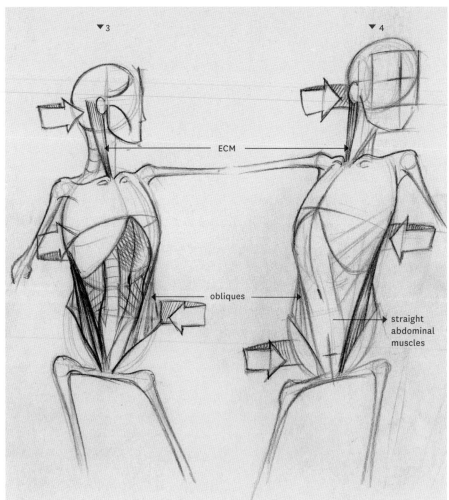

▲ Fig. 75

› obliques and abdominal cavity
› torsion of the three structural blocks
› head, thorax and abdomen

The straight abdominal muscles cover and protect the abdominal cavity and form two strips, from the pubis to the sternum.

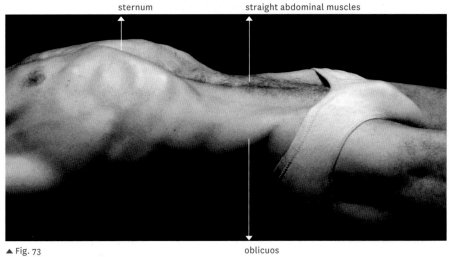

▲ Fig. 74

▲ Fig. 73

Abdominal work
Showing the thorax and abdominal structural blocks.

Functioning of the torso **muscles**

1 | For the rib cage and pelvis the muscles or tensors of the straight abdominal muscles do the work, and for the head it is the SCM muscles. The obliques also help out, acting like the SCM but without turning. (Fig. 76)

2 | For the opposite movement, the spinal muscles and those around the spinal column operate by creating an upward arc at the column when they contract.

3 | During torsion of the head and torso the muscles used are analogous in function. The oblique abdominals acquire a straight and vertical form when being worked, which makes the ribcage and hip turn. The same thing happens for the head through the SCM muscles. (Figs. 76 and 77)

54

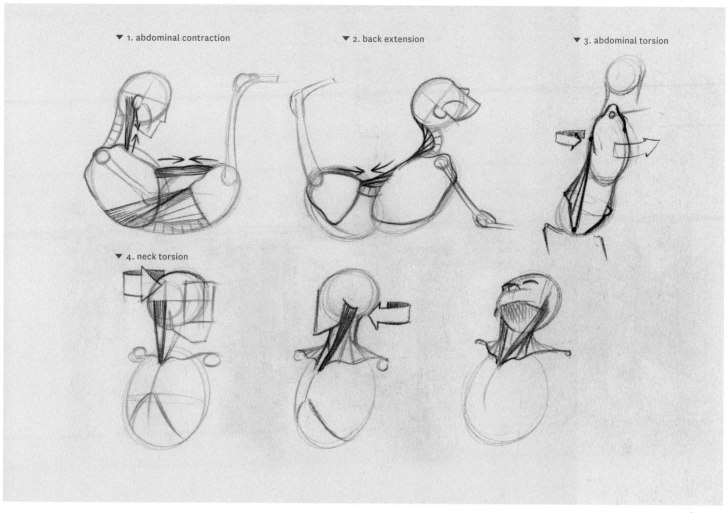

▼ 1. abdominal contraction ▼ 2. back extension ▼ 3. abdominal torsion

▼ 4. neck torsion

Fig. 76 ▲

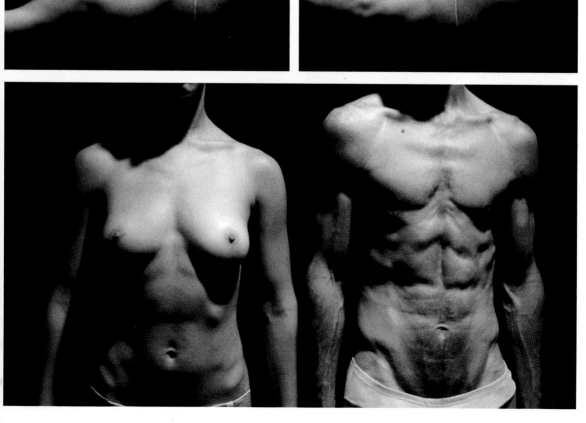

◀ Fig. 77

Anatomical differences between the male and female abdominals

Note that the male's obliques are more pronounced

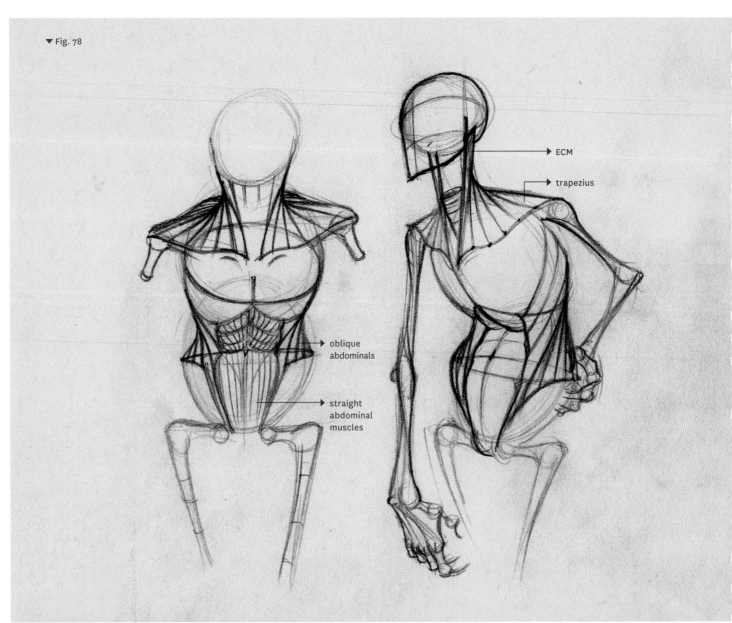

oblique
abdominals

straight
abdominal
muscles

ECM

trapezius

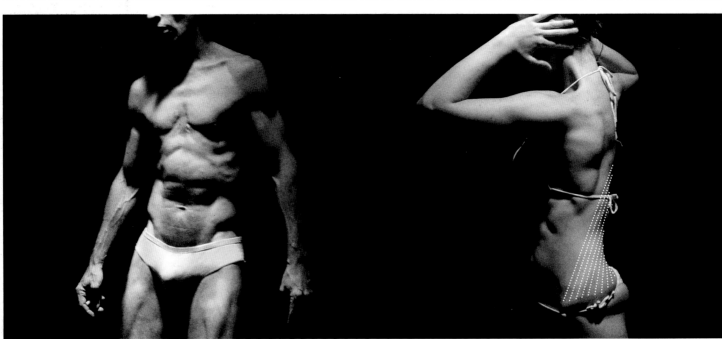

▲ Fig. 79

Notional covering of the obliques, like a corset between the ribcage
and the pelvis. (Fig. 80 and 82-A)
Rear view showing the spinal muscles following up the sides of the
spinal column as two tubes, starting from the sacrum. (Fig. 82-B)

▲ Fig. 78

**Contraction of the
torso**

¾ front view of
abdominal crunch

▲ Fig. 80

Torsion and outline
of obliques

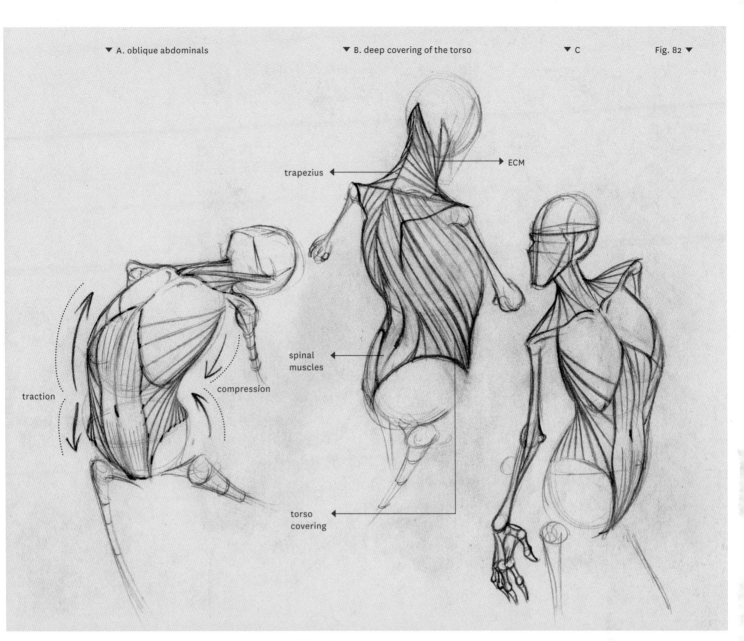

trapezius

ECM

spinal
muscles

traction

compression

torso
covering

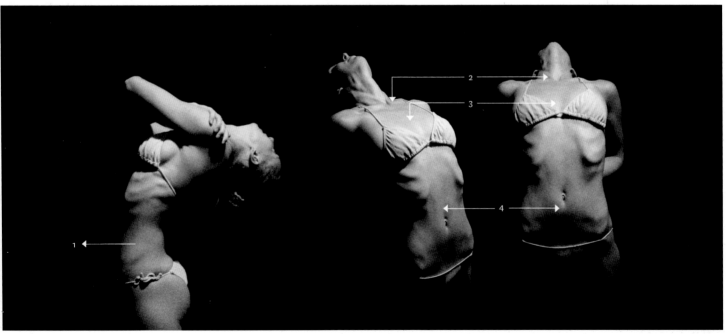

▲ Fig. 81

1. obliques
2. clavicles
3. sternum
4. straight abdominal muscles

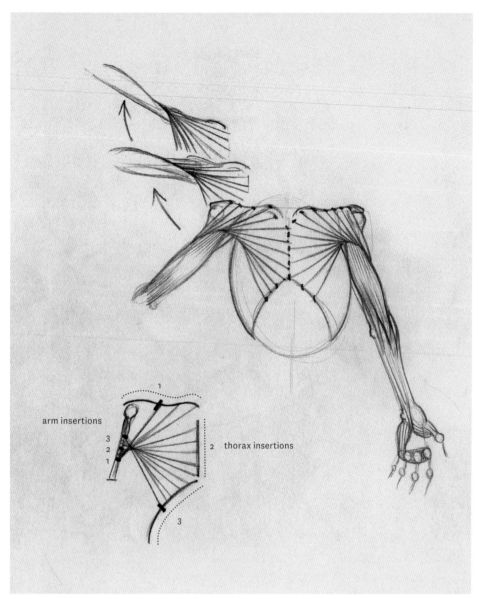

arm insertions

1
3
2
1

2 thorax insertions

3

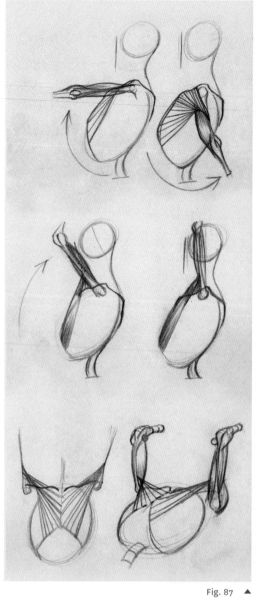

Positioning and movement of the pectoral muscle

◀ Fig. 87

Different movements and viewpoints of the biceps and pectoral muscle

Fig. 87 ▲

Fig. 83 ▶

1. pectoral
2. biceps

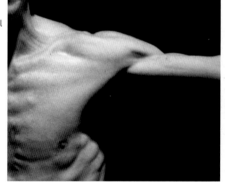

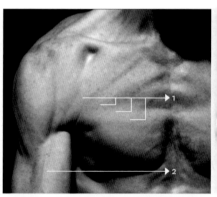

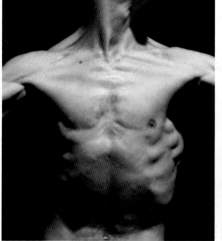

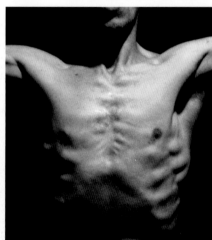

Pectoral muscles

The pectorals are drawn as a fan that extends from the external middle point of the arm (humerus), first to the clavicle, then lower down to the sternum, and finally to the ribs.

Below them are the biceps, which cause the arm to flex; these should be drawn first, going from the clavicle at a point near the shoulder to the forearm. If we first draw the biceps it will be easier to understand the movement of the pectoral muscle and its curve at the underarm, which covers the cylindrical volume of the biceps.

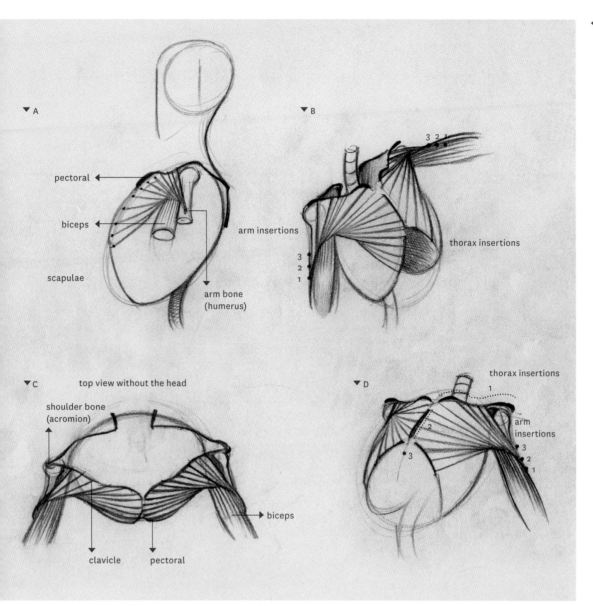

▼ A

pectoral ◀

biceps ◀

scapulae

arm insertions

arm bone
(humerus)

▼ B

3 2 1

thorax insertions

3
2
1

▼ C top view without the head

shoulder bone
(acromion)

biceps ➤

clavicle pectoral

▼ D

thorax insertions
1

2

3

arm
insertions
3
2
1

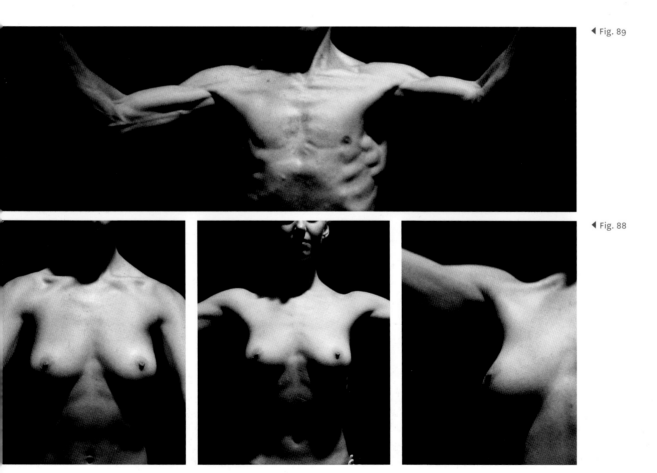

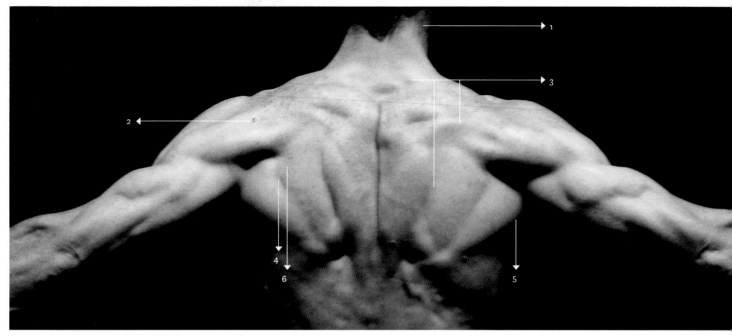

Fig. 91 ▲

1. ECM
2. deltoids
3. trapezius
4. teres minor
5. teres major
6. infraspinatus

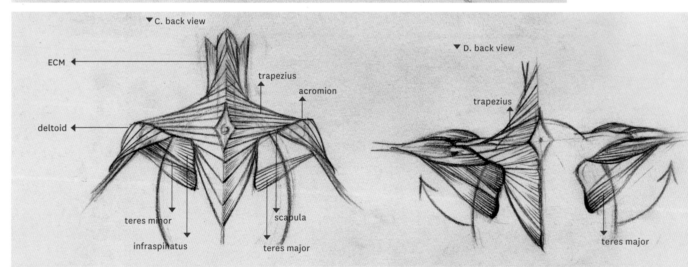

▼ A. front view

clavicle

deltoids

biceps

pectorals

▼ B. profile view

deltoids

▼ C. back view

ECM

trapezius

acromion

deltoid

teres minor

infraspinatus

scapula

teres major

▼ D. back view

trapezius

teres major

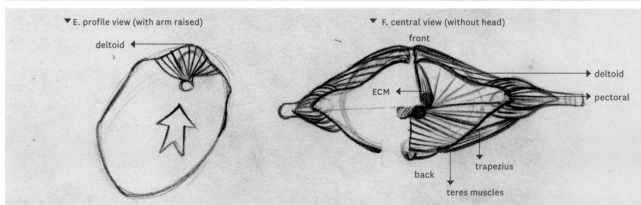

▼ E. profile view (with arm raised)

deltoid

▼ F. central view (without head)

front

deltoid

ECM

pectoral

trapezius

back

teres muscles

60

◀ Fig. 92, 93, 94

Fig. 95 ▶

**Pectoral and deltoid
views**

1. deltoids
2. trapezius

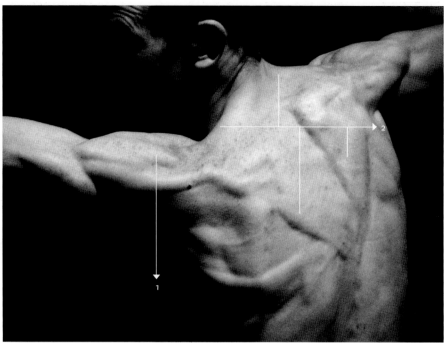

Fig. 96 ▼

Deltoid, trapezius and teres muscles (Fig. 92, 93, 94)

A | Following the same rotation of the tensions of the pectoral muscle as far as the arm, we will put in the deltoid muscle, which starts at the area of the clavicle nearest to the shoulder and goes to the same insertion point as the pectoral muscle and covers it.

B | The deltoid muscle is fan-shaped with its apex at the arm at the same height as the insertion of the pectoral muscle, and branches out to the clavicle at the front, to the side of the shoulder, where the clavicle and scapula (acromion) meet, and at the rear (back) as far as the scapula of the shoulder blade. Its function is to raise the arm at all rotational angles.

C | We will draw the trapezius later, when we have created some torso poses with the pectorals, sternocleidomastoids (SCM) and biceps. One of the main functions of the trapezius is rotational movement of the shoulders and shoulder blades, as a result of which its morphology is pre-torsioned and flat.

This muscle runs from the spinal column to the nape, coming to an apex at the acromion (shoulder). The tensors positioned in this way move the shoulder blade to the neck, the spine and downwards.

D | We will also place in the teres major tensor, which runs from the base of the shoulder blade to the arm and near the armpit, as well as other tensors that continue to the arm, covering all the space from the scapula to the shoulder.

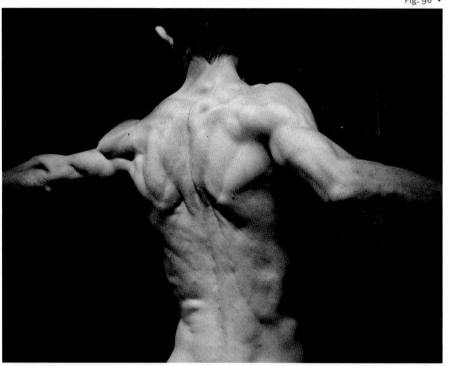

Fig. 97 ▼

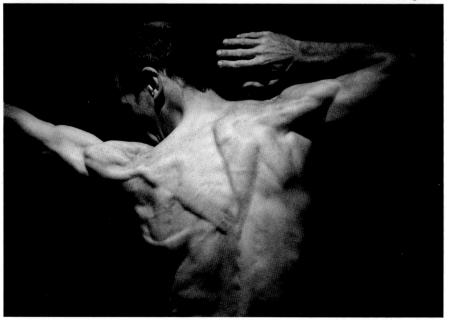

Compare the drawings in figures 92, 93 and 94 and attempt to visualize the muscles in these photographs.

Trapezius and scapulae
Arrangement of the tensors and movements they produce

Shoulders up

Upper trapezius contraction
and lower elongation.
Upward turn of the shoulder blades.

Shoulders forward

Elongation of the trapezius during forward
positioning of the shoulders.
Widening of the distance between the shoulder blades.

Shoulders back

Shrinking of the trapezius during backward
positioning of the shoulders.
Reduction of the distance between the shoulder blades

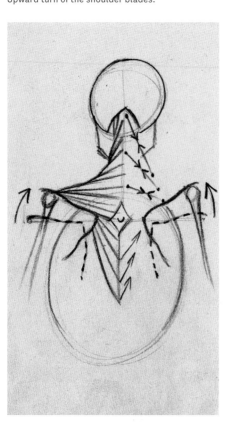

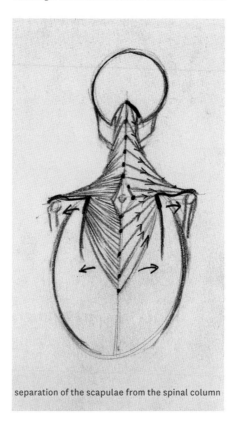

separation of the scapulae from the spinal column

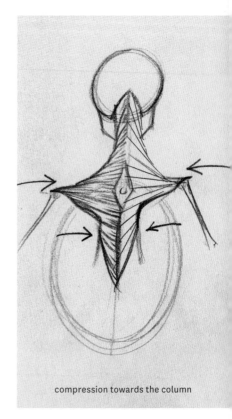

compression towards the column

▼ Fig. 99

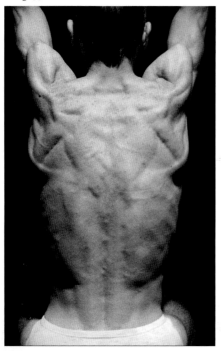

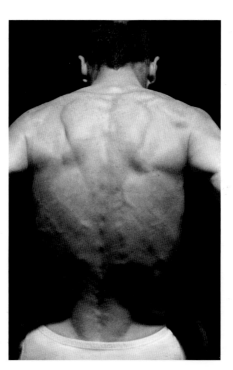

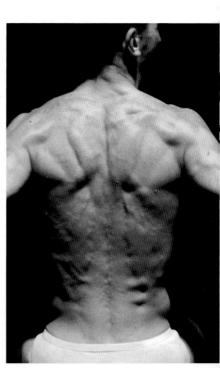

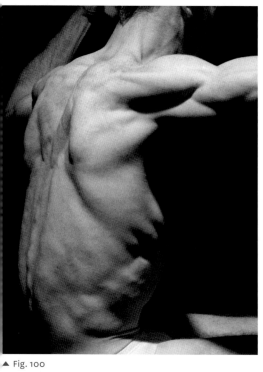

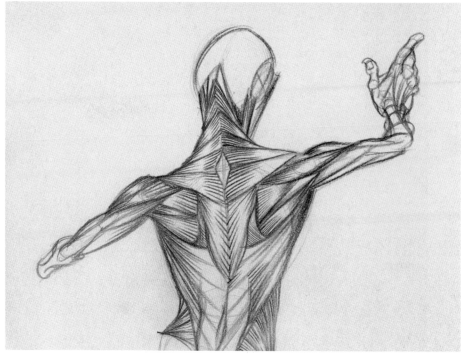

The shape of the muscle varies with the pose, but the position of its insertions does not / Fig. 102 ▼

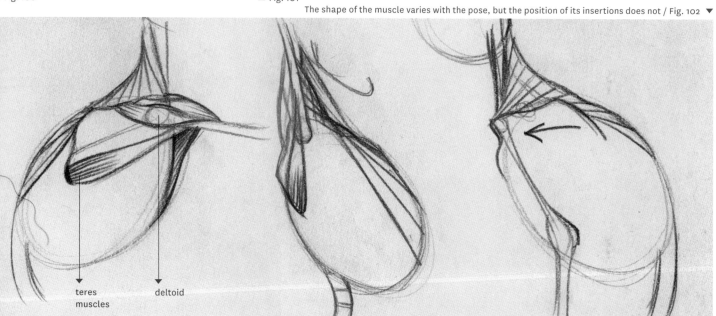

teres
muscles

deltoid

▼ Fig. 104 / 1. deltoid, 2. lats, 3. teres muscles

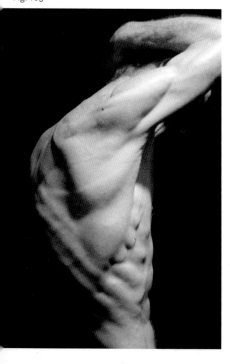

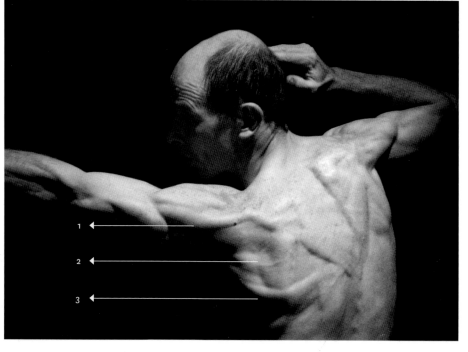

1

2

3

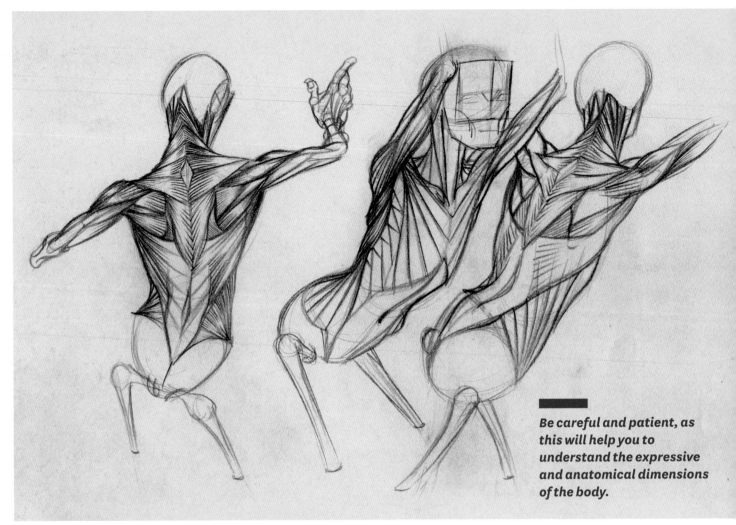

> **Be careful and patient, as this will help you to understand the expressive and anatomical dimensions of the body.**

▲ Fig. 106

1. trapezius, 2. deltoid, 3. lats / Fig. 105 ▼

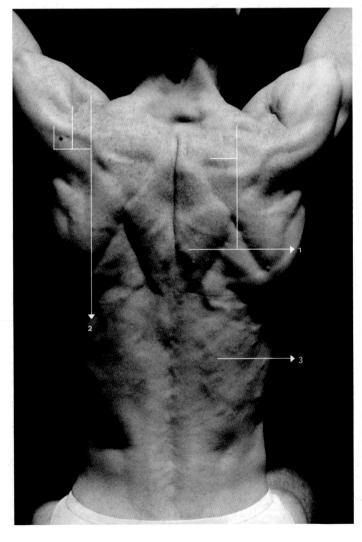

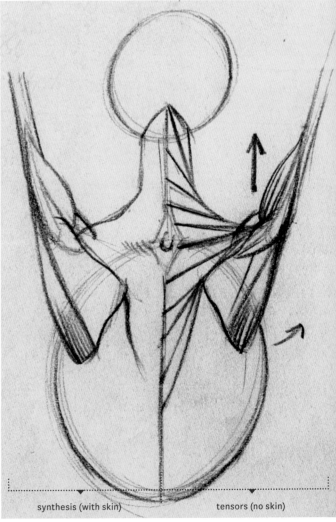

synthesis (with skin)　　　　tensors (no skin)

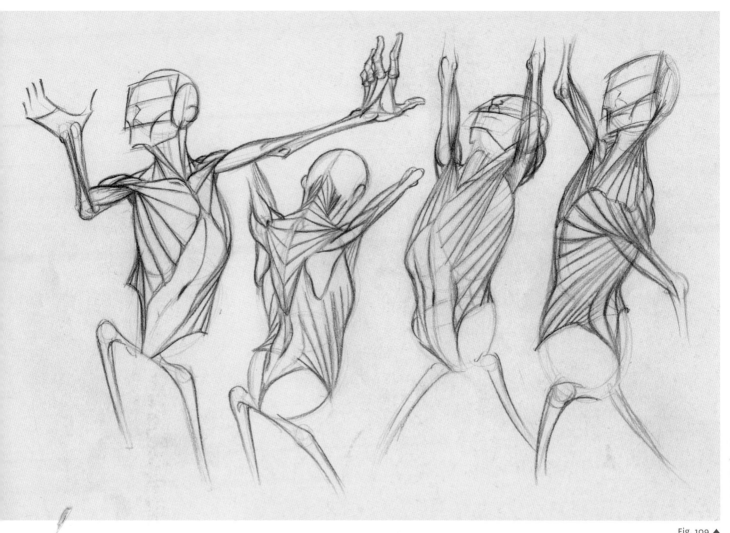

Fig. 109 ▲

Upward movement of the shoulders and turning of the shoulder blades

Create pictures of different poses and viewpoints in which you include all the muscles seen so far. Do not be demoralized: practice makes perfect.

Learning materials
It is advisable to get hold of photographs that allow you to observe all this information. I recommend that you look at magazines about athletics, dance, and so on. Beware of body-building or *fitness* magazines, because the muscles that you see in these are overdeveloped, and they do not allow you to understand muscles as tensors, appearing instead as volumes. Nevertheless, they are useful in the respect that the overdevelopment of the muscles allows you to see a great amount of subtle musculature.
Look for photos with good light contrast. For the moment do not *make assumptions* about or *make up* muscles: if you cannot see it you cannot fully understand it.

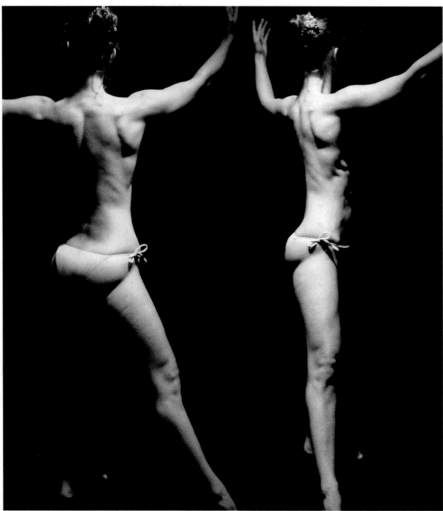

▲ Fig. 107 / Examine the pose and lighting; you will be able to work out the musculature from doing so. Fig. 108 ▲ 65

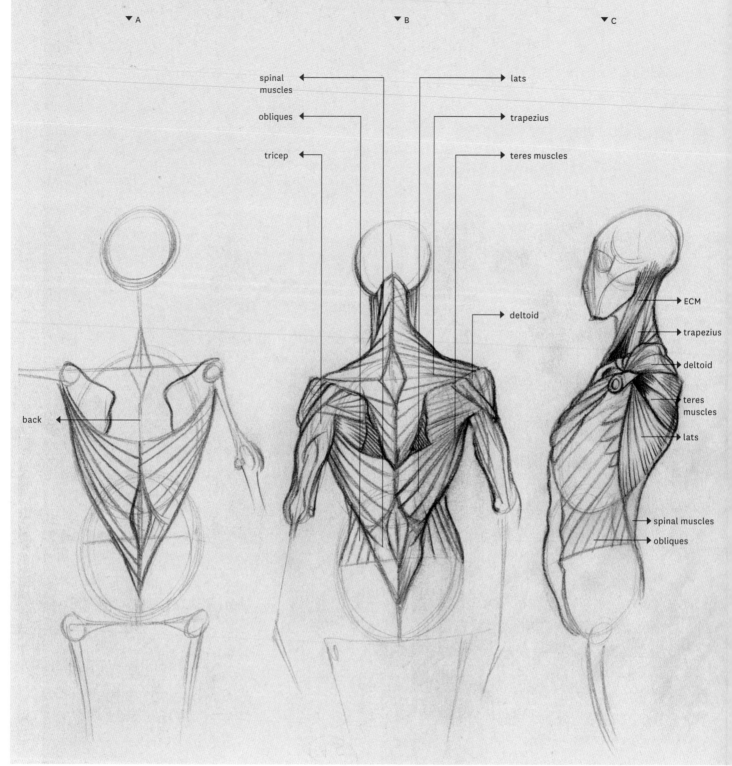

spinal muscles

obliques

tricep

lats

trapezius

teres muscles

deltoid

back

ECM

trapezius

deltoid

teres muscles

lats

spinal muscles

obliques

Fig. 111 ▲

Lats and triceps (Fig. 111)

A | The latissimus dorsi is a muscle whose fibres run from the spine to the arm or armpit, fanning out from an apex at the armpit to each vertebra, from the end of the trapezium to the coccyx.

B | It seems to hold the shoulder blades at its upper edge and pass under the tip of the trapezius, but it actually passes over the top, covering the spinal muscles and the obliques.

C | In profile its covers part of the side of the ribs while the serratus muscles poke out from underneath it.

Triceps

Antagonists of the brachial biceps, the triceps are located at the back of the humerus (arm bone) and perform the arm's extension movement; we will see these muscles in greater detail below, along with the limbs.

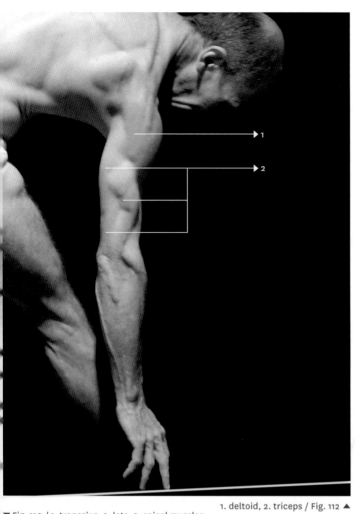

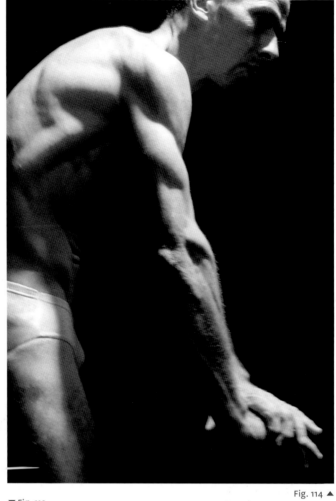

1. deltoid, 2. triceps / Fig. 112 ▲

Fig. 114 ▲

▼ Fig. 110 / 1. trapezius, 2. lats, 3. spinal muscles

▼ Fig. 113

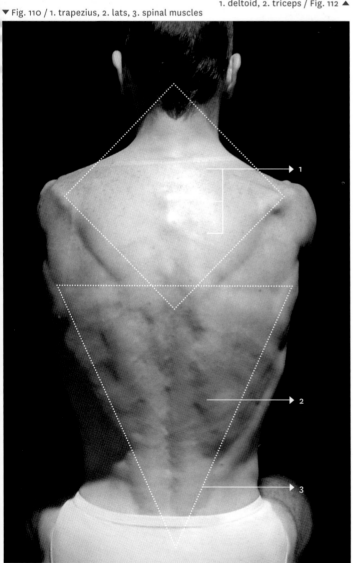

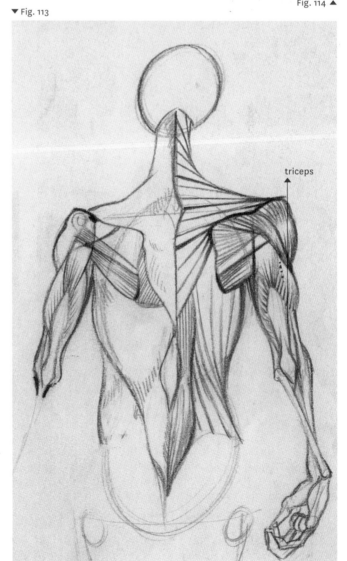

triceps

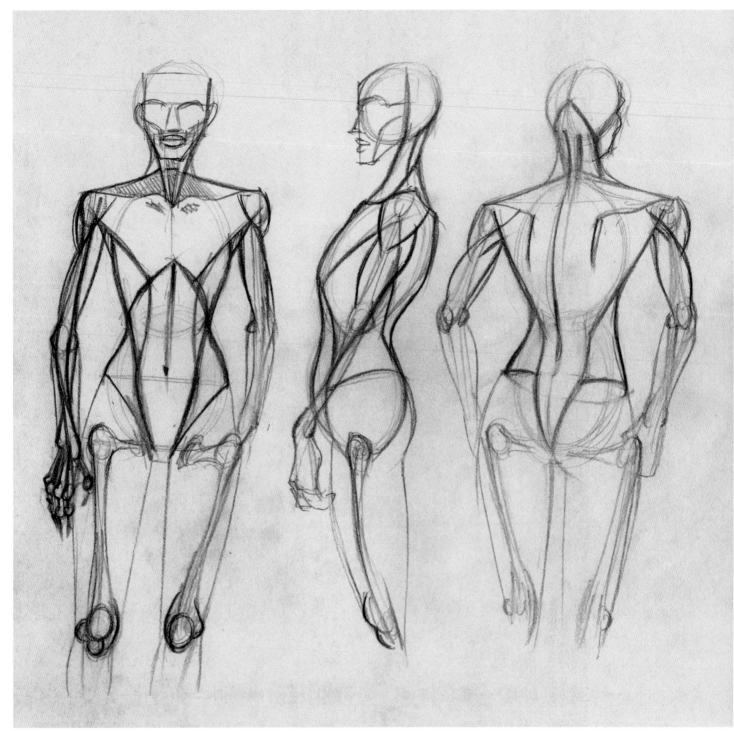

　　　　　　　　　　　　　　　　　　　Fig. 117 ▼

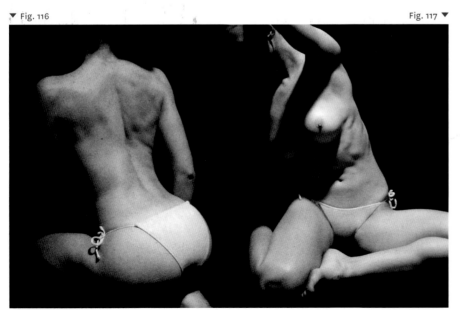

A series of drawings, examples of quick schematizations for studying the body and poses that consider the bone and muscle structure of the torso. In them we see the structure, dynamics, foreshortening and anatomical synthesis. (Figs. 115, 118 to 122)

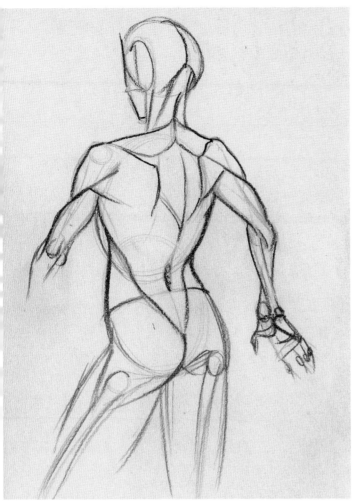

▲ Fig. 118

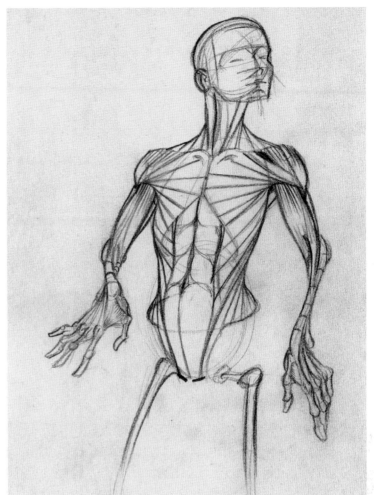

▲ Fig. 119

Fig. 120 ▼

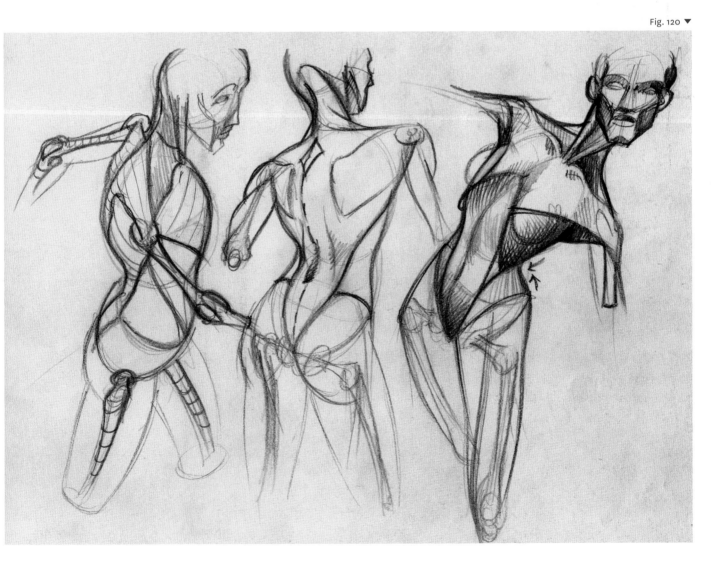

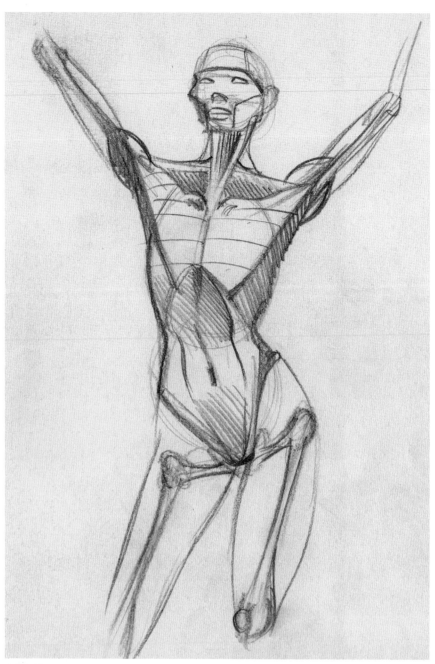

▲ Fig. 121

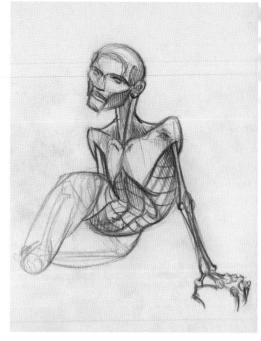

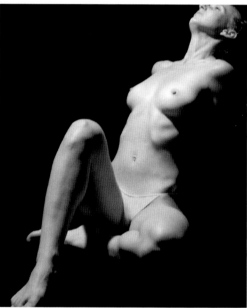

▲ Fig. 122 / Use this photo as a model

Fig. 123 ▼

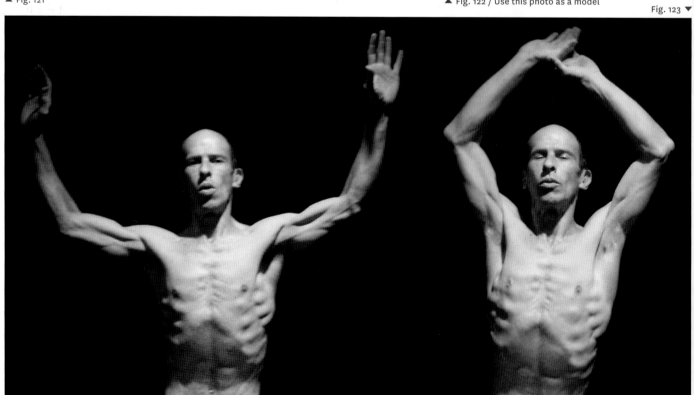

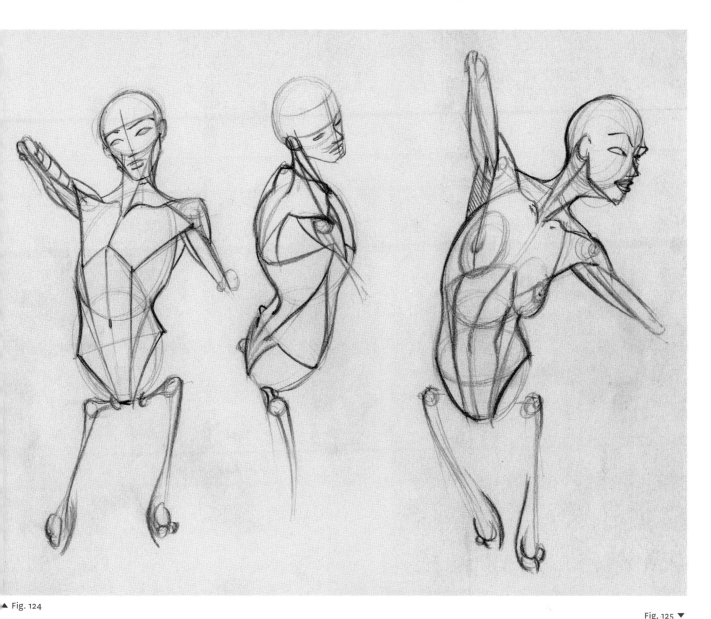

Fig. 125 ▼

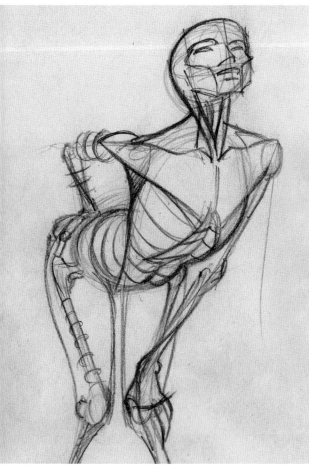

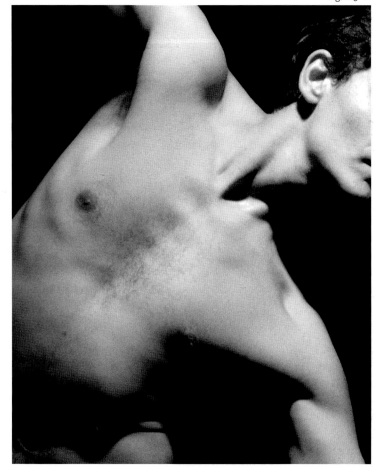

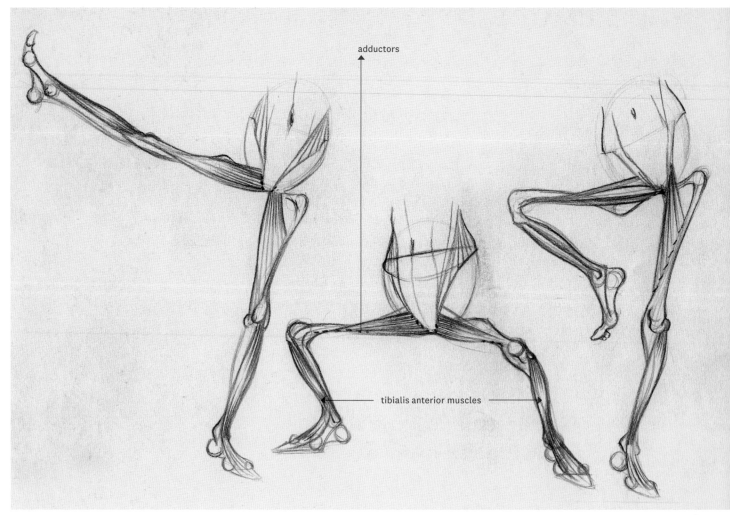

adductors

tibialis anterior muscles

Fig. 128 ▲

▼ Fig. 126

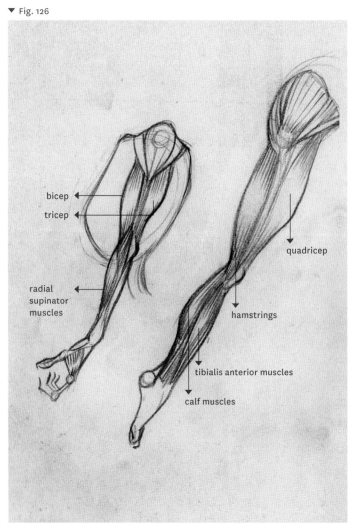

bicep

tricep

radial
supinator
muscles

quadricep

hamstrings

tibialis anterior muscles

calf muscles

▼ Fig. 127

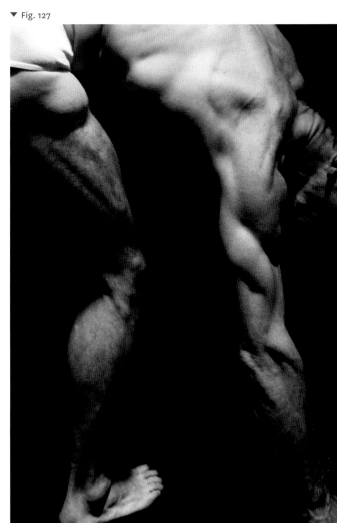

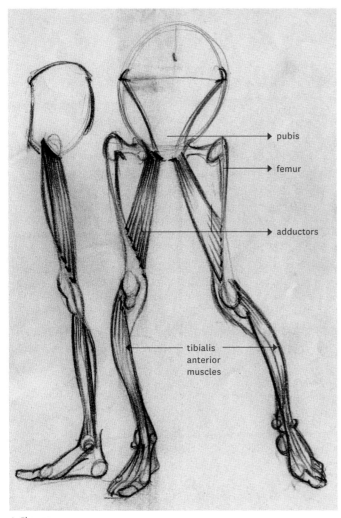

▲ Fig. 129

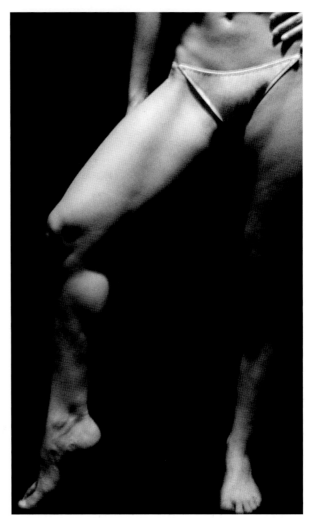

Limbs

To make our study of the musculature easier it is important to note morphological similarities exist between different muscles because some of their functions are similar. A similar function generates a similar form, and this imposes standardization. It is an economic synthesis, and also an aesthetic one, a natural source of harmony and unity. (Fig. 126)

Legs
In this first picture we find four tensors added to our kinetic-bone* structure.
The two upper ones will fulfil the function of bringing the legs toward the central axis of the body, the same role played by the pectorals for the arms.
These muscles are called adductors, and their insertion is at the pubic symphysis (at the lower centre of the hip) and the inner face of the femur.
The tensors found along the tibias are the tibialis anterior muscles, which are grouped with the extensor digitorum, and serve to lift the foot up. We will draw these muscles as a single volume that emerges from the outer side of the knee, passes over the ankle and reaches the toes.

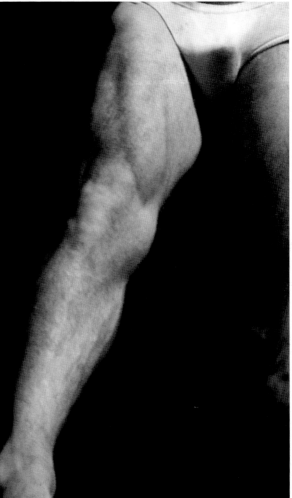

* That is, the line dynamics and bone information.

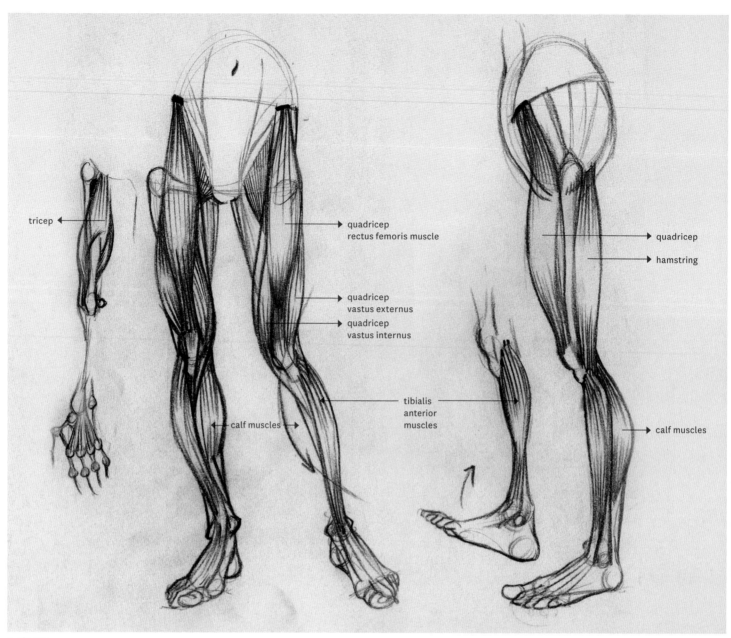

tricep

quadricep
rectus femoris muscle

quadricep
vastus externus

quadricep
vastus internus

calf muscles

tibialis
anterior
muscles

quadricep

hamstring

calf muscles

▲ Fig. 132

Fig. 134 ▶

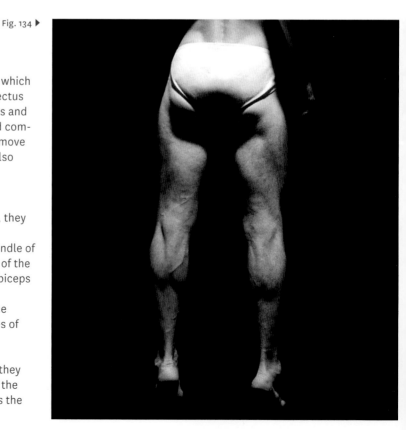

Quadriceps (Fig. 135)

At the front part of the legs we will draw the quadriceps, which are divided into three distinct parts: a central one (the rectus femoris muscle) and two lateral ones, the vastus externus and the vastus internus. They are on top of the abductors and completely cover them at the knees. These muscles serve to move the knees and tibia forward and make the hip and knee also rotate in that direction.

Hamstring group

At the back of the leg are the antagonist muscles (that is, they fulfil the *opposite function*) of those we have just seen.
The hamstrings as we will draw them here are a single bundle of muscles and are like the biceps but in the leg, hence one of the hamstrings being named the biceps femoris (that is, the biceps of the femur).
We will draw them as a long and continuous form from the lower curve of the abdominal volume, passing to the sides of the knee and until the tibia area.

From inside the gap that the hamstring muscles leave as they open up to the sides of the knee we will draw the start of the calf muscles, which taper out and come together towards the heel, forming the Achilles tendon. (Figs. 131 and 134)

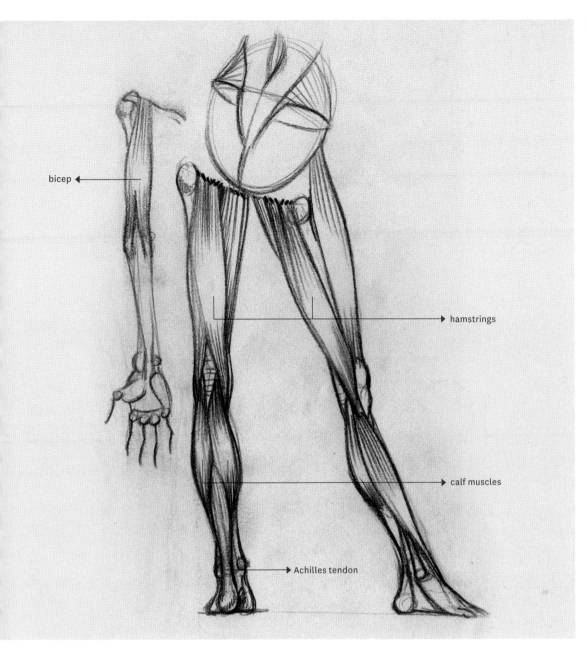

bicep ◀

hamstrings

calf muscles

Achilles tendon ▶

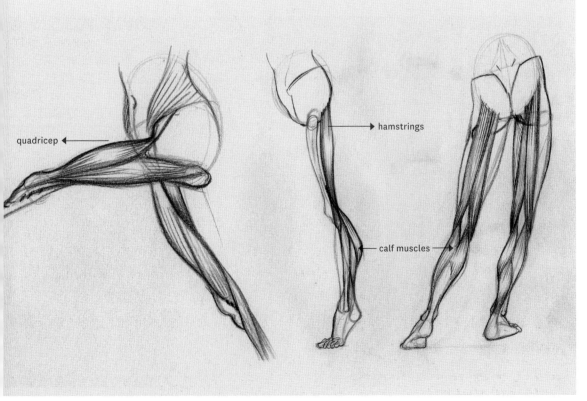

quadricep ◀

hamstrings ▶

calf muscles

Step-by-step construction of the front view of the legs

A | Adductors, tibialis anterior muscles and tensors of the fascia lata. The tensors of the fascia lata are those that stand out from the hip to the femur head.

B | Incorporation of the rectus femoris of the quadriceps.

C | Addition of the vastus externus and vastus internus of the quadriceps to the leg and the inner calf muscles (the outer ones are covered by the tibialis anterior muscles).

D | The drawing of the legs concludes with the incorporation of the curves of the fascia lata. (Fig. 136)

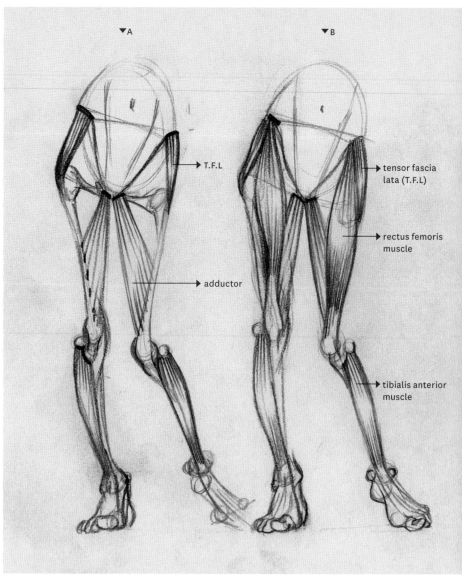

▼A ▼B

→ T.F.L

→ tensor fascia lata (T.F.L)

→ rectus femoris muscle

→ adductor

→ tibialis anterior muscle

Gluteal muscles

▼ Fig. 137

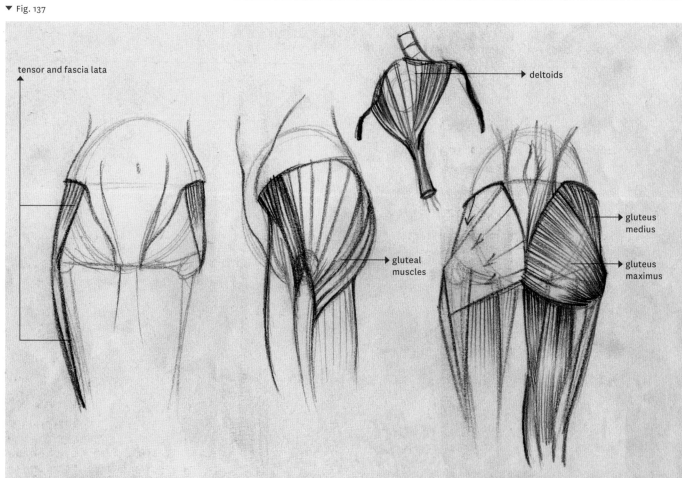

tensor and fascia lata

→ deltoids

→ gluteal muscles

→ gluteus medius

→ gluteus maximus

76

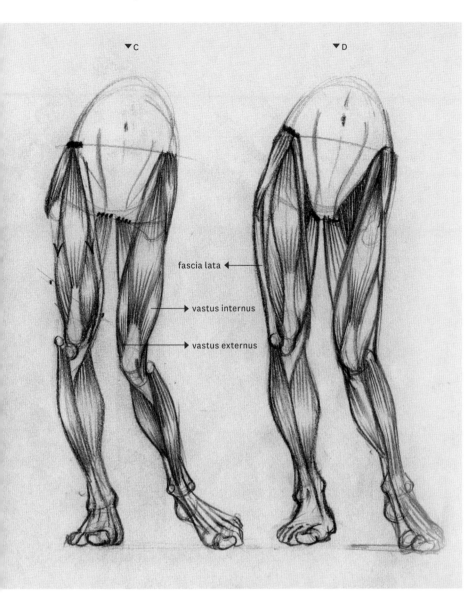

▼C ▼D

fascia lata ◀

▶ vastus internus

▶ vastus externus

Gluteal muscles

The gluteal muscles are the hip's analogous muscles to the deltoid muscles in the shoulders. They serve a similar function, since they move a long bone in a circular motion through a ball-and-socket joint. In the case of the gluteus, the apex is located just below the trochanter, and from there spreads to the pelvis, the sacrum and coccyx (iliac crest, sacrum, coccyx) forming a similar fan to the deltoids (clavicle, acromion, scapula). (Fig. 138)

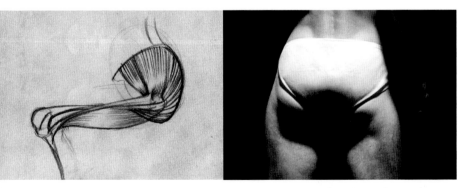

▼ Fig. 139

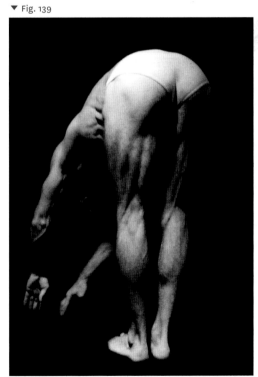

Fig. 138 ▼

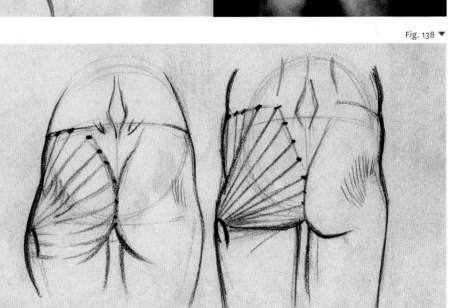

Observe the appearance of the hamstrings in the rear view of the legs when the torso is brought toward the floor. Notice how they surround the knees and bifurcate on either side.

Fig. 140 ▶
─────────
Arms

▬▬▬

The forearms are very complex and I have therefore simplified them into just three bundles: radials, palmars and extensors.

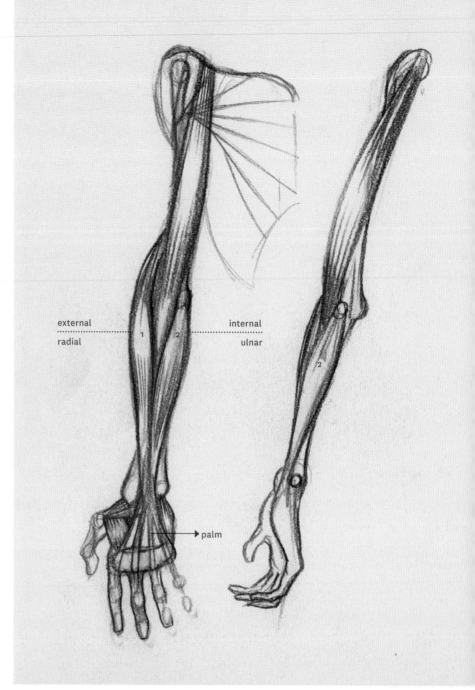

▼ front view ▼ internal profile view

external internal
radial 1 2 ulnar

→ palm

Arms

We have already seen the muscles belonging to the humerus –that is, the biceps and triceps– along with the back muscles. We will now complete this information with the three muscles groups of the forearm:

1 | External muscles (these are outwards when the palm of the hand faces upwards and the thumb outwards), or radial muscles, since they are located around the radius. In the drawing they pass through the wrist and go on to the fingers, but this is only a synthesis, as the drawing of the forearm is very complex and does not give us much information. Draw them so they cover the two spheres that we have created for this purpose (see page 42), the large one for the elbow and the large one for the wrist. (RADIUS) (Fig. 140)

2 | Internal muscles (in the same hand position) or palmars, since they serve to flex the fingers for gripping. They are located around the ulna and, as we did with the radial muscles, we simplify them by having them go to the palm, but this time for a better reason, as these muscles pass it. The small sphere of the elbow is linked to the small sphere of the wrist.

3 | Rear muscles, or the finger extensors, which start at one side of the elbow and continue to the knuckles, and from there to the fingers.

Note that in this hand position, these muscles remain straight and parallel, but when the wrist bends or rotates relative to the elbow these muscles also twist. (Fig. 140)

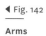

▼ rear view ▼ external view

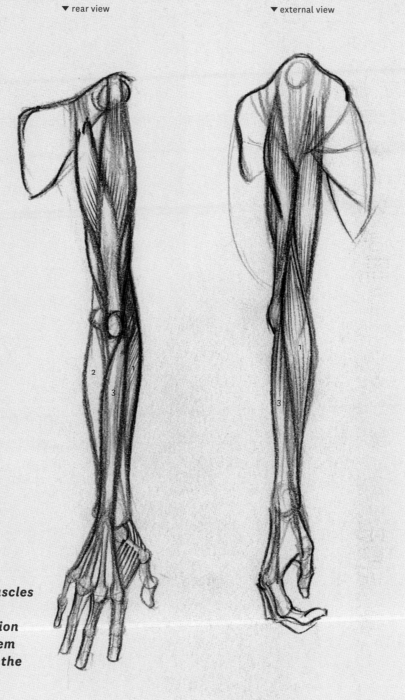

Study the different muscles by copying them from your graphic information sources, then draw them and finally synthesize the information.

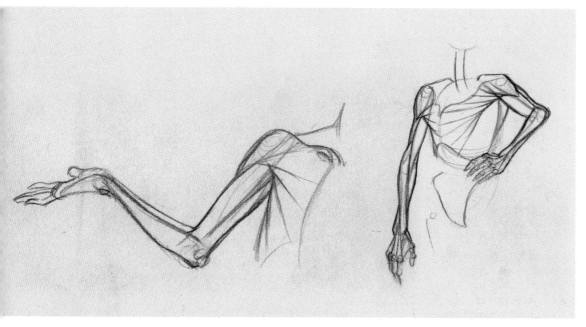

Fig. 143 ▶

**First incorporation of
the muscles**

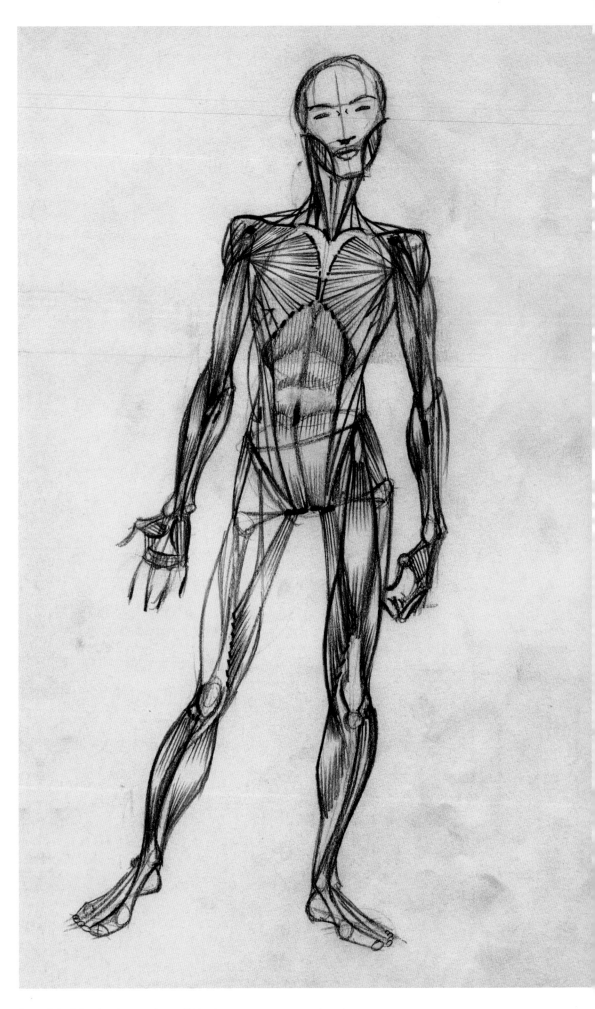

Completed front: observe how all the tensors are arranged and
their collective arrangement.
This figure must be the last one you do, having understood and
drawn the previous examples one by one, step by step. One muscle,
then another, and always the structure.

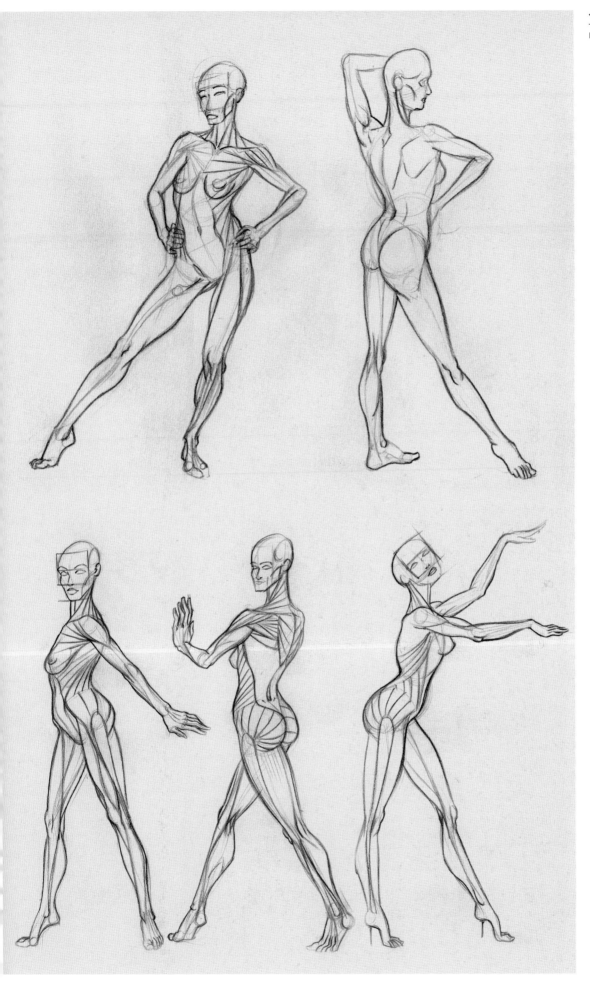

Fig. 145 ▶

**Planes and lines of
muscle action and
tendons**

First synthesis.
Regulation of muscle
planes and lines

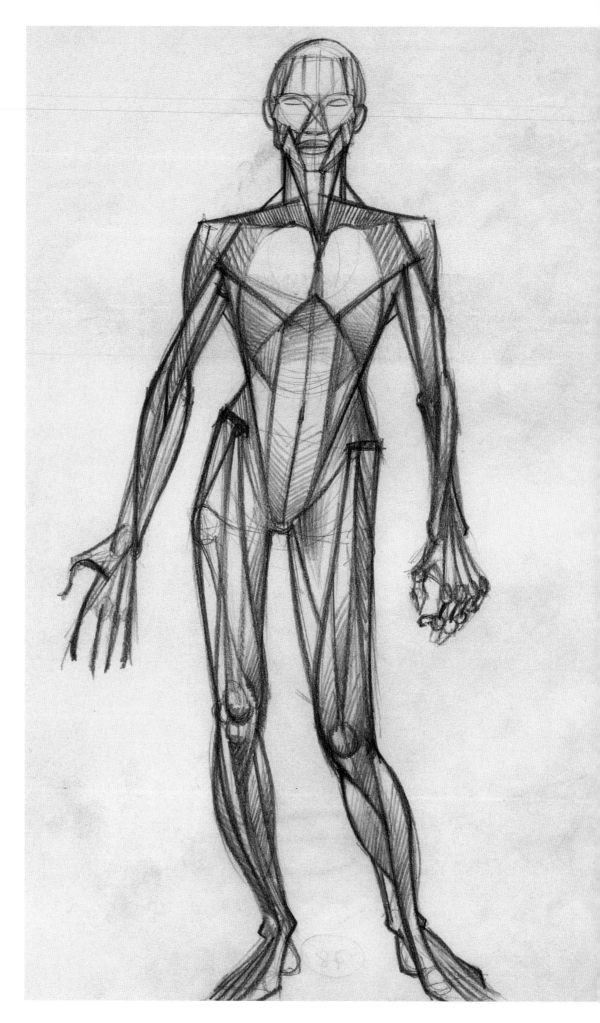

Frontal muscles expressed in principal regular lines, constructed from planes and key tension lines.

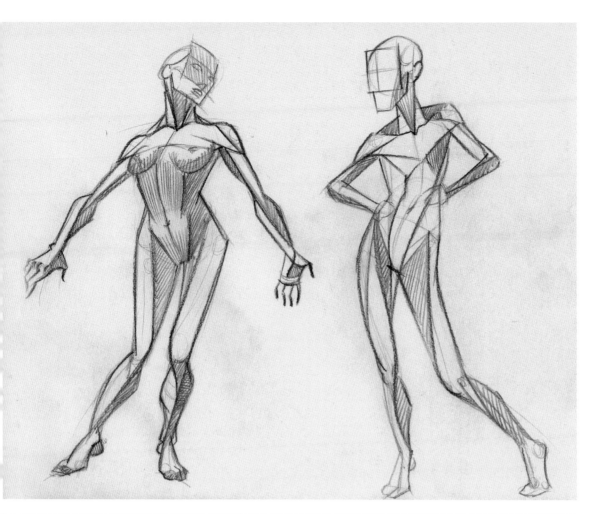

◀ Fig. 147

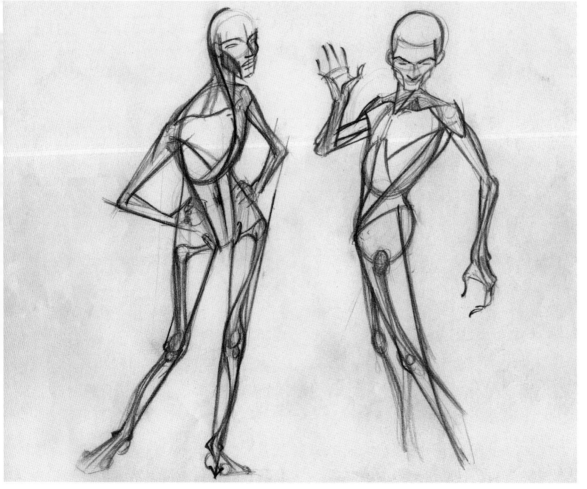

Frontal muscles expressed in regular lines and planes. The purpose of these is to synthesize the complexity of the musculature. This will help reduce the number of lines in the drawing. It is not advisable to use these syntheses too often, because they deprive the drawing of its organic feel.

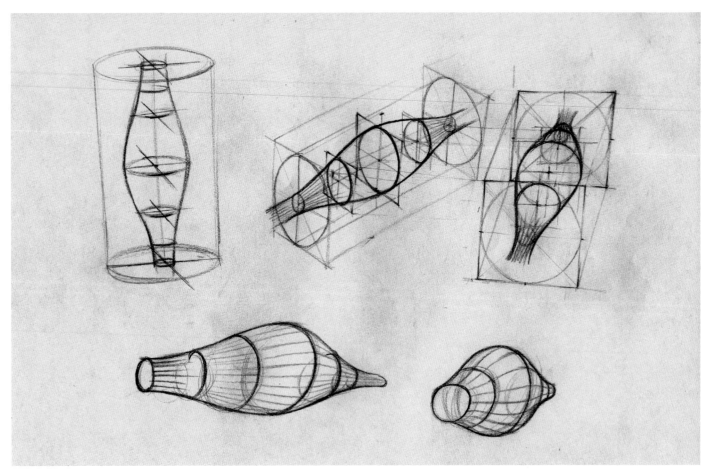

▲ Fig. 148

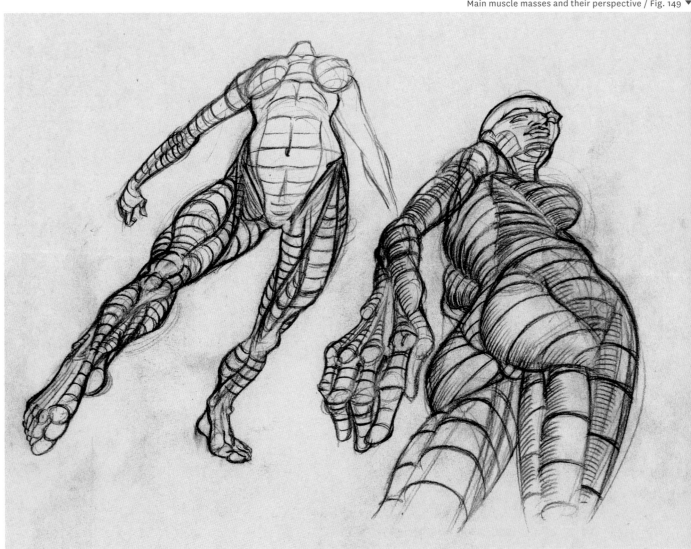

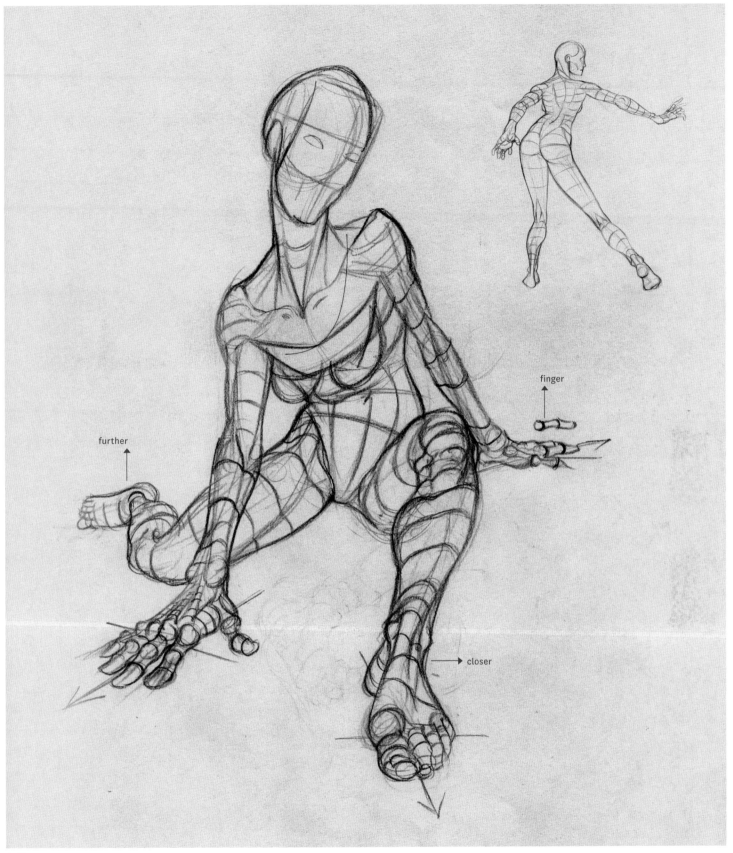

further

finger

closer

▲ Fig. 150

Muscle tridimensionality

Now we need to give the muscles we have drawn the feeling of occupying a three-dimensional space. In most cases muscles develop as tubular volumes, meaning that most of the muscles, and especially those of the extremities, have a circular section that is similar to what we have drawn in previous chapters.

These sections will be more elliptical and more circular according to their spatial position and the viewpoint. The idea is to imagine what the section of each muscle or sector (thigh, tibia, arm, forearm, and so forth) would be like.

In the following examples of foreshortening you will see illustrations of this idea (also see the previous chapter).

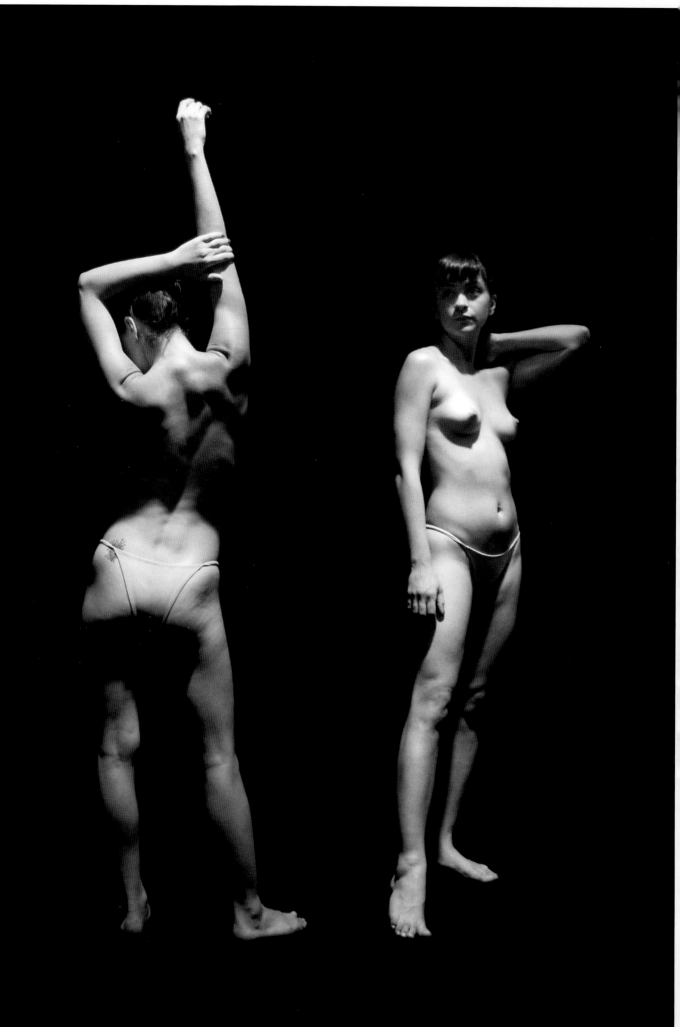

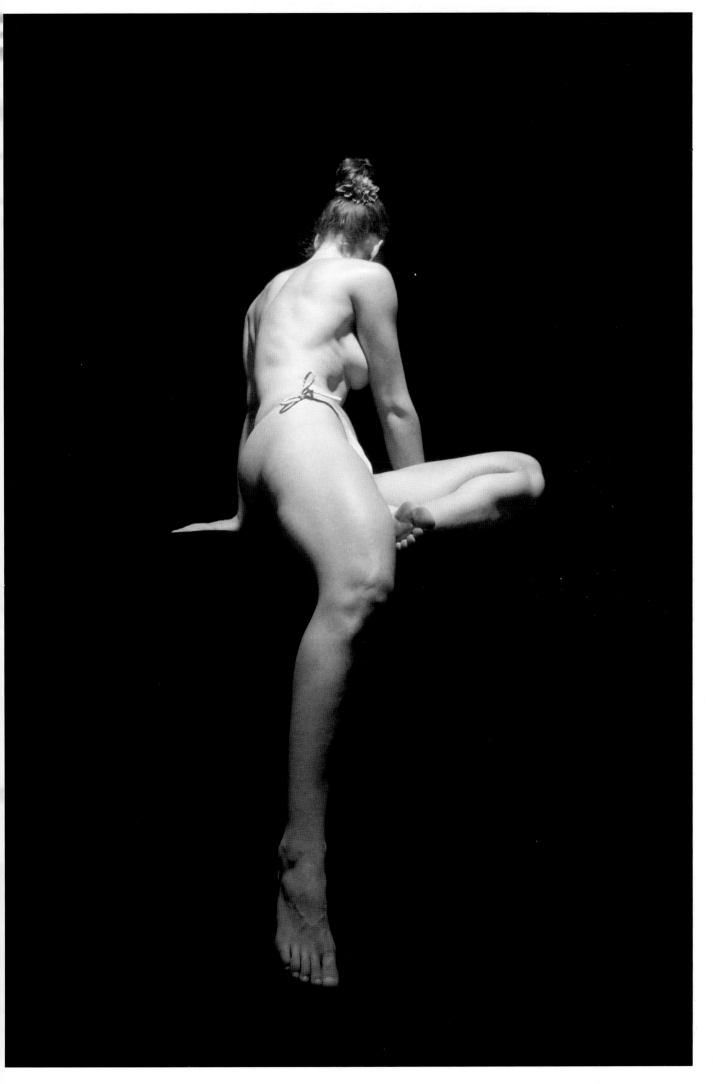

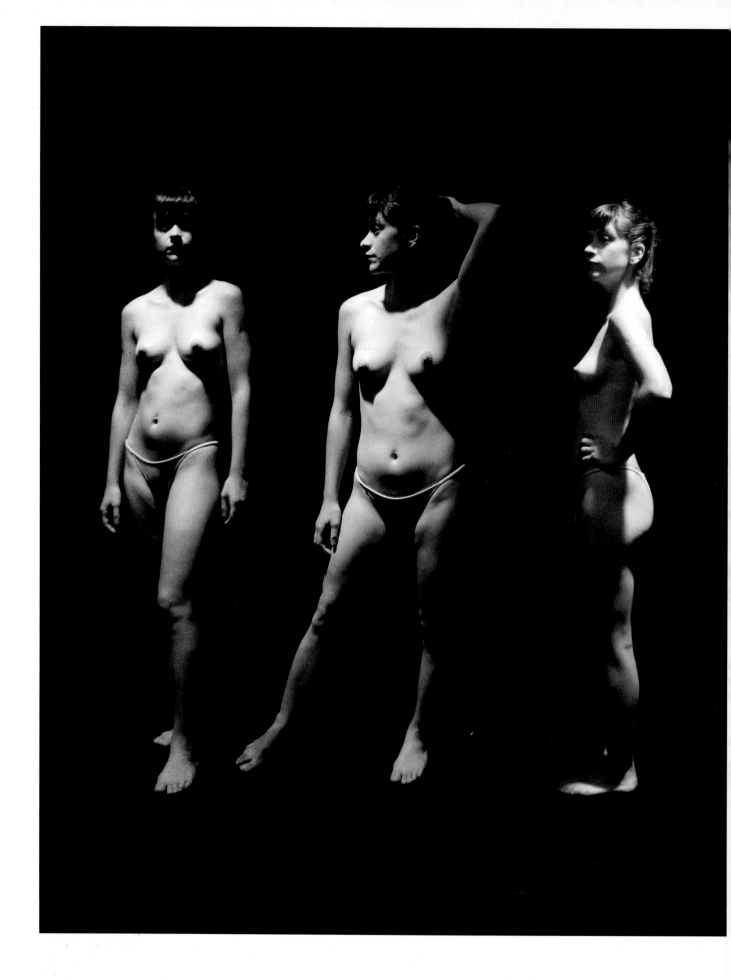

Use your acquired knowledge and what you have practiced to copy these pictures. The goal is not to copy the external appearance of the images but to imagine, feel and rationalize the body's movements.

Steps to help you with this practice:

1 | Establish the kinetic structure.
2 | Establish the structure of spheres with meridians and equators.
3 | Sketch the skeleton.
4 | Based on the skeleton draw the muscles.
5 | Synthesize the information.

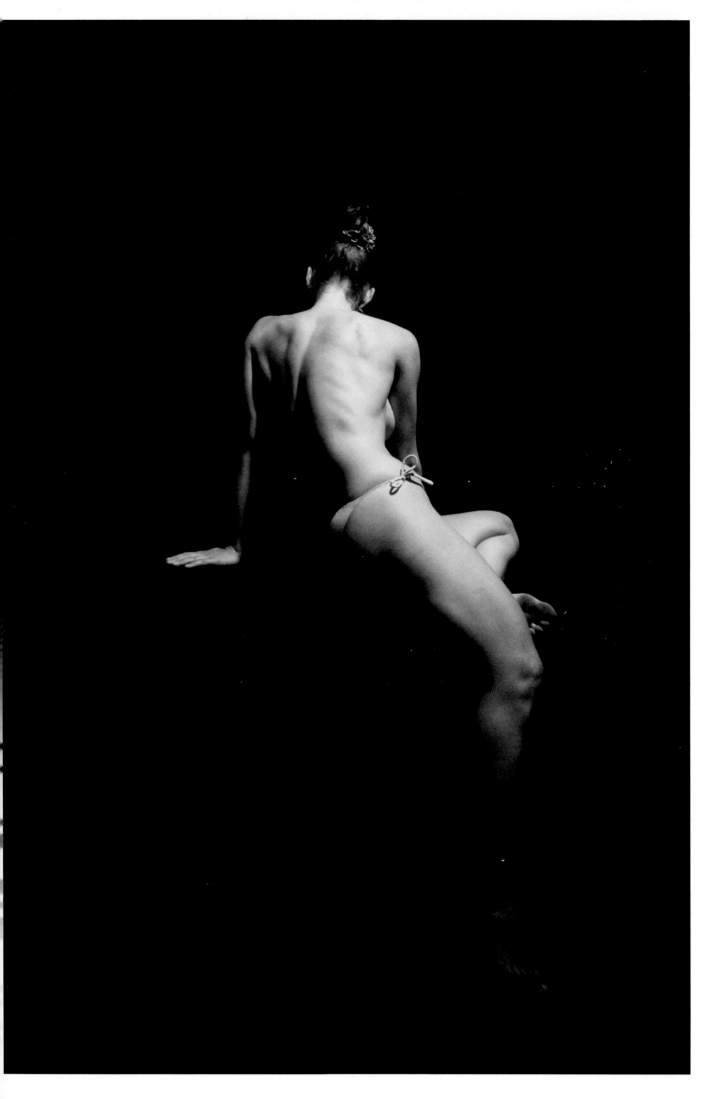

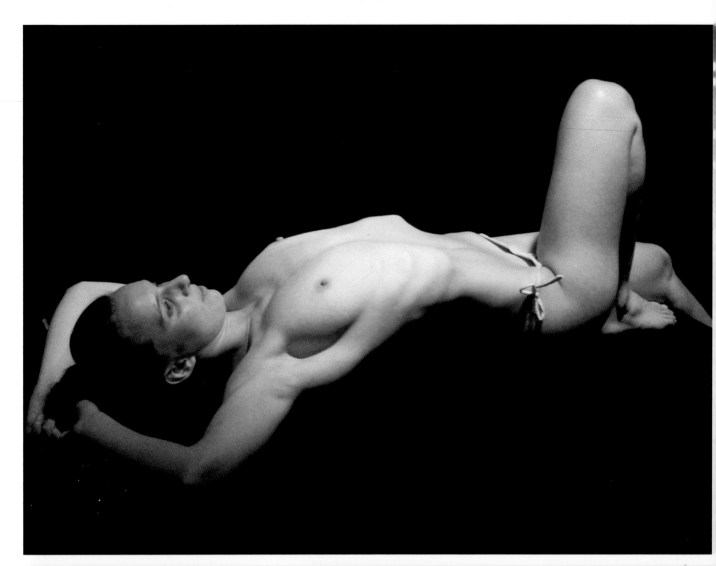

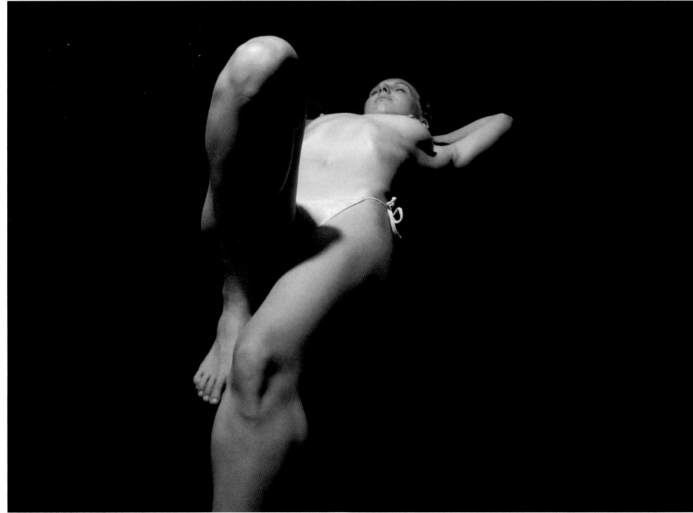

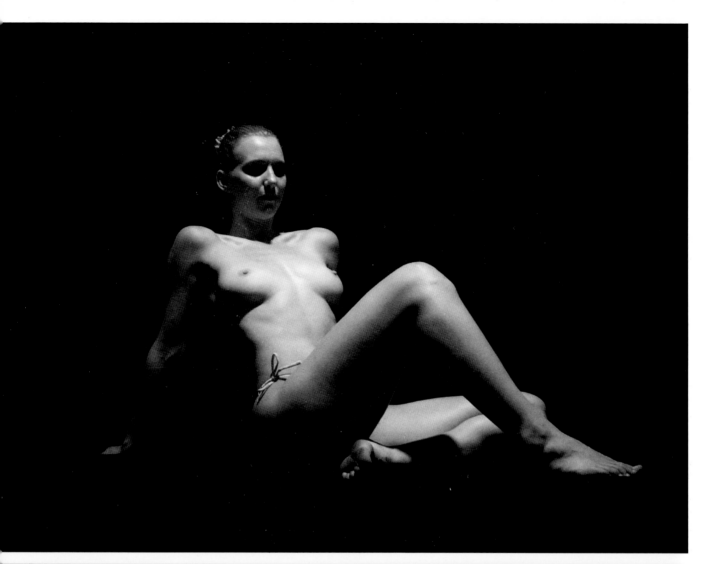

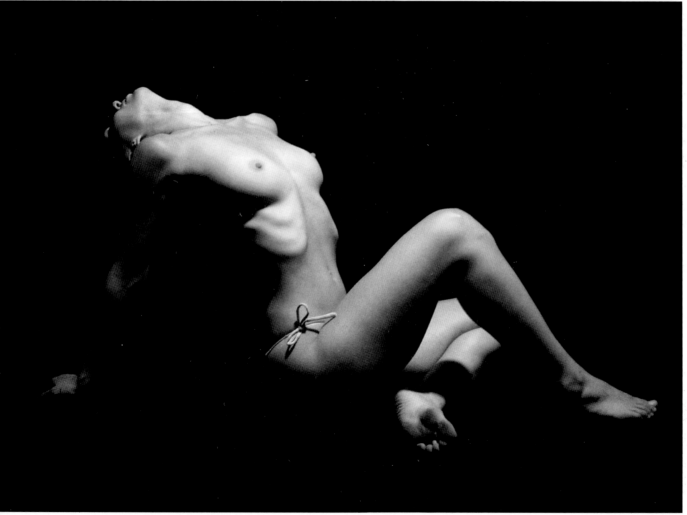

proportional variation

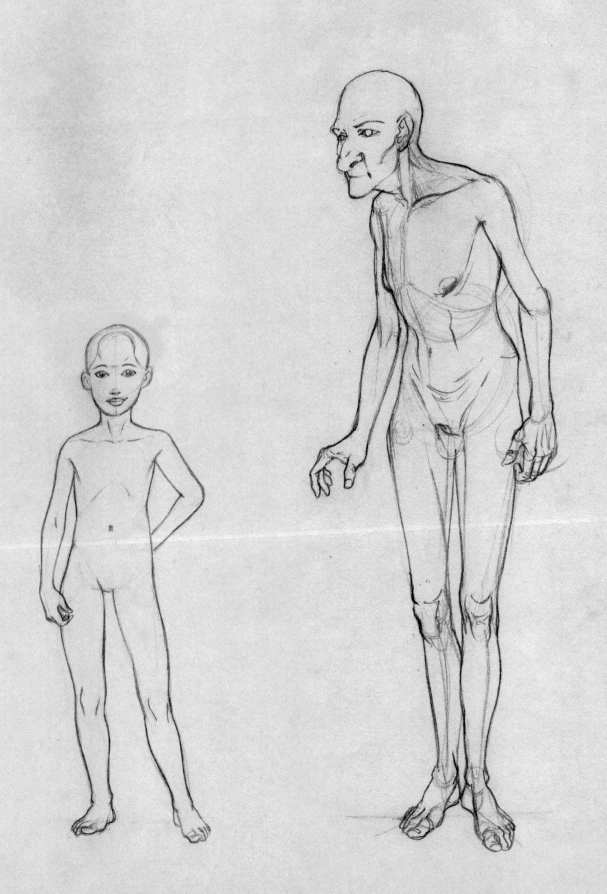

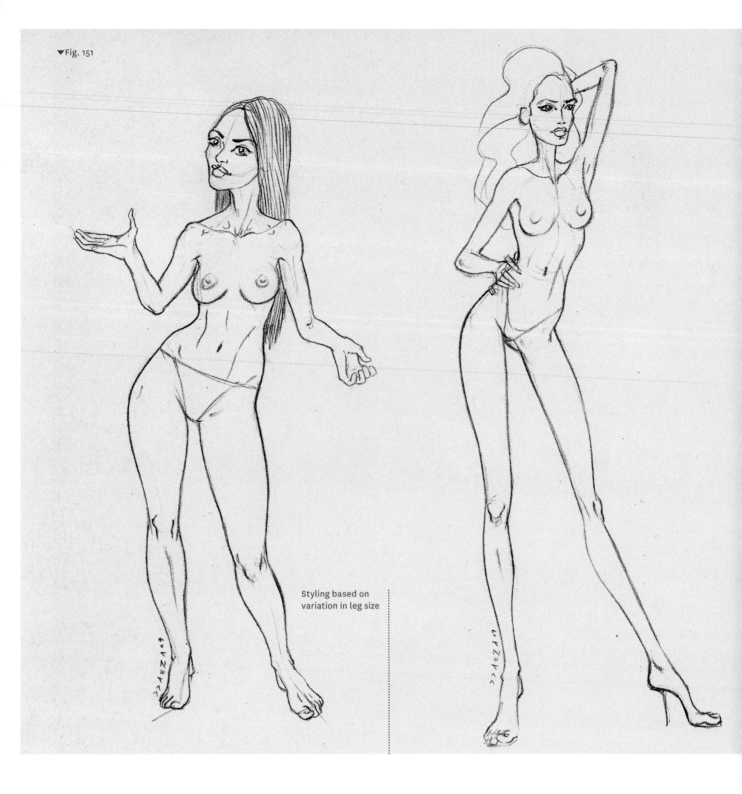

Styling based on
variation in leg size

We will use the term proportional variations to refer to both the idealization of the proportions of the drawing that we are producing (to achieve a synthesis of the figure) and changing the harmony of our drawing to create different body types.

Variations in relative position and size alter the harmony and produce a different body type. This new body can be a figure that shows the cultural norms associated with *femininity*, but these same variations can also be applied to the different genders, ages and builds of the figures being drawn. This means that the secret of defining a human figure according to sex, age and build lies in the proportional variation of its structure

Slenderness may be one of the aesthetic norms to be considered when styling, but there are others such as sturdiness, firmness, contrast, and so forth, and they depend on other variations and harmonies.

Styling is all about giving style to something. If we are unaware of this fact and confuse slenderness with styling, we prioritize one type

of harmony at the expense of others, giving slenderness stylistic supremacy and attaching it to the dogma of beauty or ideal body shape, since there is also a tendency to confuse idealizing with "ideally styled" when in fact all styling is ideal (cultural, mathematical, sacred, philosophical, moral, personal, and so forth).

Having extensively practiced drawing the human figure and its synthesis of muscles, and when you can spatially arrange it without problems and can quickly and spontaneously create the structuring while also being accurate and confident, you can allow yourself the *luxury* of styling (that is, add style, not slenderness) to your figures to achieve different types.
You will in any case always be styling the figure, since your drawing will always be subjective and –even if you don't want it to be– personal.

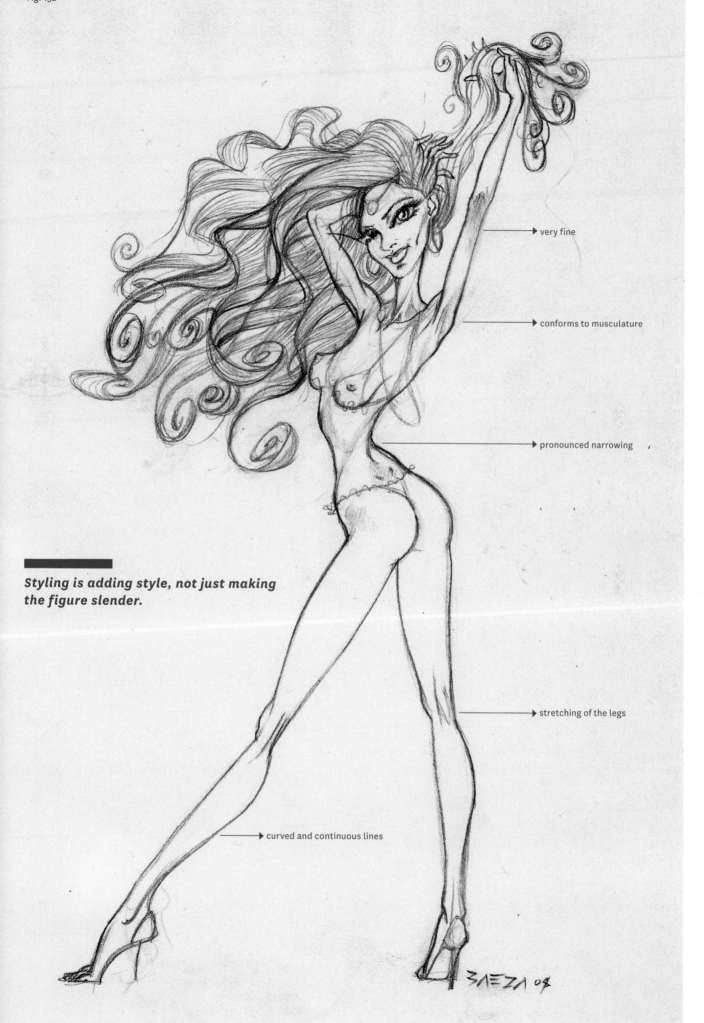

very fine

conforms to musculature

pronounced narrowing

stretching of the legs

curved and continuous lines

Styling is adding style, not just making the figure slender.

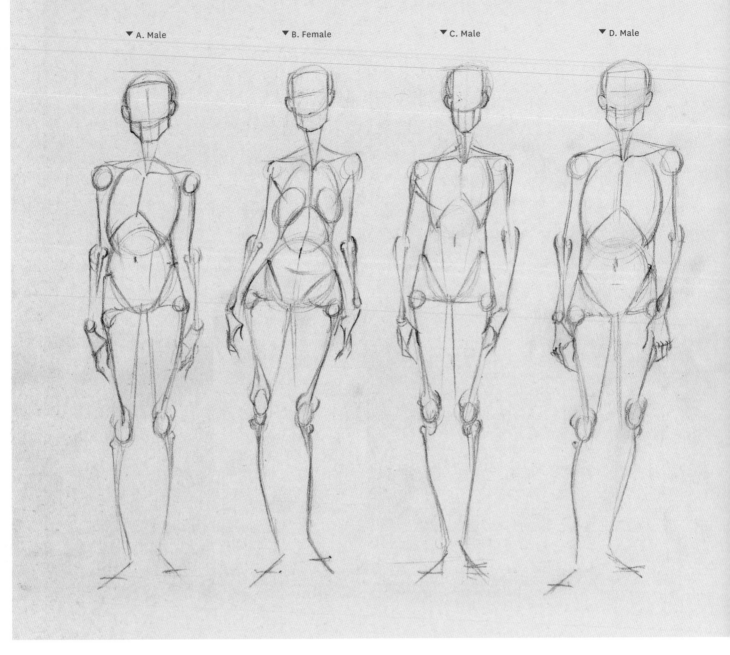

▼ A. Male ▼ B. Female ▼ C. Male ▼ D. Male

› **Starting point**

› **Cranium** narrower
› **Thorax block** narrower

› **Abdominal block** wider

› **Hips** wider

› **Cranium** más estrecho
› **Thorax block** narrower

› **Abdominal block** narrow

› **Hips** narrow

› **Cranium** sin variación
› **Thorax block** wider

› **Abdominal block** smaller

› **Hips** no variation

▲ Fig. 154 / Note the variations in heights and widths in the construction of different harmonies.

Styling for the figure

Variation in the structure

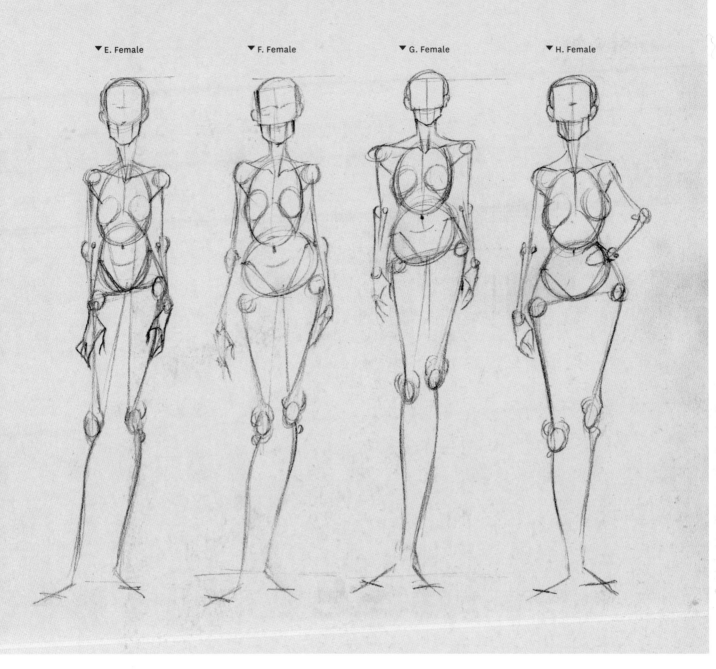

▼ E. Female ▼ F. Female ▼ G. Female ▼ H. Female

> **Cranium** no variation
> **Shoulders, thorax, abdomen and hips** narrow

> Elevation of hip height

> **Cranium** no variation
> **Thorax block** narrower

> **Abdominal block** wide

> **Hips** wider
> Variation of hip height

> **Cranium** smaller
> **Thorax block** small
> **Hombros** no variation
> **Abdominal block** smaller but wide
> **Hips** narrow
> Large increase in hip height

> **Cranium** no variation
> **Thorax block** small

> **Abdominal block** small and flattened
> **Hips** no variation

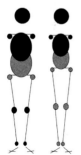
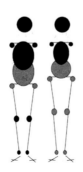
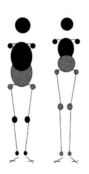
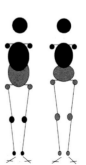

▼ A. Athletic male ▼ B. Athletic female ▼ C. Slim male

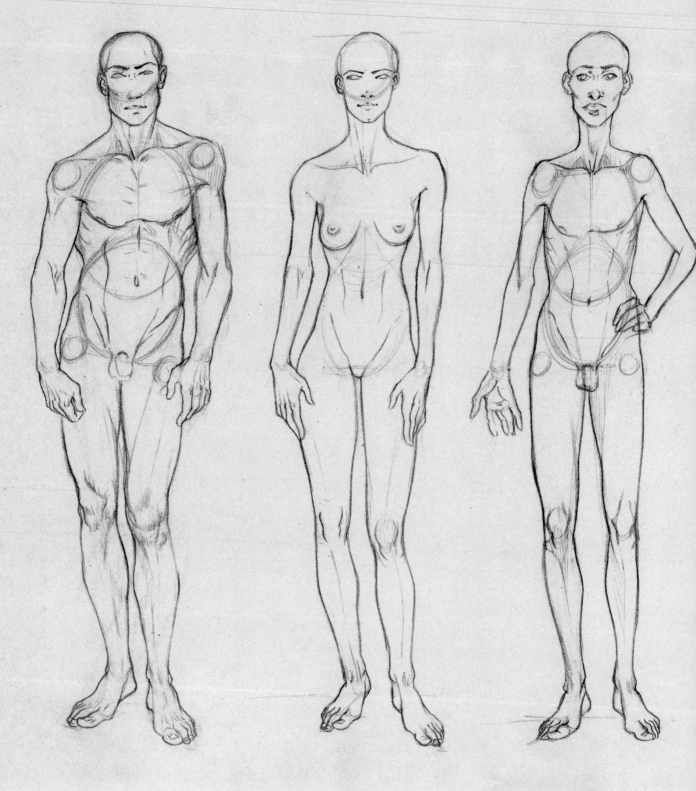

Notice how the widths vary if the heights of the various body builds and sexes are kept.

Physical builds of different bodies are not tied directly or necessarily to heights. It is possible to have an athletic build and an average height, or a slim build and short stature, or a stocky and tall stature. In any case what should be considered is the proportional variation of the head.

The head grows to a relatively standard size; taller people have a larger body in relation to their skulls and for short people the relationship may be the opposite.

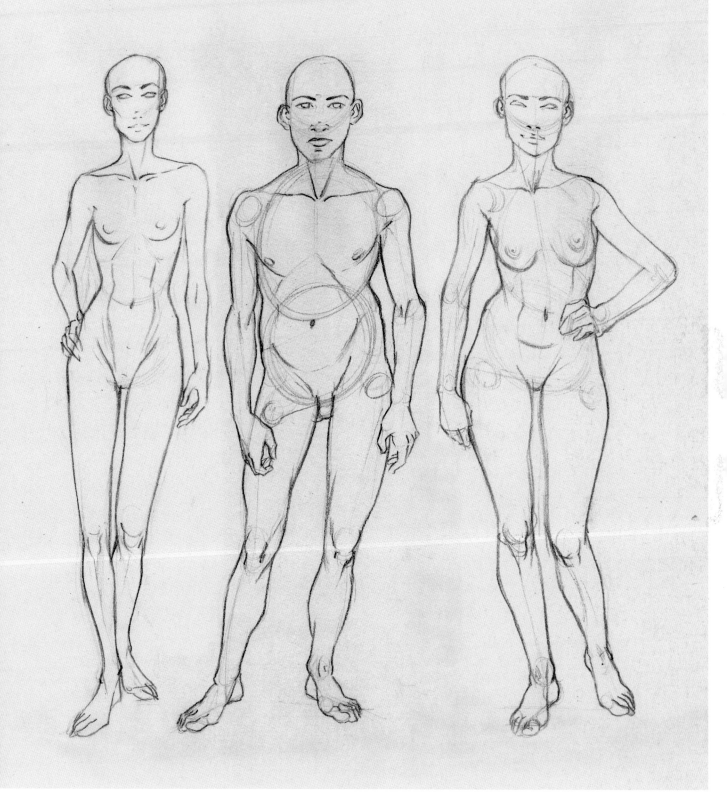

▼ D. Slim female

▼ E. Stocky male

▼ F. Stocky female

Fig. 156 ▶

Changing proportions
based on build: note
the variables for width
and height

According to age
(see position)

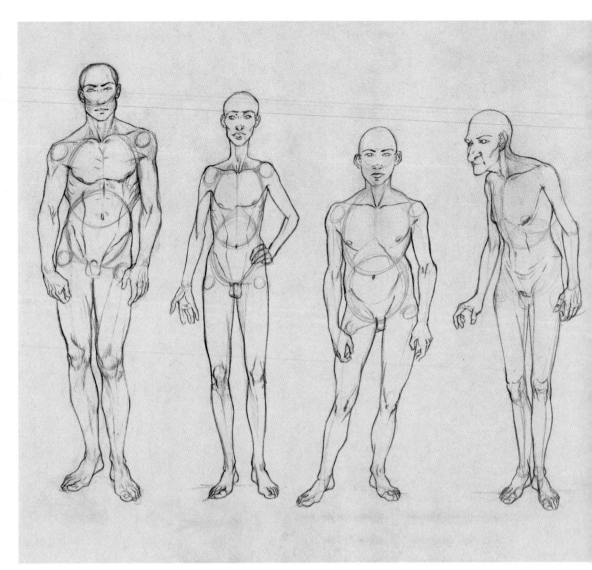

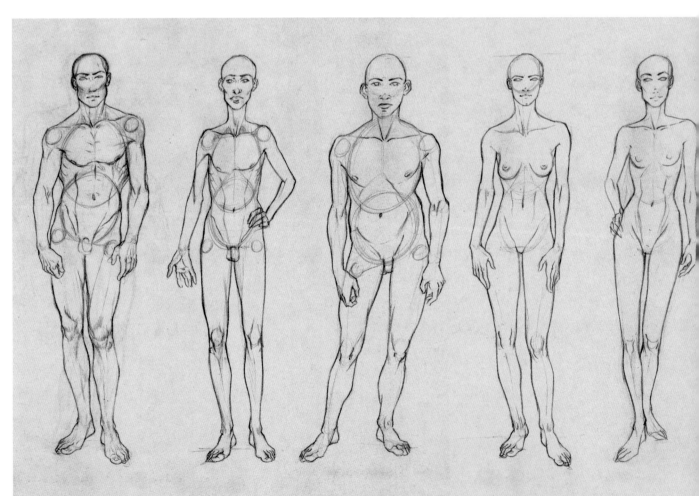

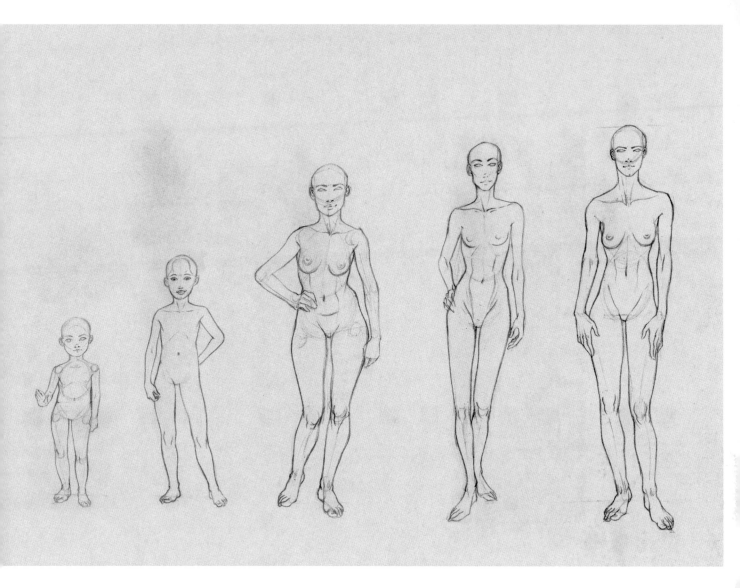

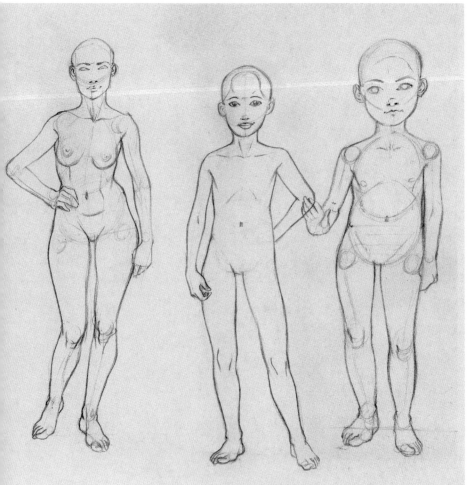

▲ Fig. 158

Changing proportions based on age: note the change in height

◀ Fig. 157, 159

Changing proportions based on age: note the cranium and widths

Changing proportions based on build: note what happens to the craniums (if the heights stay the same)

By altering the proportions while using the same structure we achieve different builds and ages.
Note the differences when compared to the same height.

▼ stocky build

▼ Infant

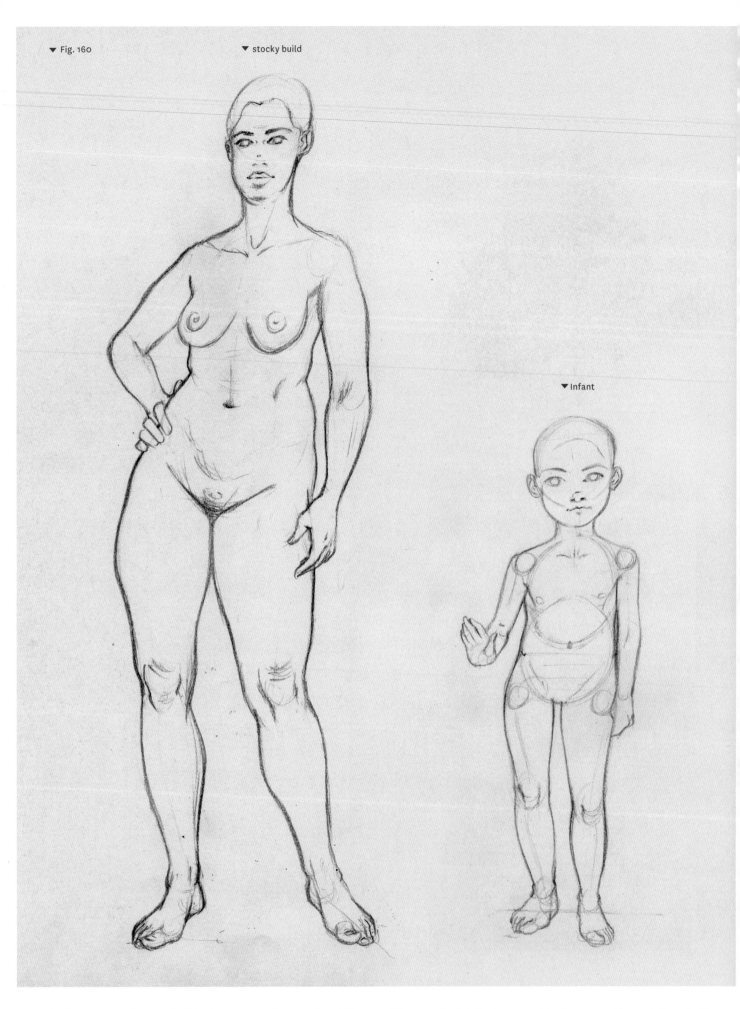

In these cases of stocky builds there are no structural variations, but what changes are peripheral elements, such as the addition of fat deposits and skin folds.

For children, the key to their morphology is the variations in size and position of the structural elements.

When our task is to draw an elderly person, the variations to the structure only involve the position of elements (which change to represent the forward-leaning curvature of the back), but it is also important to know the effects of aging on skin.

Fig. 161 ▼

▼Elderly person

▼Child

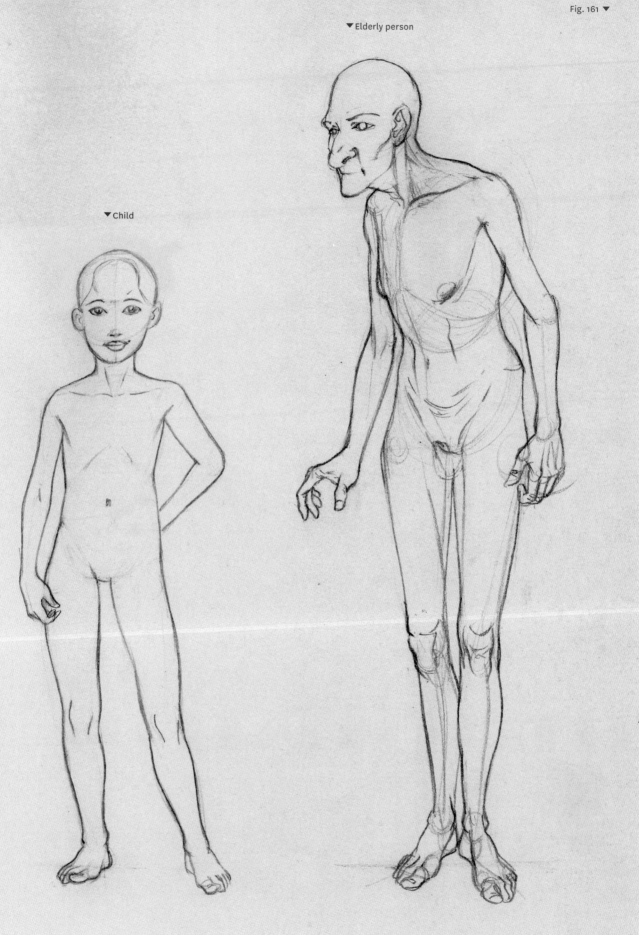

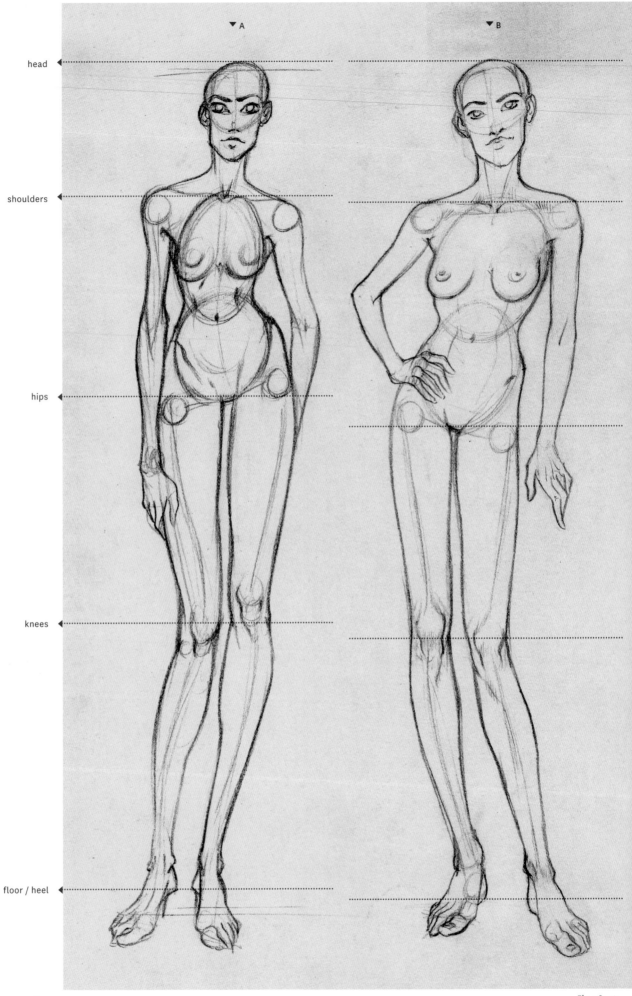

head

shoulders

hips

knees

floor / heel

▼ A ▼ B

Fig. 162 ▲

Note the different stylings created by proportional variations in
the structure applied to the variables for size.

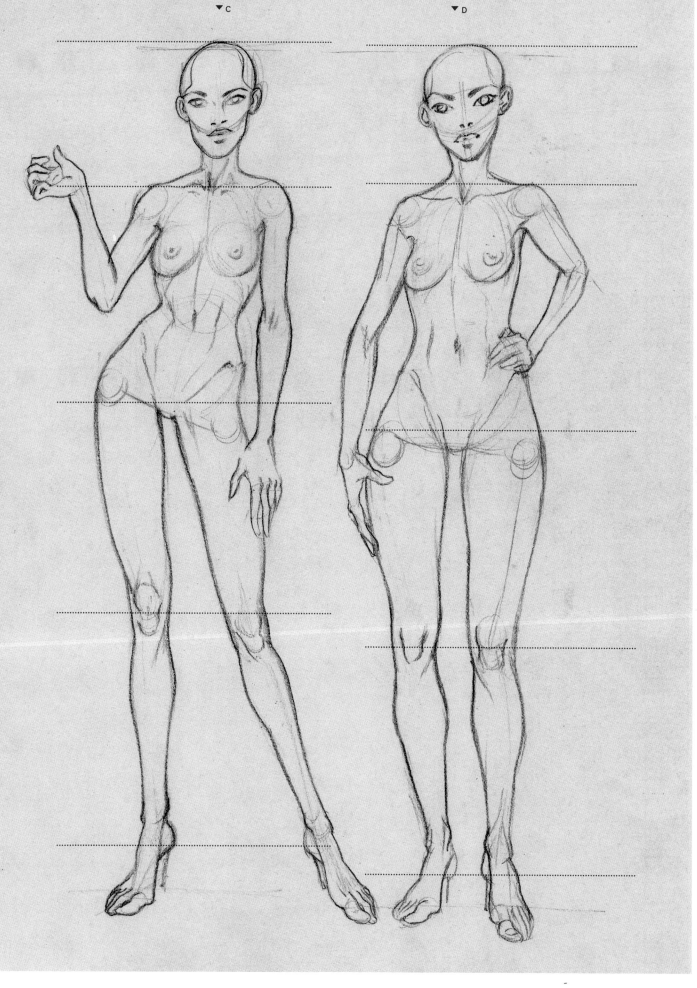

Volumetric synthesis

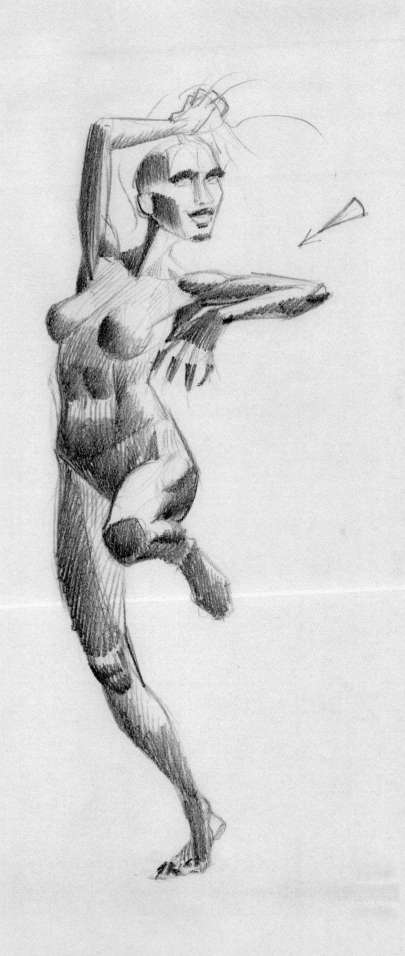

Fig. 163 ▶

Cubes

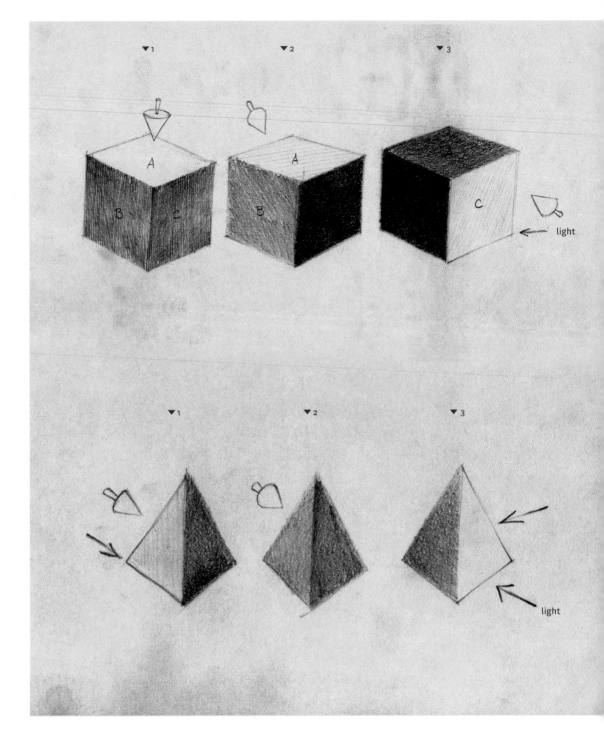

Fig. 164 ▶

Pyramids

Following the synthesis of lines and planes for the human body, we can approach the study of chiaroscuro based on its component volumes. To do this we must understand anatomy as volumes that are exposed to light, creating areas of high values (light) and others of low values (shadows).

The name of the chapter refers to understanding, aided by observation, of the phenomenon of illumination of complex volumes of the body, based on a regularized and synthetic conceptualization of these volumes. Accordingly, we will begin with the lighting of regular volumes, for which light produces simple–or rather, more comprehensible–forms and paths.

We will then deconstruct the human figure into regular volumes similar to those studied to produce chiaroscuro of the body that matches the given lighting conditions.

However, I will not go too far in explaining the incidence and workings of light on a surface, so as not to nullify or divert the reader's intuition, and nor will I dwell on particularly technical aspects of the topic (the pictures in this book will be of help, although it will be necessary to deepen and complement this material with books, photographs and real-life observation).

There is nothing better than regular volumes to begin the process of getting to know the influence of light and our perception of it. For this reason we will study the incidence of light on cubes, pyramids, cylinders and spheres. These regular problems will help us to understand the phenomenon of chiaroscuro, which we can then apply to more complex situations for different parts of the human body.

◀ Fig. 165

Cylinders

light

◀ Fig. 166

Truncated cones

light

light

◀ Fig. 167

Spheres

Examples for creating chiaroscuro in regular volumes

CUBES

1 | Single light source from above. Zenithal light over the cube: maximum light on the horizontal face and the equivalent level of brightness in shadows on the vertical faces. This is because the light strikes the horizontal surface at 90°, that is, perpendicularly; when this happens the luminosity level is maximum.

2 | Single light source from above, from the viewer's left to right and from above to below (backlighting). Backlighting parallel to face B directed horizontally. No light reaches face C. Face B is tangentially exposed to light and we can see a low level of brightness; however, the light continues to touch the horizontal surface of face A, but not perpendicularly, so the brightness is less than in the previous case.

3 | Light from below to above, from right to left and from front to back.

PYRAMIDS

1 | Back left, side.
2 | Back, left side.
3 | Front, right, above.

CYLINDERS

1 | Light from the right, in front and above.
2 | Light from the front and above.
3 | From the back (backlighting), right and above.
4 | From below, right and from the front.

TRUNCATED CONES

1 | From above, left, front.
2 | From above, right, front.
3 | From behind, above (frontal backlighting).

SPHERES

1 | From above, front left.
2 | From below, front, right.
3 | Backlit from above.
4 | Frontal backlighting.

Cubes and pyramids have a uniform value, without the gradients seen in cones, cylinders and spheres. For these, the light (sun in the example and therefore parallel rays) has a different angle of incidence at each point where it touches the surface. On a flat surface, each point receives light at the same angle. In the cylinder, each of the straight lines that make up the curved surface has a variable angle of incidence, so they form linear gradients, whereas all the points on the sphere have different angles of incidence, hence the radial gradient.

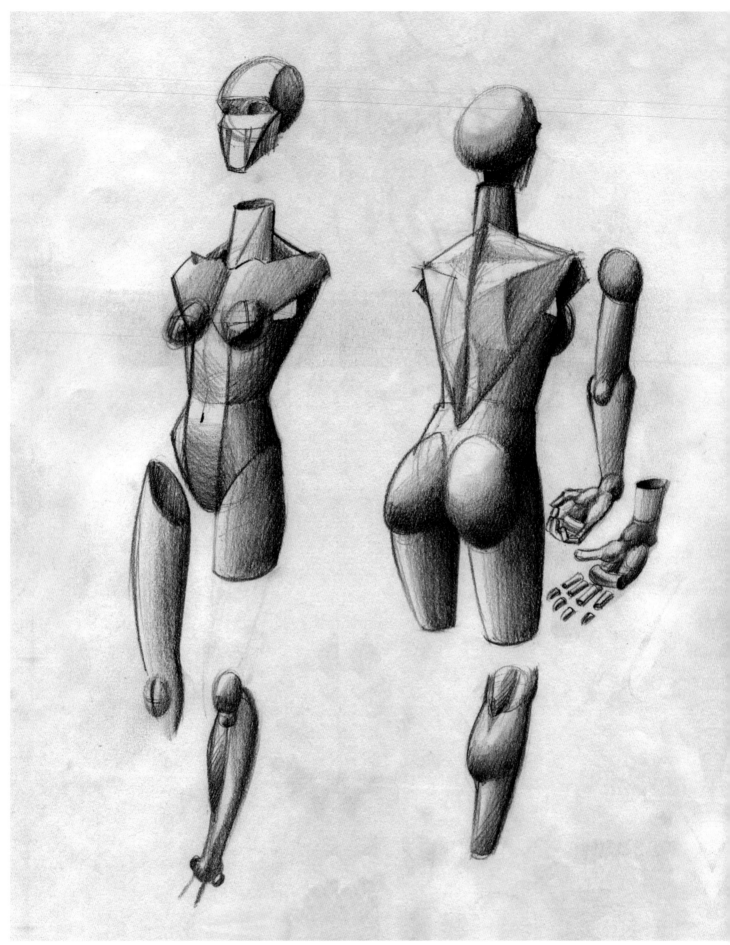

▲ Fig. 168

**Volumetric
composition**

The human body can be divided into different semiregular or regular geometric shapes and chiaroscuro can be separately applied to them. Accordingly, the head is spherical in its cranial area, the chest and back are flat, and the arms and legs are cylinders and truncated cones.

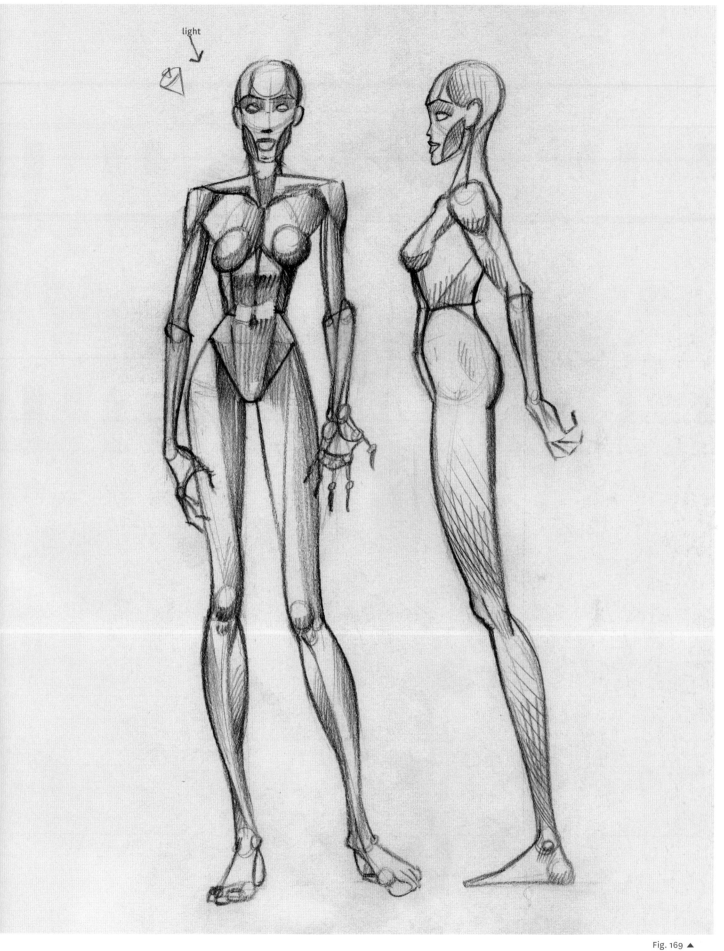

light

The association of volumes can be varied and complex; the drawing process then continues with the faceting of the body surface, and we can even shade the muscles of the body by treating them as spherical, cylindrical or flat objects.
Here's an example with the model styled and synthesized in volumes and chiaroscuro.

Fig. 169 ▲

Synthesis and interpretation of volumes

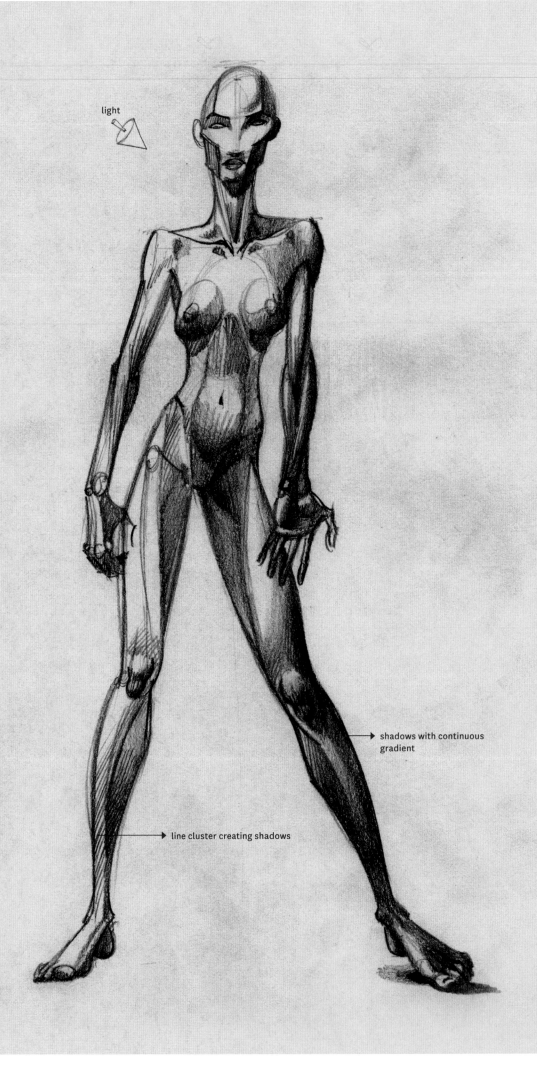

light

shadows with continuous gradient

line cluster creating shadows

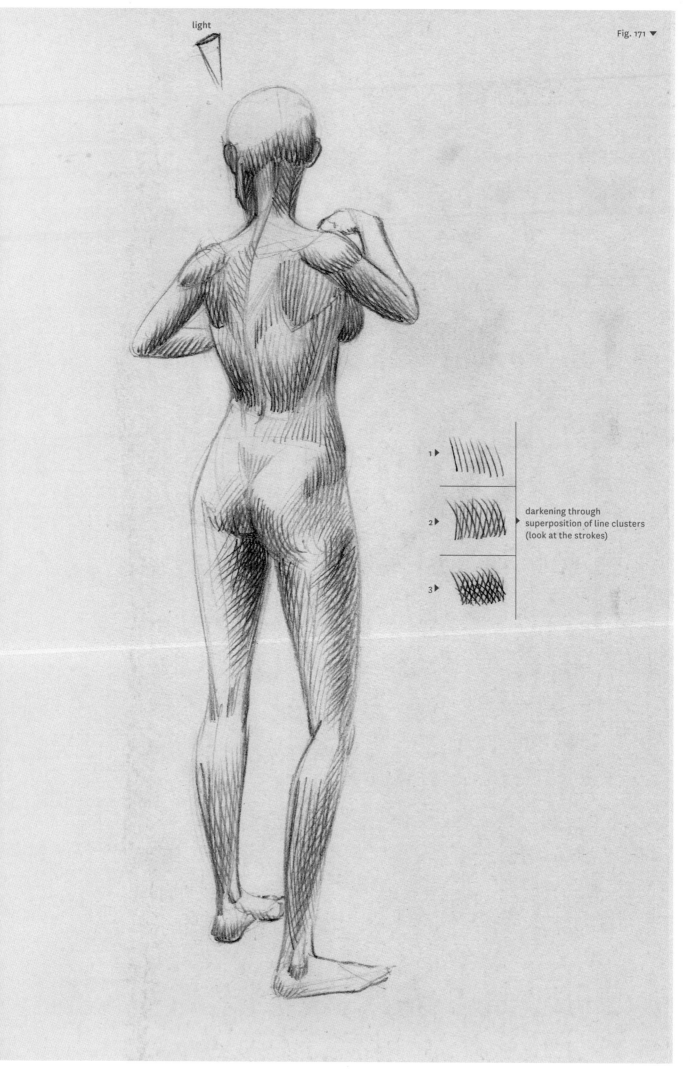

light

Fig. 171 ▼

1 ▶

2 ▶ darkening through
superposition of line clusters
(look at the strokes)

3 ▶

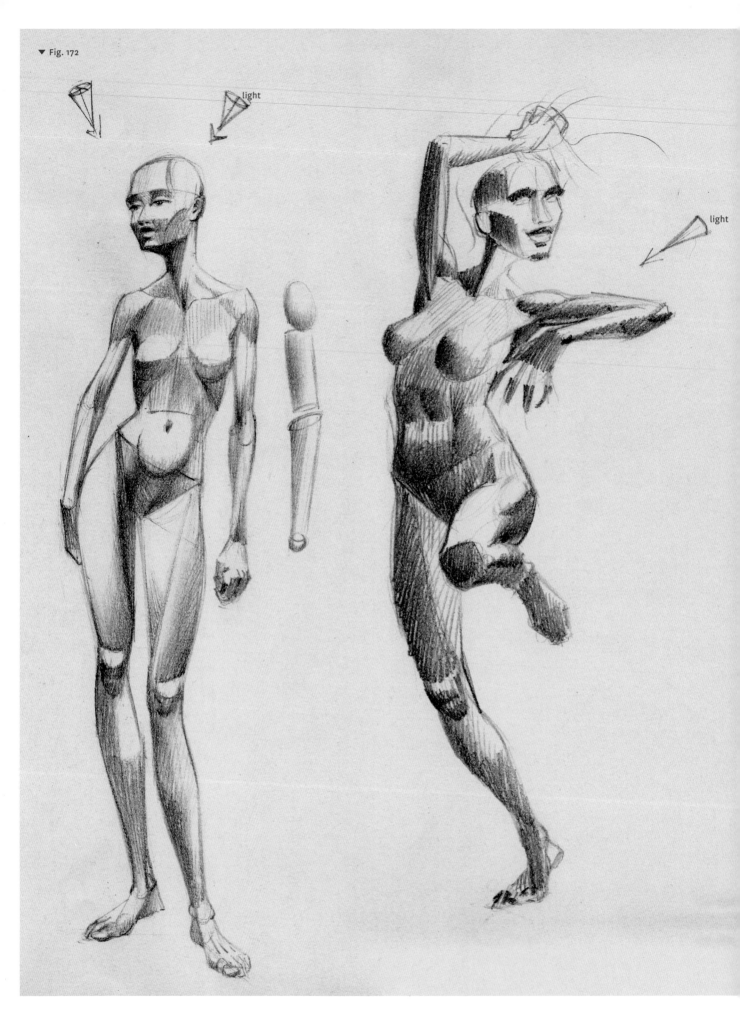

light

light

The associations of volumes depend on you. Some are obvious and logical, but there are other more arbitrary ones that will require your judgement. It is therefore necessary to study anatomy and always observe the body.

Fig. 173 ▼

light

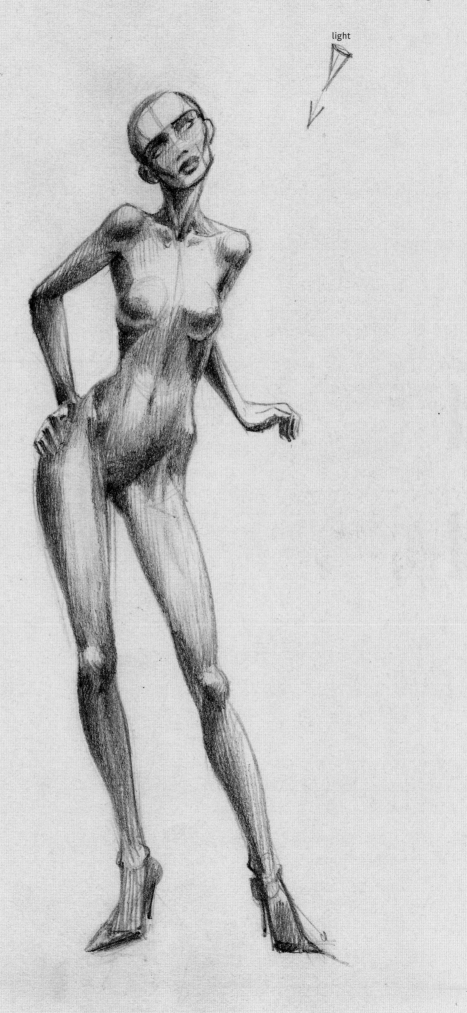

head and face

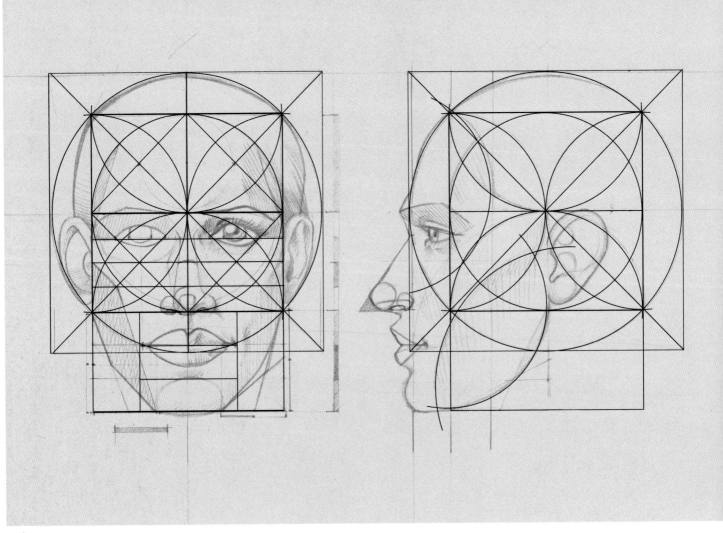

▲ Fig. 174

Having studied the complexity of the body as a kinetic structure, bone synthesis, muscle anatomy, styling and proportional variation and finally chiaroscuro, the time has come to begin the study and representation of the human head of the figure.

The head in itself has an equal or greater complexity than the rest of the body. Although the issue of movement does not play as much of a role since it is a structure with virtually no joints (except the mandible), the features, location and volumes are very complex, delicate and expressive in themselves.

But what adds to the difficulty of representing the face and head is human brain's highly specialized ability to recognize the smallest morphological variations of the delicate composition that is the human face, a structure that has always been used as the primary means of communicating emotions and thoughts.

This greatly influences the frustration that beginners experience with the drawing of the face, with the slightest error being perceived as grotesque or monstrous.

Therefore, do not become demoralized if when trying to draw the face you do not achieve any apparent results. You must understand that this step may be the hardest and we must be patient and follow the building steps methodically.

Do not try to proceed to the detail of the features if you have not first geometrically structured the position and shape of the base volumes and planes.

Frustration will be overcome with the perseverance of methodical practice. From practice comes mastery, and from that comes results.

Proportions of the face

The face is a structure that can be divided into three horizontal segments:

› The two upper ones are the halves of the square placed into the circle that until now represented the cranium.
› The third, this time outside the circle and the same size as the other two segments, is the lower part of the face (mandible).

From this we will obtain, from top to bottom, four important dividing lines: the start of the scalp, the eyebrow line, the line of the base of the nose and the mandible line.

The vertical limits of these lines are the left and right sides of square inside the cranial circle, and the median or vertical height will be the face's symmetrical axis. We therefore have three sections: forehead, eyes and mandible.

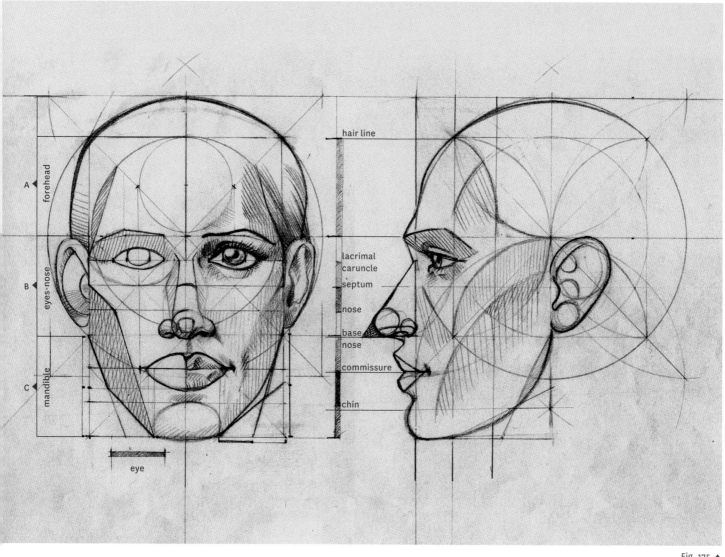

Fig. 175 ▲

FOREHEAD (A)

The forehead section will not have any more divisions. In contrast, the eyes-nose section will be divided into four equal parts in order to position the features of eyebrows, lacrimal caruncle, septum, and so forth. The same applies to the mandible and mouth section, except this is divided into three equal parts.

EYES - NOSE (B)

We will divide this middle segment of the face into four equal and also horizontal parts, which from top to bottom will mark out:

1 | Eyebrows.
2 | Lacrimal caruncle.
3 | Nasal septum.
4 | Tip of the nose.
5 | Base of the nose.

We first create the eyes, positioning each one at the intersection between the line for the lacrimal caruncles and the diagonals of the square inserted into the circle for the cranium.

This will give a proportion of three equal segments (eyes) in the centre of the face, and a half on each side of the eyes; the maximum width of the face is equal to four eyes.

We then put the eyebrows on the corresponding line, using the eyes as a reference. The nose is the width of an eye and is centred on the axis of the face. Note that the eyebrows begin slightly closer to the centre than the eyes do, and end almost reaching the edge of the base square or the edge of the face.

MANDIBLE (C)

The third section of the face corresponds to the jaw. The features found in this section are the mouth and chin.

But now the dividing modulation changes and we mark out three fractions: the first line at the height of the commissures of the lips, the second at the beginning of the chin at the edge of the orbicularis oris (lip muscle) of the lower lip, and the third defines the end to the mandible line.

Before starting to draw you might review the concepts and drawings on pages 36, 37, 38 and 39.

119

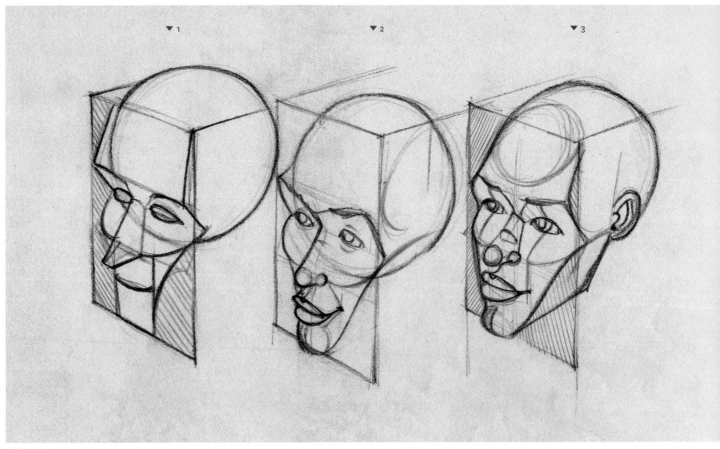

▲ Fig. 176

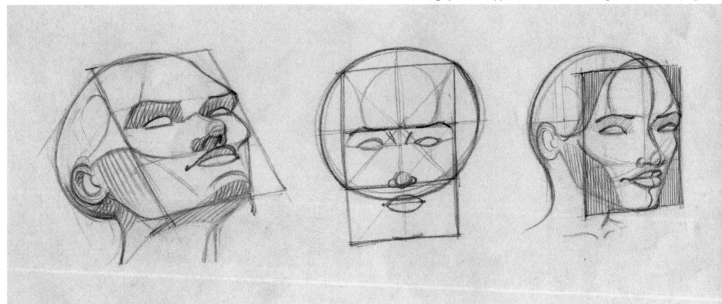

Once you have the three sections of the face divided up, place the features geometrically to familiarize yourself with its structure. In the drawing you can see how to arrange them to establish a regular harmony.

Repeat this drawing in frontal and profile form several times, correcting errors through comparison and analysis.

1 | Structural mask plus circle (sphere).
2 | Detail of facial volumes.
3 | Joining with the cranium via the mandible.

Note how, from a simple geometric structure, we have gradually shifted to a more complex one. First there is the mask plane, then the divisions, then the geometric features and afterwards the details.

It should now be clear that the face works like a mask or facade of the cranium with a tripartite structure that takes different positions and viewpoints.

Analyze these examples and draw them before starting to look at and draw the ones that you will use to help you practice.

Use photographs that show the position of the face from the front and in profile. First draw models' faces and then any faces you like. At first it may be helpful to draw bony faces, to better see the internal structure and main curves.

Fig. 178 ▼

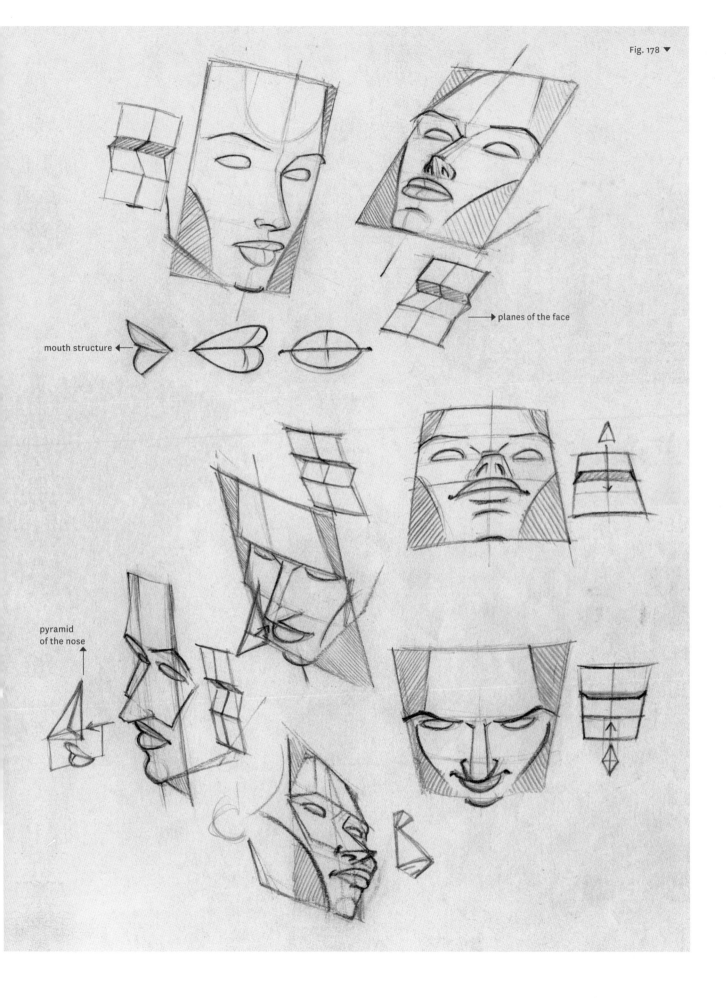

mouth structure

planes of the face

pyramid
of the nose

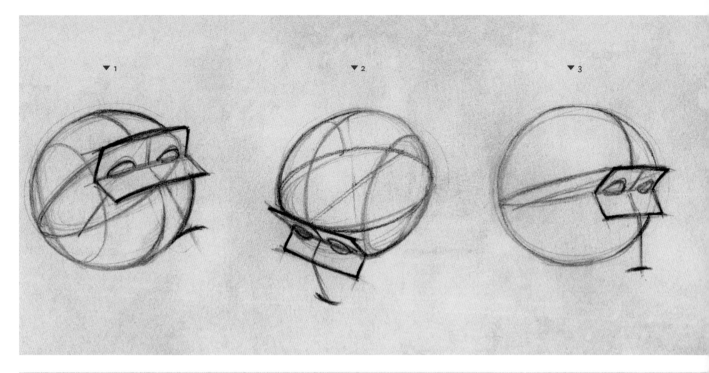

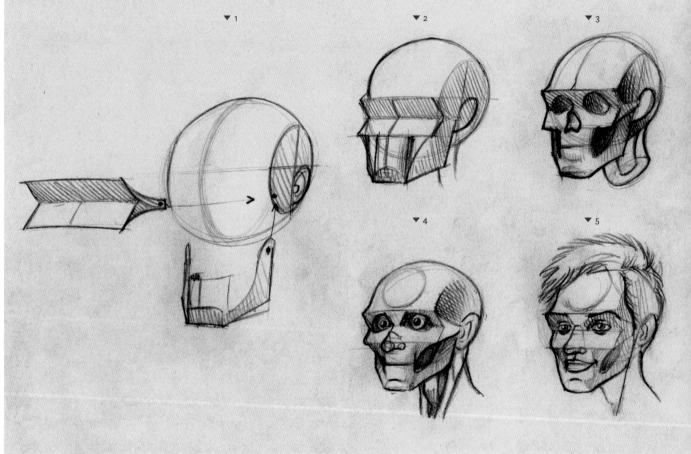

Fig. 179 ▲

Views of the eye planes coupled with the cranium

Based on the structures of the face we give shape to the cranium.

Notice how these hinges can establish the whole perspective of the head.

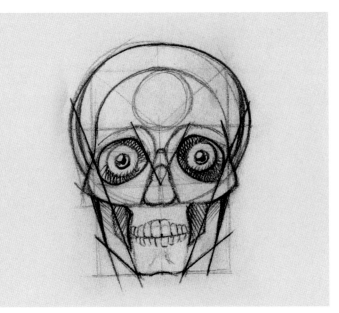

Facial features

EYES

1 | The eyes are spheres floating within the sockets through a group of muscular tensors.

2 | The sockets are embedded in squares, but within them they are irregularly structured. Even so, the eyeball is centred in this framing. The iris is never completely seen, since the curve of the upper eyelid partially covers it; the lower lid barely touches it, if it does at all. The iris therefore touches or rests on the lacrimal caruncle line.

Fig. 181 ▼

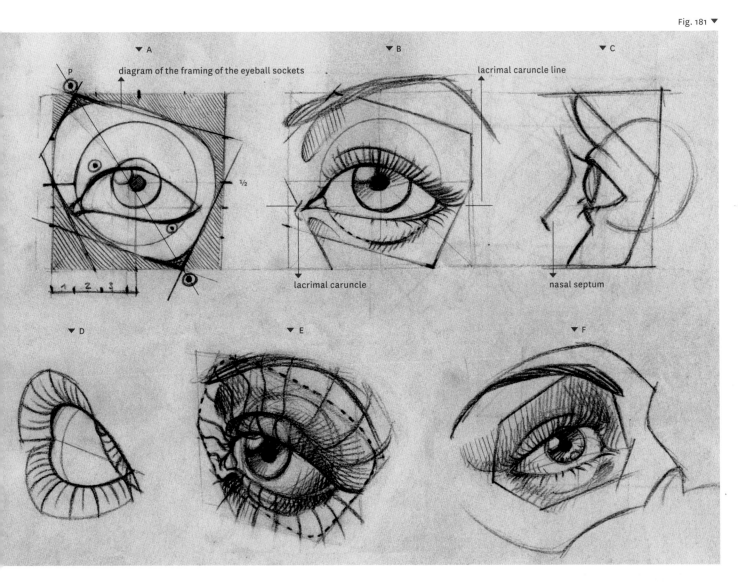

▼ A
diagram of the framing of the eyeball sockets

▼ B
lacrimal caruncle line

▼ C

lacrimal caruncle

nasal septum

▼ D

▼ E

▼ F

▼ Structuring and types of eyes

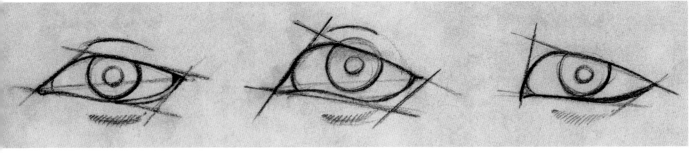

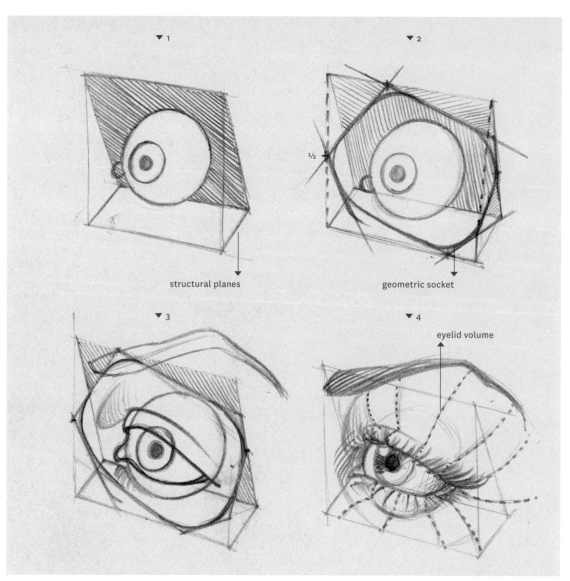

▼ 1

structural planes

▼ 2

½

geometric socket

▼ 3

▼ 4

eyelid volume

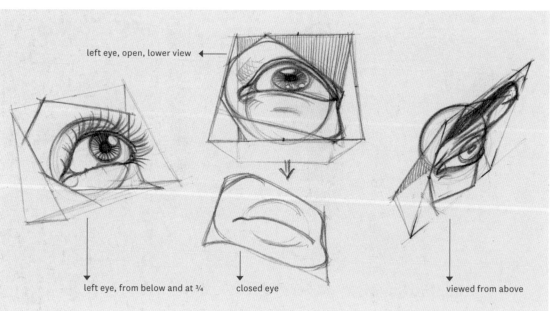

left eye, open, lower view ◀

left eye, from below and at ¾

closed eye

viewed from above

The shape of the eyelids and eyelashes is another issue. If we look at the structure that houses the eyes, that is, the sockets, we see an upper and inner tip and an outer bottom one (Fig. 181-A). These two *tips* influence the shape of the lashes, so that the upper lashes have a steeper curve towards the brow, while the lower lashes steepen towards the edge of the face.

The eyelids can take different shapes, but always cover the curve of the sphere of the eyeball.
The lacrimal caruncle is located outside the eyeball but attached to it, creating a peak where the eye begins.

NOSE

The nose is the most variable of the facial volumes. It goes into and protrudes from the plane of the face, creating complex volumes. We structure it by using the full height of the middle part of the face, that is, from the eyebrow line to the base of the nose.

1 | It is essentially divided into four parts, with its centre marked by the septum. The first upper quarter is a narrowing that forms a trapezium whose longest side is the distance between the eyebrows, and whose shortest is the beginning of the nasal septum, at the height of the lacrimal caruncles. From there downwards the volume develops as a pyramid. The base is formed out of three spheres: a large one, whose diameter is equal to a quarter of the nose and projects out from the plane of the face, and two smaller ones of half the size of the previous one, located at the sides and attached to the surface of the face. Before moving on to detail the parts of the nose it is advisable to first establish this pyramid and its spheres.

Structural pyramid / Fig. 183 ▲

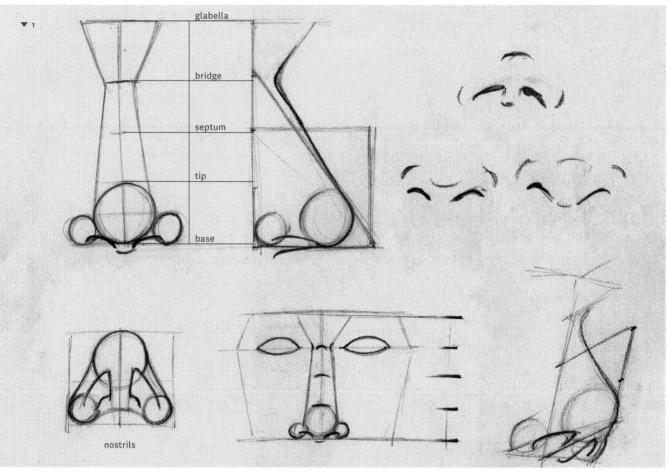

Types and synthesis of nostrils / Fig. 184

Types of nose and structures / Fig. 185 ▼

Fig. 186 ▶

Foundation planes

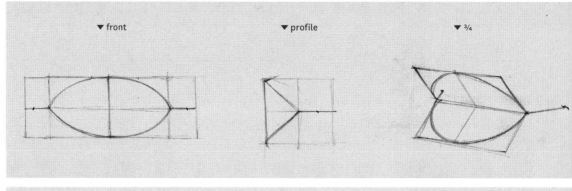

▼ front ▼ profile ▼ ¾

Fig. 187 ▶

Planes

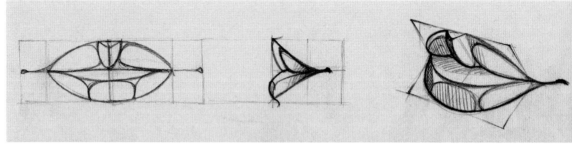

Fig. 188 ▶

Volumes

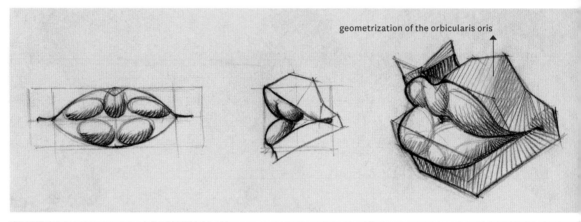

geometrization of the orbicularis oris

Fig. 189 ▶

Perspective and turning of foundational planes

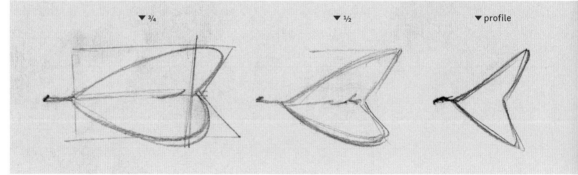

▼ ¾ ▼ ½ ▼ profile

MOUTH

The mouth looks like a simple volume, but it has its complexities. We construct it in a simple way and then add volume and detail.

1 | Rectangle containing the mouth (remember that the width is limited to the middle of the eyes). (Fig. 186)

2 | Planes that will form the mouth.
Note that for the construction of the lips we will makes use of different quantities, shapes and sizes of planes. Here we will use four main planes for the upper lip and four for the lower one, arranged symmetrically (just as the whole face in general is arranged). (Fig. 187)

3 | Volumes that make up the mouth. These also vary in shape, size and quantity. Here we will take five volumes as the organizing principle, but these traits can vary greatly. (Fig. 188)

4 and 5 | To establish the three-dimensionality of the mouth it should be understood as two (upper and lower) frontal planes and two lateral ones, which are the commissures of the lips. The mouth thus appears as a covering for the teeth and does not lie flat on the face.

1 | Step one: establish the line for where the lips meet and their upper and lower limits, and then mark the middle, or symmetrical axis (which has a close relationship with the axis of the face).

2 | Step Two: Place the planes and/or volumes of the lips as per the structuring. (Fig. 190)

3 | Different lip shapes and movements. All these movements and forms are constructed in the same way as has been explained. (Fig. 191)

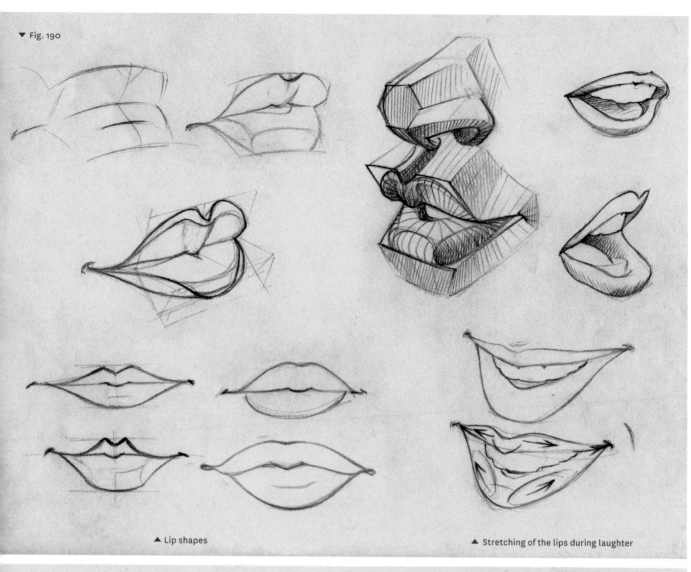

▲ Lip shapes

▲ Stretching of the lips during laughter

▼ Fig. 191

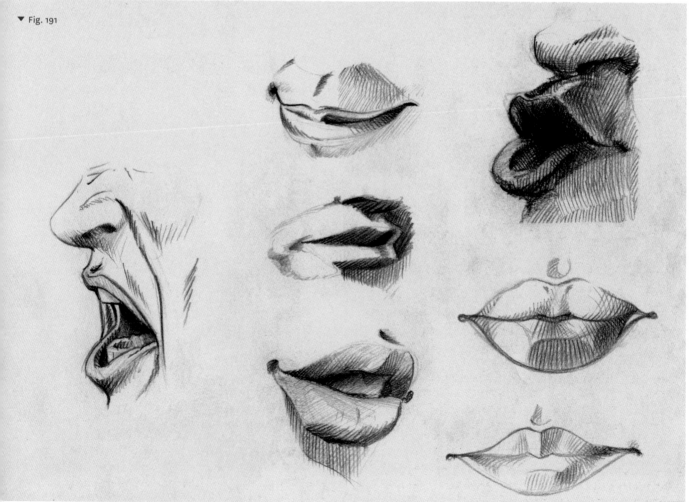

▲ Fig. 192

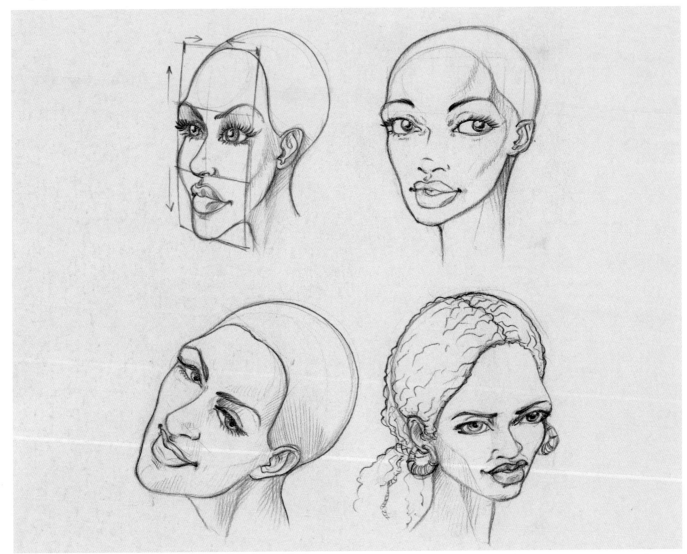

Fig. 193 ▲

Integration of the elements

Different types of faces.
Note that slightly varying the geometric structure of the face will produce significant changes, as does varying the shape of the mandible or the position of the features.
You can try out rounder face shapes, more angular ones, or more elongated or narrow ones, varying slightly the proportions of the structure and the position, shape or scale of each of the features. These variations can result in different faces and different stylings

of the same type of face; that is, we can style a face (or a body, as we have seen previously) from its realistic representation to its graphical idealization (figure, cartoon, and so forth). (Fig. 192).

Once you've drawn every feature of the face in different positions and poses several times, draw the head and facial structure and complete the picture by adding the details of the features.

STYLING OF SHAPES ON THE FACE

Styling, as mentioned previously, is the process by which a natural form is idealized. This process can be carried out based on a formal synthesis, varying levels of iconic information (that is, drawing) and descriptive information through different graphic, visual and technical resources. In this case, we begin with a realistic* representation to reach an abstraction** of the motif that is more refined and subtle.

But you can also idealize the motif to be represented by leaving the information of the object represented *constant* and working on the configuration, size, position and density of the form, as well as on its technical expression.

It is also possible to combine formal synthesis with the idealization of the form, and in fact most representations oscillate between both processes. (Fig. 194)

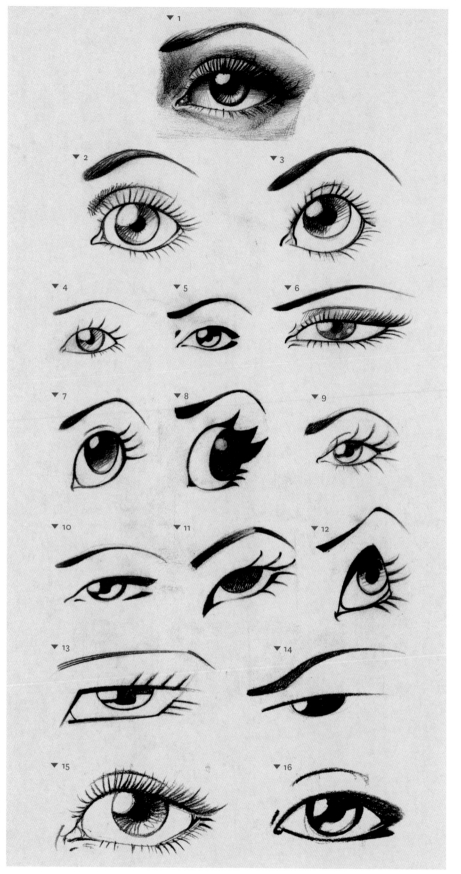

Fig. 194 ▲

1 | Highly figurative eye in which values, proportions and details are represented.
2 | Styling through size, expression in a modulated line.
3 | Same as 2 but also with removal of features.
4 | Greater subtraction of features.
5 | Geometrical and regularized synthesis expressed through planes.
6 | Styling by varying size (width) and synthesis of features.
7 and 8 | Geometrization and variation of size expressed respectively through a modulated line and uniform plane.
9 | Similar to 4 but with exaggeration of size.
10 | Same as 5 but with variation of width.
11 | Change of position, geometrization of shape, regularization of line and plane.
12 | Change of the geometric structural configuration from circle to triangle.
13 | Same as 12 but with a rectangular configuration and a regularized but modulated line, as with the plane.
14 | Subtraction and geometrization of features expressed through uniform planes.
15 | Same as 1 but with subtraction of values.
16 | Geometrization and representation through synthesis of planes.

* We use the term realism here to refer to figurative-naturalistic representation, that is interpretation based on an approximation of the real object that "formally sets out the anatomical and/or psychological characteristic features of the model." These are concepts used by Professor César Sondereguer as classifications in the work *Estética de nuestra América precolombina*, though they are also applicable to other forms of artistic expression.

** Visual abstraction, like any formal synthesis, the product of a particular morphological concept departing from naturalism. Sondereguer, C. and Punta, C. *Amerindia: Introducción a la Etnohistoria y las Artes Visuales precolombinas*. Ed. Corregidor. Buenos Aires, 1999.

17 | Same as before but with variation of scale (height)

18 | Planes only.

19 | Geometrization and scale variation of the features expressed through variable plane.

20 | Subtraction of features and expression through variable planes.

21 | Variation in size and subtraction of features.

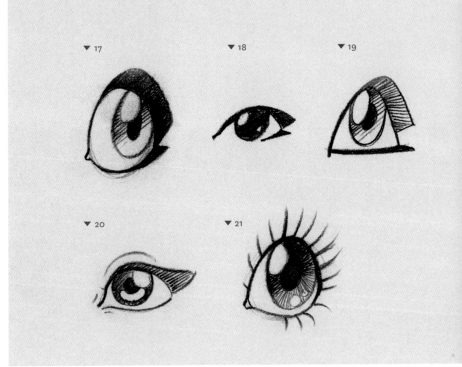

Fig. 194 ◀

▼ Fig. 195

Caricature is the humorous idealization of the natural form; geometrization is a gradual idealization that tends toward regular geometric figures. It is not possible to go in a linear fashion from hyperrealist figurative representation to geometric or expressionist abstraction. Rather, this gradation is expressed as a tree with many branches, so it is difficult to classify and determine where a drawing lies or what it is from its information or its rhetorical style. For example, we can draw an eye with technical finishing touches that incorporate subtle softening, representation of appearance through contrasts, and so forth (Fig. 194-1), and vary its formal configuration by accentuating its roundness and the relative sizes of its constituent elements (iris, eyelashes, eyelids), as in Fig. 194-17. In this case we would obtain a drawing that on the one hand *appears* like the reality perceived by the eye, while on the other idealizes its shape and proportions, meaning it is no longer realistic.*

* On this subject, see Sebastian Krüger's cartoons, the figurines of Arturo Elena and the huaco pottery portraits of the Mochica culture.

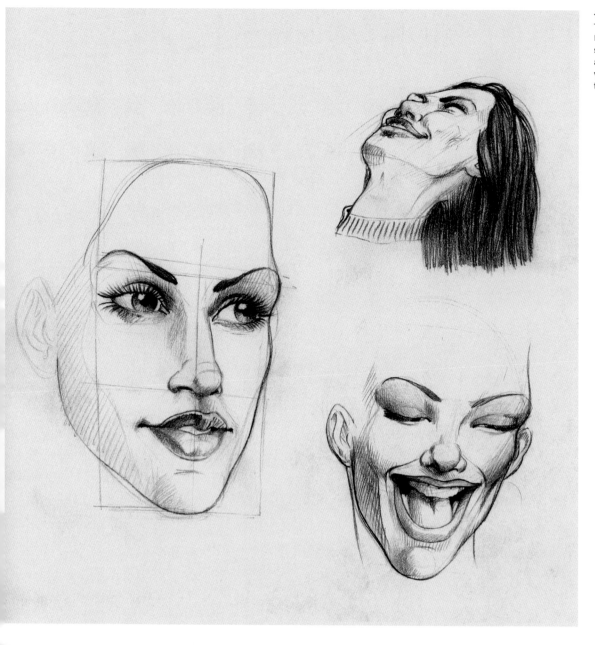

◀ Fig. 196

Integration of structure, features and morphological variations in different faces.

strokes

◀ Fig. 197

Linear synthesis and geometrization of features

pencil movement

▲ Fig. 198

Practice different syntheses, face shapes, hairstyles and expressions.

Fig. 199 ▼

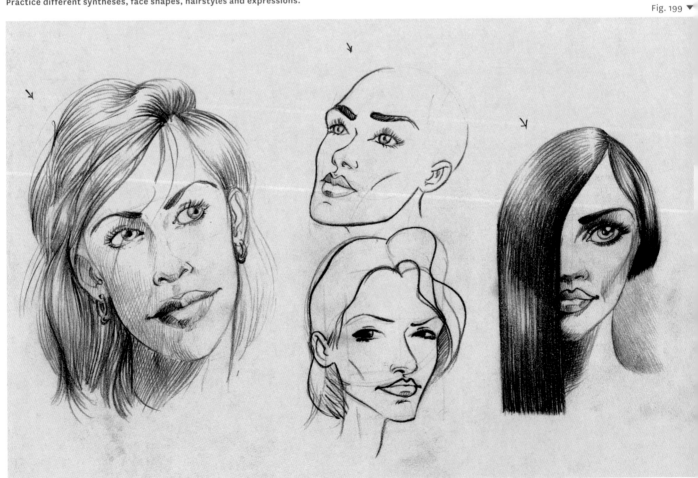

▼ A ▼ B

▼ C ▼ D ▼ E

▼ F ▼ G

STYLING OF THE FACE

In this set of drawings of faces you can see in what way a particular concept of synthesis, idealization, and expressive and morphological variations functions.

A | Synthesis with chiaroscuro and variations of values that are closest to realism.

B | Idealization based on variation in size, shape and position of the features and synthesis of them by subtracting linear detail.

C | Same as B with opposite effect. Masculinization of the face by exaggerating the bone structure. Note that the features have distinctly feminine attributes through medium to high levels of linear synthesis, which does not interfere with the general perception of masculinity in the face. Through this we can deduce that the bone structure of the face is more important in communication than features are.

D | Humorous idealization with synthesis through a significant regularization of strokes and curves, which is also achieved through subtracting details. Variation of vertical scale.

E and F | Similar to B but with a *grotesque* touch, based on the relative size and details of the features (mouth, eyes, eyebrows).

G | Brush or pen linear synthesis, subtraction of detail and simplification of features. Different idealizations based on the plasiticity or expressiveness of the lines. We can see a modulated brush or pen line, expressed through the open curves.

133

drawing clothing

In the following pages we will see how to convey the materials of clothes using drawing's graphical code. A garment is a complex set of physical and technical variables that translate into graphic elements, creating a relationship between reality and representation. After learning how to handle and be in conscious control of graphical language, through the medium of drawing we will be able to express a creation, design or visual idea of a project idea before it takes material form–before it exists in space-time.*

ORDER

With regard to the representation of the dressed human figure we will establish an order for the methodical observation of the behaviour of the garments on the human body, in order to provide a rational criterion for the conscious use of graphical language.

Primary structure THE BODY

We will establish anchor points in areas where the fabric is subjected to stresses caused by body movement. The anchor points vary according to the movement; that is, they change continuously.

Secondary structure THE GARMENT

We will also establish anchor points where the fabric is joined together in a continuous way (seams, fasteners, knots, buttons, and so on) or hugs the body due to an accessory (belts, elastic, and so forth). These anchor points are not as variable as those for the body, especially considering that the structure of the clothes in a design can hide, highlight or remodel the body and affect the relationship between the anchors for the body and those for the clothes.

> Basic Forces

During continual movement, the anchor points of the body produce stresses and strains in the fabric which in turn produce the fundamental behaviour of the garment.

> Fabric characteristics

The behaviour resulting from the forces generated by the structures also varies according to the material and structural features of the fabric or fabrics that make up the garment.

> Fabric thickness

We distinguish this from the previous category because, although they are closely related, isolating this category allows us to better study the variation that representation of a thicker or thinner version of the same type of fabric creates in our line work.

> Visual properties of the fabric

We separate these properties from the question of materials and structure since understanding them is based on visual appearance or properties and on the action of light in the material, and not its mechanical behaviour in response to forces.

* This does not mean that it is enough for the designer just to excel at drawing; he or she must also understand technical issues, have a sensitivity to material properties, and so forth. A precise and expressive drawing requires equally precise and expressive techniques during all the phases of production.

▲ Fig. 201

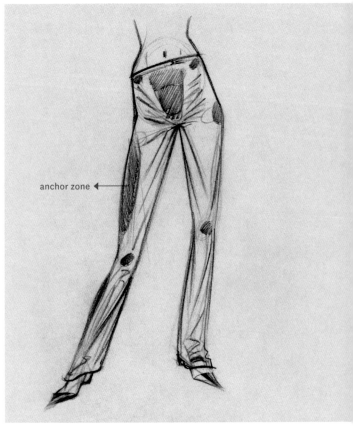

anchor zone ◄

▲ Fig. 202

Fig. 203 ▼

FORCES AND ANCHORS

When a garment comes into contact with the body, it is subjected to three main forces: traction, compression and torsion, which are caused by body movement. So before jumping into the topic of folds and creases we must keep in mind that these are produced by the relationship between forces, material and anchor points. Anchor points have two different origins: some are produced by the volumes in contact with the garment –contacts that vary based on body movement– while others are derived from the structural elements of the garment. Therefore, we have three types of tension, based on the anchors:

A | Between body anchors.
B | Between garment anchors.
C | Between both anchor types.

This does not affect the form of the line representing the traction, but it does help us to understand the meaning and direction of a fold going from one anchor to another (for example from the elbow to the shoulder or armhole in a long sleeve, regardless of whether the garment is a cotton/modal t-shirt, a cotton/polyester shirt or a denim, leather or synthetic jacket).

It is also important to bear in mind the strength of the movement at the body anchors and the rigidity or resistance of the anchors in the garment structure, as the strongest anchors resist forces more and influence the representation of folds and creases.*

Forces involved in the formation of folds in clothes

Three forms of line represent three fundamental forces.
These three types of line represent the three characteristic forces that the garment experiences in different areas according to its arrangement on the body.

* In a coat structure, the folds are suppressed by the force of the garment structure, whereas in a light robe or suit the forces generate a wealth of folds if the fabric is thin and not very resistant to its weight (silk)–that is, if its structure is not self-supporting.

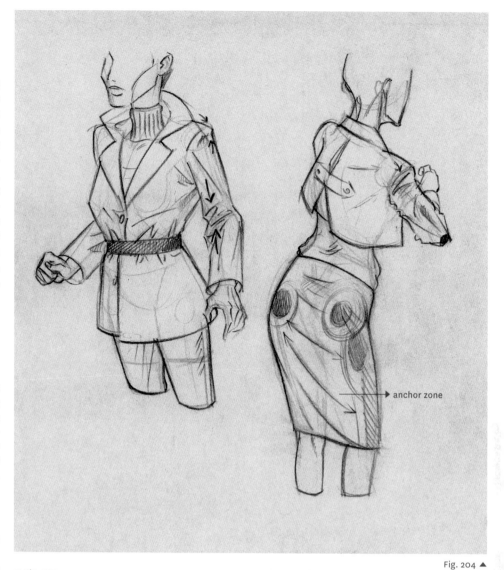

Fig. 204 ▲

▼ Fig. 205

3 basic forms for 3 basic forces

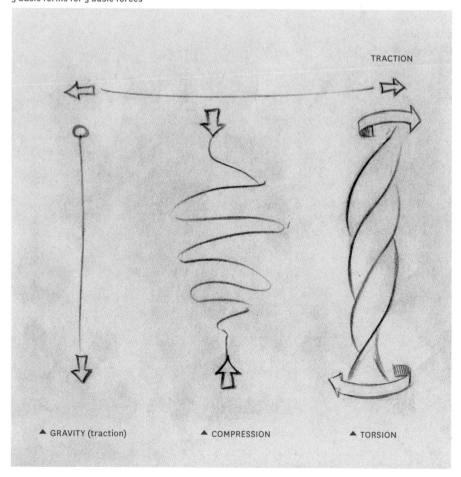

TRACTION

▲ GRAVITY (traction) ▲ COMPRESSION ▲ TORSION

Fig. 206 ▶

Gravity or drape

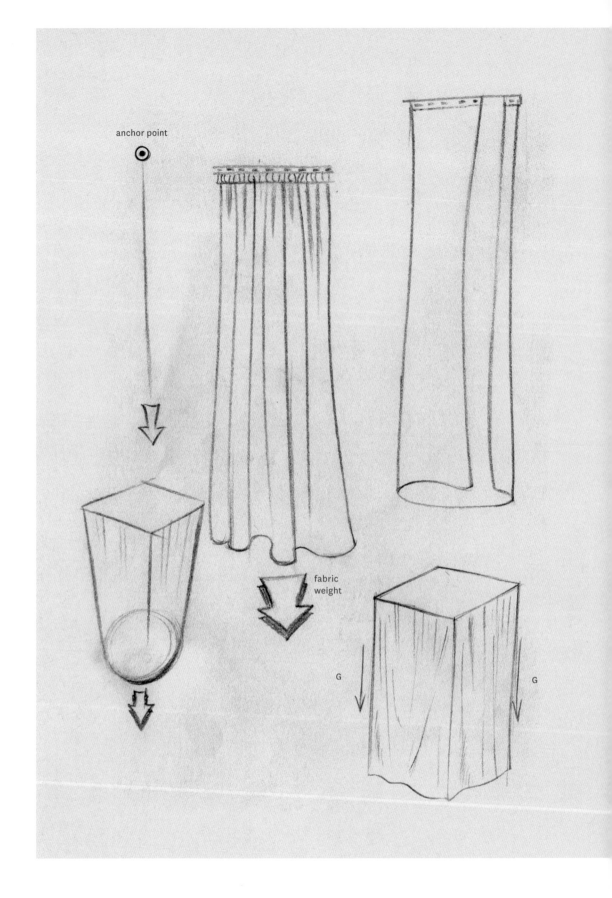

anchor point

fabric weight

G G

Traction from gravity

Gravity creates tension from top to bottom and the line will manifest itself in the fabric to a greater or lesser extent depending on:

A | Its raw material.
B | Its textile structure (leather, vinyl).
C | The specific weight of the fabric.
D | Its mechanical resistance to gravity. (That is, the weight of the fibre(s) that make up the fabric, its yarn, whether it is knitted or woven, and its weave type.)

The drape of a fabric depends on its constitution and expanse; no fabric has the same drape when in the form of a small fragment as it does when in the form of a larger piece.

When we have to draw a material whose weight in relation to its strength is high, we must think of a fabric that is experiencing significant vertical traction, a traction that will manifest itself in continuous vertical lines.

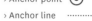
G

139

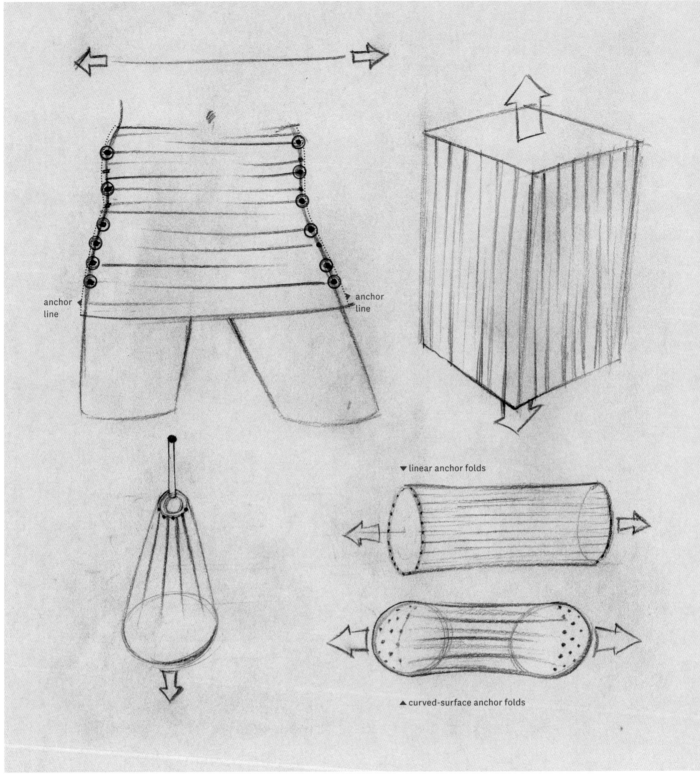

anchor line

anchor line

▼ linear anchor folds

▲ curved-surface anchor folds

Fig. 208 ▲

Traction

Traction

Traction occurs in a garment when the anchor points are separated, resulting in a pulling tension on the fabric. The greater the force, the more pronounced the lines, which also have a greater level of simplicity, almost always forming straight lines, like a fully tautened rope.

The traction line is drawn, in most cases, in a rectilinear direction from one anchor point to another.

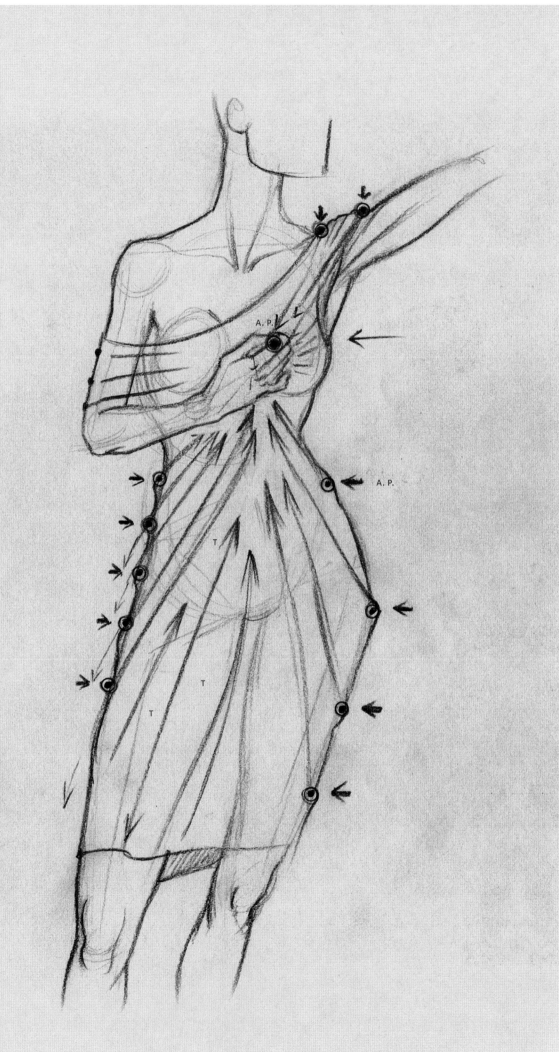

Fig. 210 ▶

Traction + gravity

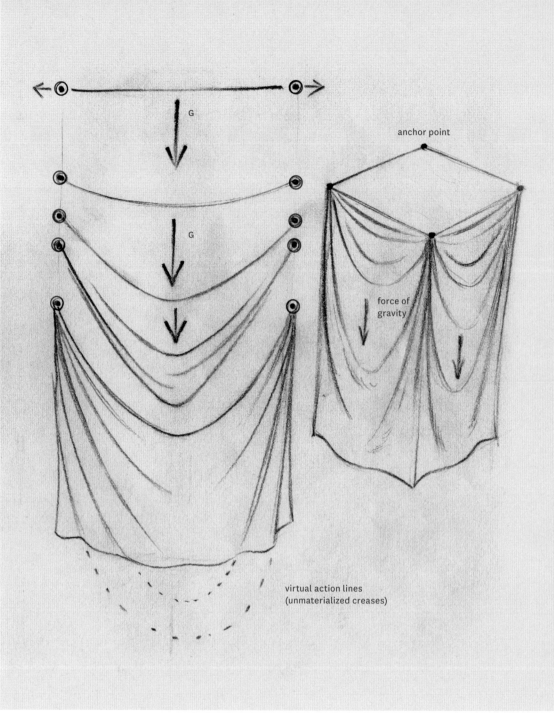

anchor point

force of
gravity

virtual action lines
(unmaterialized creases)

Fig. 211 ▶

Traction and gravit

⊙ › Anchor poin

↓ › Forc

Traction plus gravity

This combination generally occurs when the material behaves as
a bridge between two anchor points between which there is not a
particularly high level of tension. The same straight line that ap-
peared through traction now curves due to the disappearance of
traction as the dominant force and the appearance of the force of
gravity, forming an upward parabola caused by the hanging fabric.

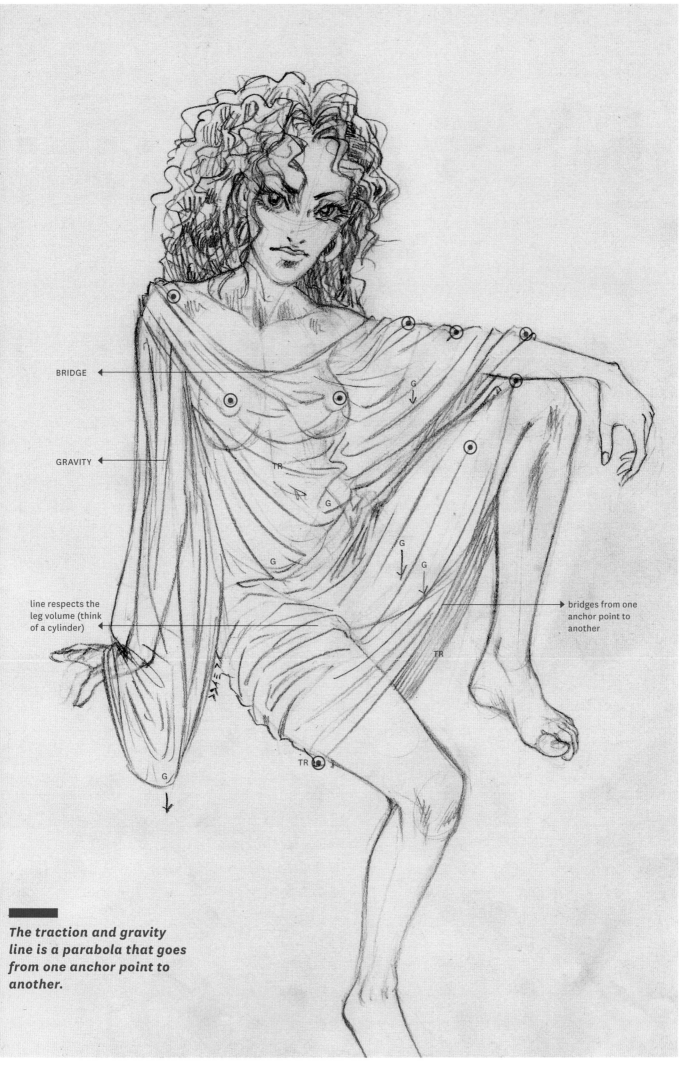

BRIDGE

GRAVITY

TR

G

G

G

G

G

G

line respects the
leg volume (think
of a cylinder)

bridges from one
anchor point to
another

TR

TR

G

*The traction and gravity
line is a parabola that goes
from one anchor point to
another.*

Fig. 212 ▶

Torsion

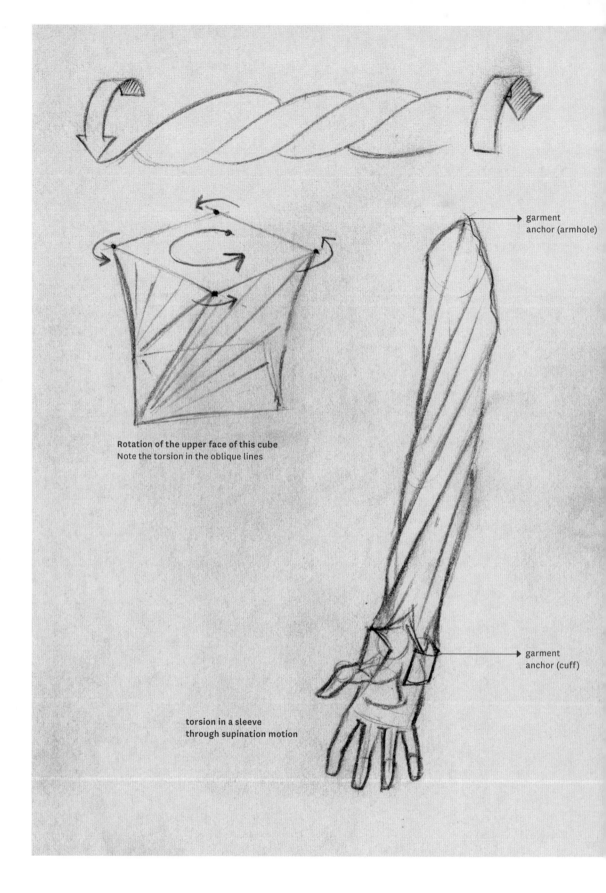

Rotation of the upper face of this cube
Note the torsion in the oblique lines

garment
anchor (armhole)

garment
anchor (cuff)

torsion in a sleeve
through supination motion

Torsion

When anchors turn in opposite ways, as often happens at the arm or waist, a torsion force is produced in the garment. The characteristic way of representing this phenomenon is the use of s-shaped lines which couple with one another to form something that looks like a rope. This is commonly seen in the arm when the forearm turns in supination or pronation (see the relationship with the muscles of the forearm).

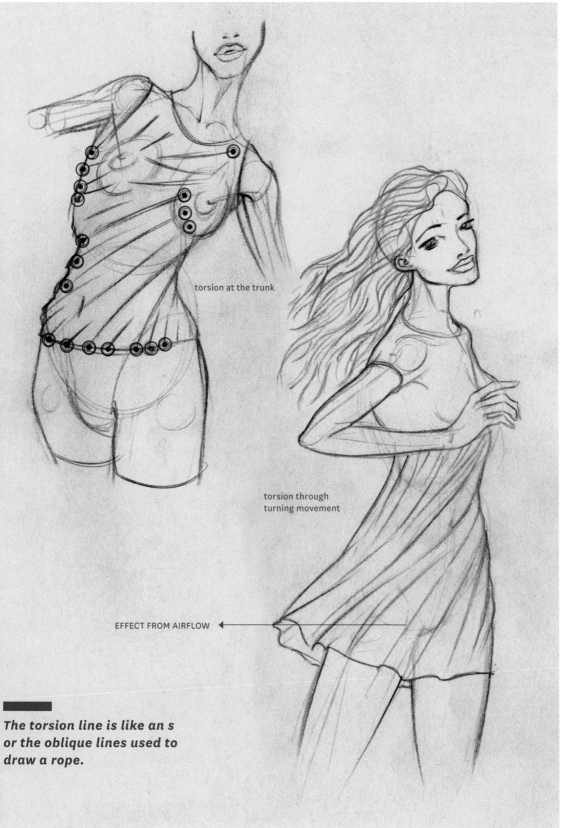

torsion at the trunk

torsion through
turning movement

EFFECT FROM AIRFLOW ←

—

*The torsion line is like an s
or the oblique lines used to
draw a rope.*

Fig. 214 ▶

Compression

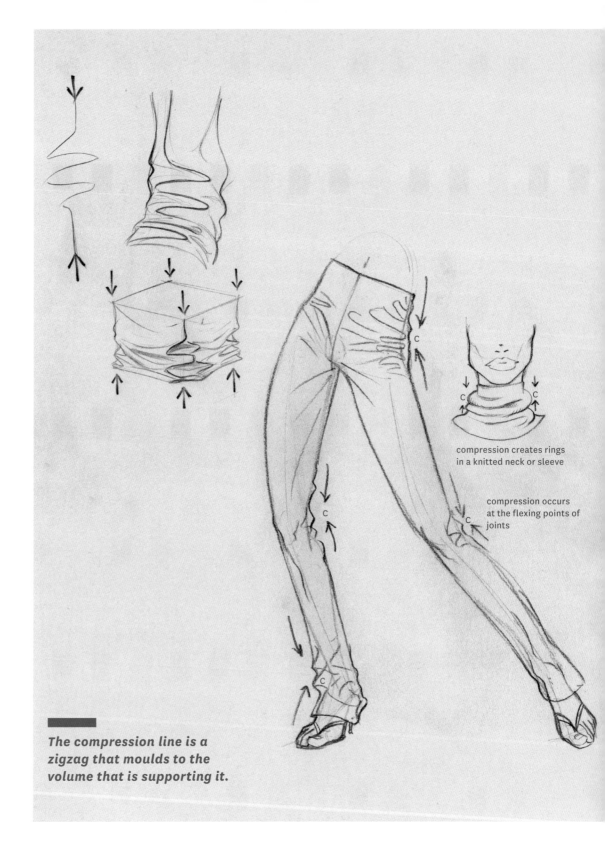

The compression line is a zigzag that moulds to the volume that is supporting it.

compression creates rings in a knitted neck or sleeve

compression occurs at the flexing points of joints

Compression

This happens when volumes come together. The characteristic curve of this phenomenon is the zigzag line, and occurs whenever there is flexing.

Note how in the places where the structure flexes due to the action of the flexor muscles the fabric compresses, while on the other side of the joint the extensor muscles elongate and the fabric experiences traction.

Once you understand these forces well on an individual basis, having observed them in action in magazines and made notes on them in real life (with real models), try to examine and understand combinations of forces in fabrics. Do not try so much to draw the appearance of the garments; rather, try to analyze and understand the logic of the forces. It is not necessary to give definition to the model wearing the clothing; instead give definition to the structure and its folds.

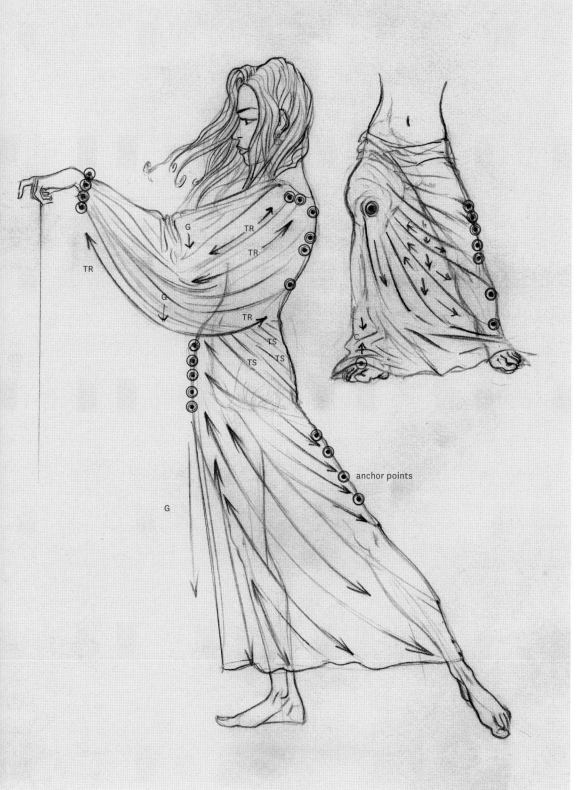

◀ Fig. 215

Compression
G › gravity
TR › traction
TS › torsion
› Anchor point ◉
› Force ↓

anchor points

Combined forces
Observe how different forces combine with one another in the fabric.
Try to discover the logic behind these lines.

Compression in tubular surfaces
If you carry out the experiment of creating a paper tube, placing it on its circular base and then compressing it by hitting it and thus crushing it quickly, you'll notice a pattern of irregular diamonds of different

Practice using photos in which these organizational features of the fold and crease lines can be clearly seen. It is not advisable to use images of clothes that are too complicated to begin with, nor ones of clothes that are very light or dark in colour. Try to select materials that are appropriate for learning the most simple points, gradually progressing to more complex drawings.

sizes when you uncrumple it. This is how shirt sleeves and pant legs compress when around joints.
Obviously, the shape of these diamonds depends on the properties of the fabric and the design of the garment. In some cases they will be more pronounced (woven fabric) and in others they› are more subtly rounded (knitted fabric), and will be larger or smaller depending on the raw material and its elasticity.

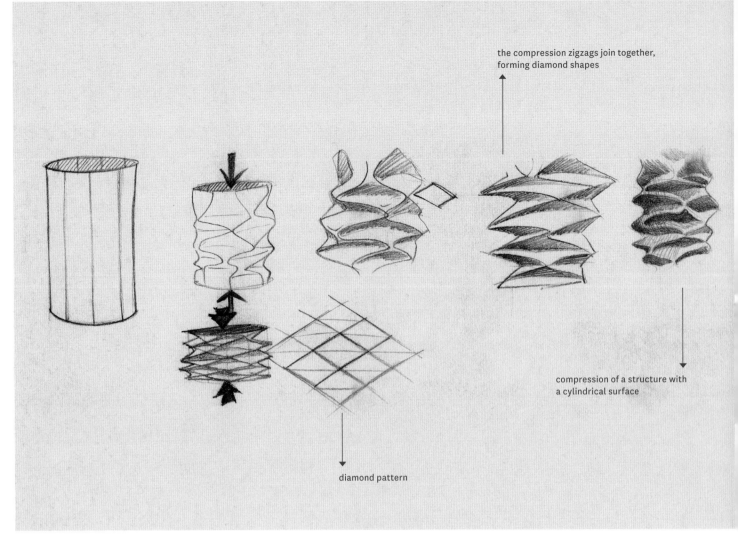

the compression zigzags join together, forming diamond shapes

compression of a structure with a cylindrical surface

diamond pattern

▲ Fig. 216

Compression in tubular surfaces

Material and structural **characteristics** of textiles and lines

Earlier we talked about the paths of the lines representing forces: traction, compression and torsion.

Now we will address the issue of how the physical characteristics of the material affect these paths, since in the representation this issue gives a particular rhythm to the main course of lines that express, for example, gravity, traction or compression. In other words, to the main path a *behaviour* is added that will represent the physical characteristics of the material.

The different lines are characterized by their rhythm, that is, the kind of fluidity with which they develop in space. This characteristic responds in real and material terms to the specific properties of the fibre, yarn, structure, weight and mechanical resistance of the fabric and garment.

Therefore, to draw clothes on a figure in motion, we must understand that a textile is a complex unity of elements that form networks in different dimensions, and each network adds different and relevant information about the ultimate behaviour of the textile to the network. The fibre is a union of cells or molecules in a microscopic network (points), and this network affect the properties of the yarn, but the fibre also has specific structural features (lines) which in turn will affect the properties of the textile (planes), and the fabric will ultimately influence the garment (volume).

It is important that when drawing the designer knows these variables, since they represent information that must be communicated.

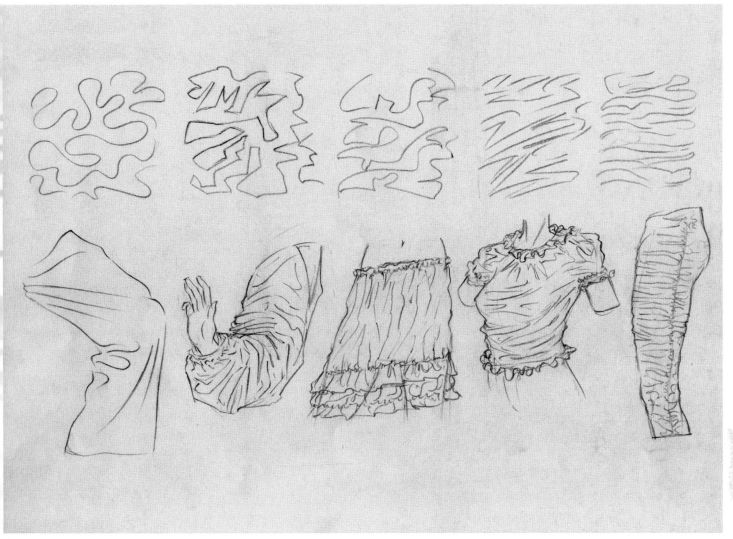

Fig. 217 ▲
Line characteristics ›
fabric properties

The rhythm of the lines expresses the behaviour and characteristics of the material from which the clothes are made.

I will explain information relevant to establishing a relationship between the material properties of the textile and drawing's graphical code.

FIBRE

A textile fibre is a substance that makes up the yarn after being subjected to the relevant processes.
Fibres can be natural, artificial or synthetic.

> **Natural:** Animal products, such as wool or silk; plant products, such as cotton or linen; or mineral products, such as asbestos or glass.

> **Artificial:** Are natural in origin, but after being subjected to processes by which their chemical constitution is changed, can be used to make fibres. For example, cellulose, of vegetable origin, is used in the manufacture of rayon, which is obtained by a physico-chemical processing of the cellulose. Casein and lanital are of animal origin, and fibreglass and metal wire are obviously of mineral origin, to name only the best known examples.

> **Synthetic:** Made from chemical syntheses, through a process called polymerization, which produces polymers, that is, large molecules formed from monomers. These molecules can be linear, forming chains, or volumetric. They are light, strong and elastic. Plastics are the best-known polymers.

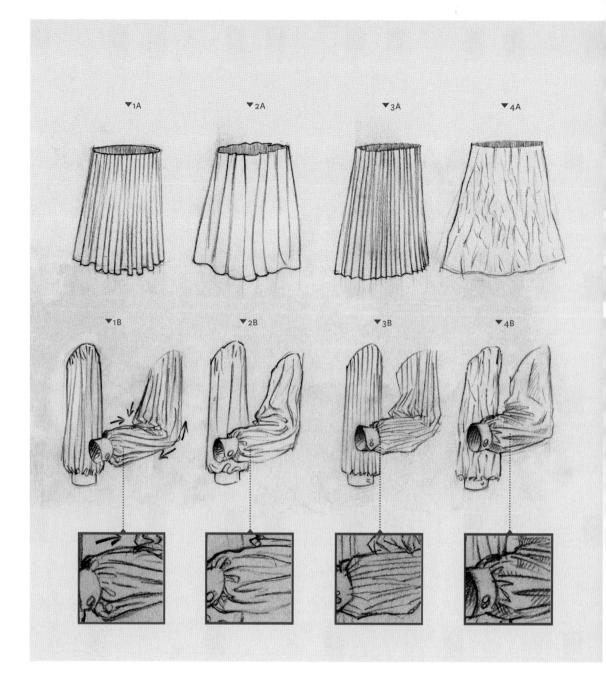

YARN

Fibres in turn form a more complex entity: yarn.

In this new complex form the properties and characteristics of the fibre and the strands contribute to the process of constructing the yarn (spinning) and new possibilities of strength, elasticity, body and thickness, weight, and so forth arise.

Characteristics of yarn include thickness, weight, its raw material, degree of twist, the number of plies that compose it, the texture of the strands that constitute it, the finishing processes that have been applied, and so forth.

FABRIC

The properties of the textile depend on those of the yarn, but, as in the previous case, the properties and behaviour of the yarn contribute to the process of constructing a woven or knitted material. However, not all materials used in the garments are made from yarn. Leather and vinyl, for example, are continuous membranes that are neither woven nor knitted, so the first classification division is between woven/knitted and non-woven/knitted membranes. There is another structural subdivision within the fabric group:

A | Knitted fabrics.
B | Woven fabrics.

Knitted fabrics

These are fabrics made through wales and courses. Basically it is a yarn that forms a fabric through tying. Its main characteristic is the elasticity that comes from its manufacture without the need for elastic fibres (elastomers). These fabrics adapt to the body, revealing its volume; they stretch, producing folds with continuous characteristics and curved rhythms that have no angles, giving a particular style to the design, as well as a wide variety of morphological and structural options. These features need to be translated into the lines in the drawing.

There is also warp (vertical links) and weft (horizontal links) knitting, which differs from the previous type in terms of its structure and technical elements involved. It is slightly stiffer and, therefore, does not adapt so easily to the body. Lace and tricot (warp) and jersey, rib, interlock and morley (weft) form this variety.

Woven fabrics

Composed of warp and weft threads that form an orthogonal network. This type of configuration generates a tight weave of threads that does not allow the freedom of movement that knitted fabrics do. Therefore, the folds are stiff, angular and choppy, and its rigidity increases the higher the density of the fabric's weave is. Its ability to withstand its own weight is much higher than that of knitted fabrics and in many cases it offers greater drape, through this also depends on the textile weight per unit of area.

The type of weave, that is, an alternation in which warp and weft cross, also significantly affects its mechanical and visual behaviour. For example, a twill has special mechanical characteristics that differentiate it from a plain weave.

The textile is determined by the material and structural relationship between fibre, yarn and fabric and, as in the case of spinning, the fabric is modified, corrected and conditioned based on its need, function and demand.

We will bear all this in mind in drawing a dressed figure, in informing the viewer of our drawing, and in giving purpose to this preview of our project.

USE OF LINES TO REPRESENT DIFFERENT FORCES AND FABRICS STRUCTURED USING FOLDS (Fig. 218)

1A | To represent this tapered cloth with a knitted and rather heavy structure, which ends in a pleated hem, discontinuous lines that nevertheless follow a nearly straight path are used. The hem is a sinuous line that is coupled with these lines; or we can make the hem first and then create the lines of the folds in an upward direction from the crests of the hem's sinuous line.

1B | In a sleeve made from a fabric with the same characteristics, the gathers at the shoulder and the cuff have different lines expressing the drape at the shoulders and *bagging* at the cuffs. There are agglomerations of small strokes in the beginning and the end, where the fabric is anchored (that is, the seam forms an anchor line created by the stitches). When the elbow flexes, the tubes produced by its anchors are broken by compression, forming zigzag lines (at the front), and stretch and open through traction (at the back).

2A | In this fabric the gather is less tight; here we are also attempting to draw a fabric that is more self-supporting but of a similar structure.
The more curved lines than those of 1 denote this; they are no longer subjected to the vertical pressures created by gravity.

2B | Now the sleeve behaves as it does in 1, but as there are fewer lines and their curves are broader, once again what we are representing is a knit, though a much thicker one without as much gather.

3A | In a structure with ironed creases and sharp ridges that is regularly pleated the lines are straight and continuous and run down the full length of the skirt, as they represent a fabric structured by its folds. The hem will be zigzagged and regular, forming a serrated edge that can open or close up depending on the movement of the fabric. These lines disappear if the fabric touches the body.

3B | With compression at the elbow these lines break, forming pronounced angles.

4A | Irregular crumpling in a woven, high-strength but fine cloth. The lines behave in an irregular, broken manner and are short, and the hem line is similar. Note the widening downwards, showing the fabric's more self-supporting structure.

4B | This means that the flexing movement (which may be in other places in the body) is represented by the zigzag lines with sharp and pronounced angles.

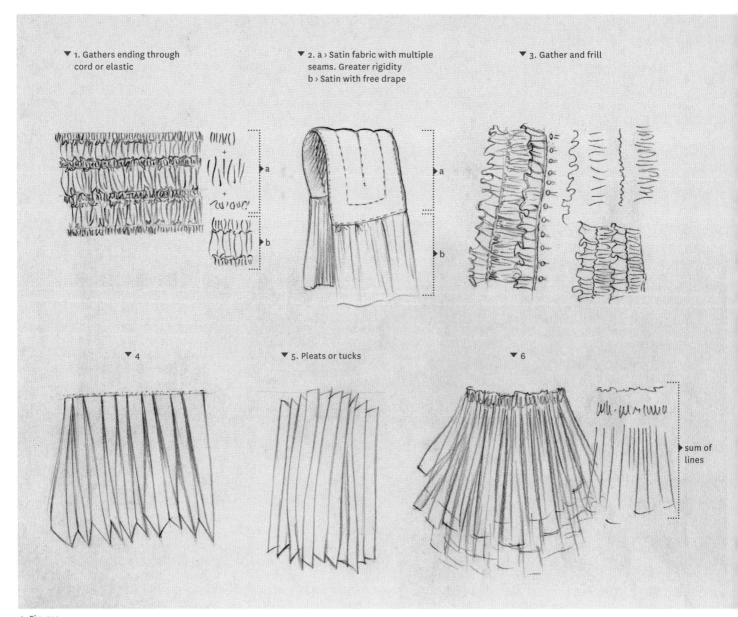

▼ 1. Gathers ending through cord or elastic

▼ 2. a › Satin fabric with multiple seams. Greater rigidity
b › Satin with free drape

▼ 3. Gather and frill

▶ a

▶ b

▼ 4

▼ 5. Pleats or tucks

▼ 6

▶ sum of lines

▲ Fig. 219

1 | Gathers through cord or elastic.
Note the agglomeration of strokes at the parts that represent the elastic.

2 | Panels ending in a pleat. Continuous lines with very little variation denote a structure based on the folding of the fabric. At the top the drawing denotes a fabric structured through seams, and the arcs suggest a filling between the seams (is it padding, material, or something else?); it is clear that it is a rigid form. (Fig. 219/2-a) Conversely, at the bottom the same fabric behaves in a completely different way, showing its structural weakness in the lines of the frills. (Fig. 219/2-b).

3 | A fabric used to create gathers and frills.

4 | Continuous and pronounced lines denote possible ironed and stitched tucks.

5 | Stitched pleats forming strips from satin fabric.

6 | An overlay of transparent materials that is gathered at the top, with a suggestion of box-pleated tulle. An agglomeration of lines creates the effect of transparency, especially when some are stronger than others.

Note in all cases the sum of the different strokes and lines creates illusion and meaning. The decontextualized lines are nothing more than isolated letters that have been shorn of their text and lack meaning. But when we join together these lines for ourselves when we read or draw they can gain a meaning and can *speak*; they can signify something that we understand. This is quite logical, since our brain continually works in this way, constantly contextualizing and interpreting to find meaning without "seeing objectively." As artists we must pay close attention to what our eyes see without the interpretation of our brain, as this will help us to discover how, through lines, we can simulate an effect that is similar to reality.

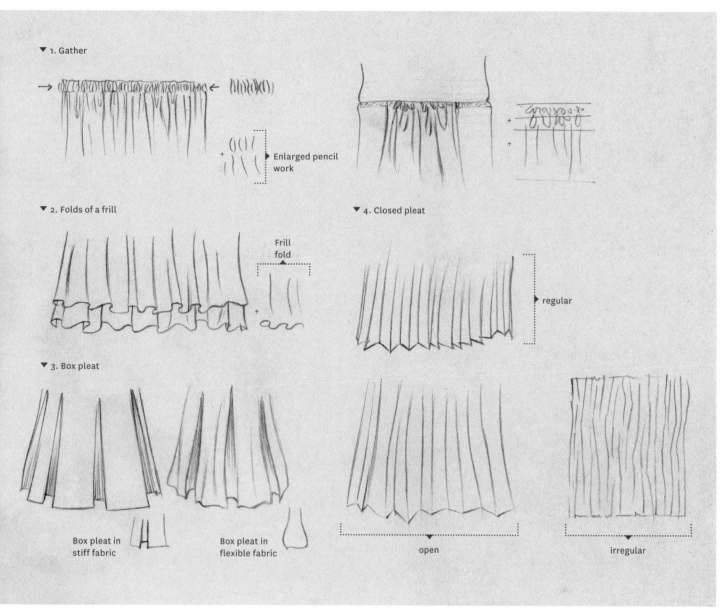

▼ 1. Gather

▶ Enlarged pencil work

▼ 2. Folds of a frill

Frill fold

▼ 3. Box pleat

Box pleat in stiff fabric

Box pleat in flexible fabric

▼ 4. Closed pleat

▶ regular

open

irregular

Fig. 220 ▲

1 | Gather (Fig. 220)

Start at the top with short lines that are continuous and quite grouped together to give the feeling of compression from the fabric being wrapped round the elastic; also try out representing it with a discontinuous, tight zigzag.

To this pencil work we add underneath another succession of lines that are similar (since it is the same fabric) but longer, and are also more widely spaced and ultimately long and separated.

2 | Folds of a frill

A section is formed by lines representing gravity according to the weight and strength of the fabric. The other section that defines the hem is created with a wavy line.

3 | Box pleats

Note that the same drawing technique can be interpreted very differently depending on the characteristics of the lines: the picture on the left appears to be a cloth that behaves rigidly due to its technical composition, while the right one suggests a flexible fabric. In any case, the folding of the box pleats keeps the same continuity at the edge; the pleats are not as straight in the second but are equally well defined.

4 | Closed pleat

This pleat is drawn in much the same way as the box pleat. As a result of the structure of its folds, its lower edge is serrated, as we have already seen.

In contrast, an unfolded pleat (for example, due to the wind) can be represented by lines that get lost as their path develops.

153

Fig. 221 ▶

Sum of lines used
for representing the
garment on the body

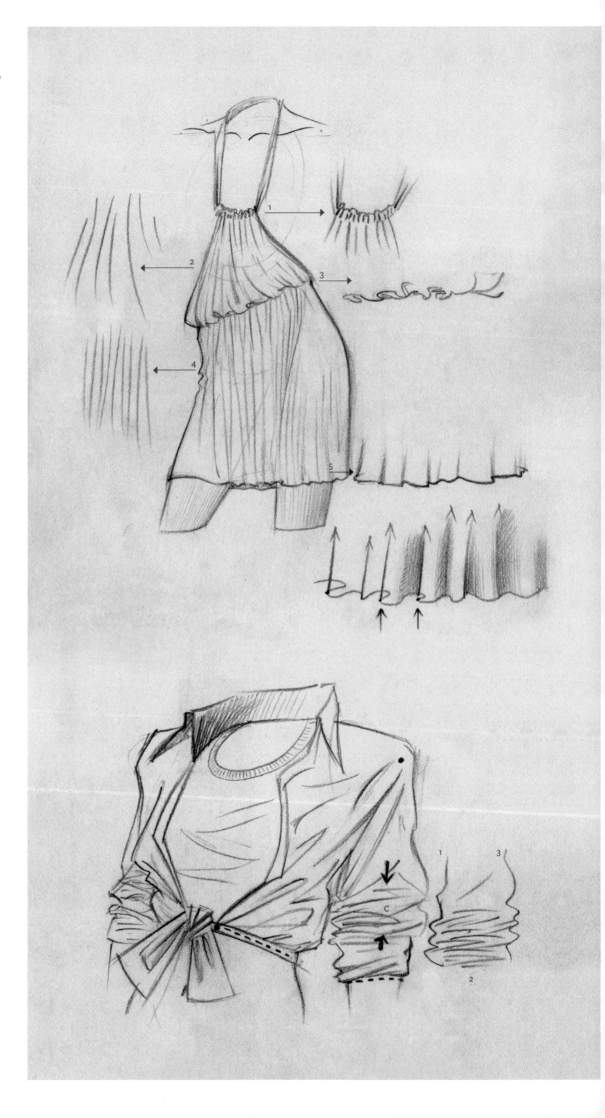

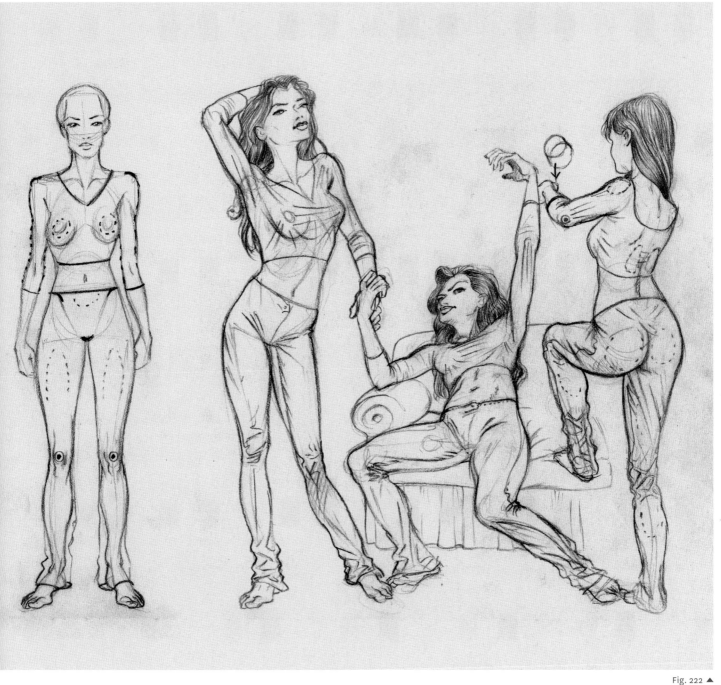

Fig. 222 ▲

The same approach is applied to the entire garment, taking into account its tensions and construction.
Observe the lines in different parts of its representation or preview. Look at the finishing of the hem; the lines that join the sinuous curve rise from the crests and cover part of the curve.

Practice the strokes that represent the behaviour of the material on a separate sheet of paper, and not on the figure. When you have decided that these strokes or lines correspond to what you want to convey, apply them to the figure. This way you will avoid ruining the drawing and you will work more productively. After a lot of practice aimed at acquiring a mastery of line use, study photographs of haute couture garments that allow you to discover different techniques for the

representation of your figure.
Having practiced your lines, it's time to combine all of these techniques in a figure.
Practice different poses, paying close attention to finding the location of body and garment anchor points, and traction, compression and torsion lines, as well as line types and complex areas.

Fig. 223 ▶

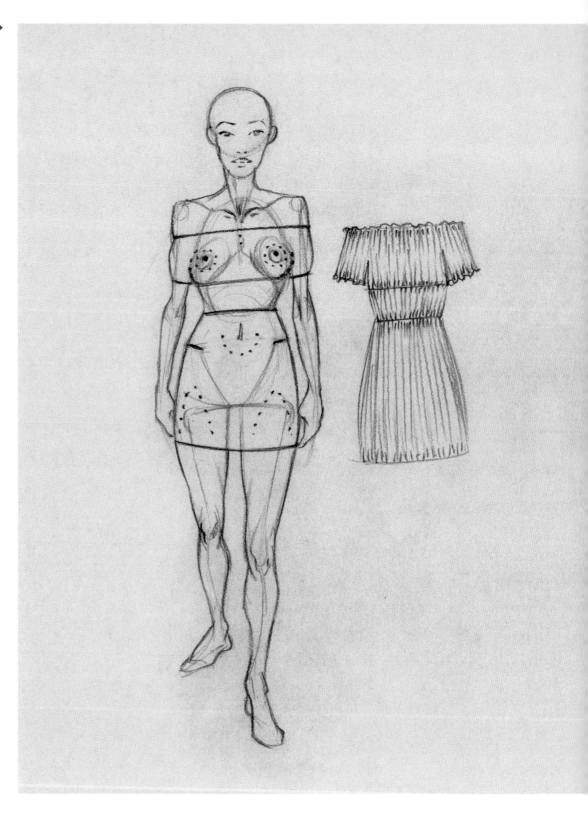

This is an exercise in integration of knowledge, as before, but with a slightly greater degree of difficulty due to the appearance of techniques related to clothing that seem to be more complex. You will find that is not more difficult just because there are more lines.

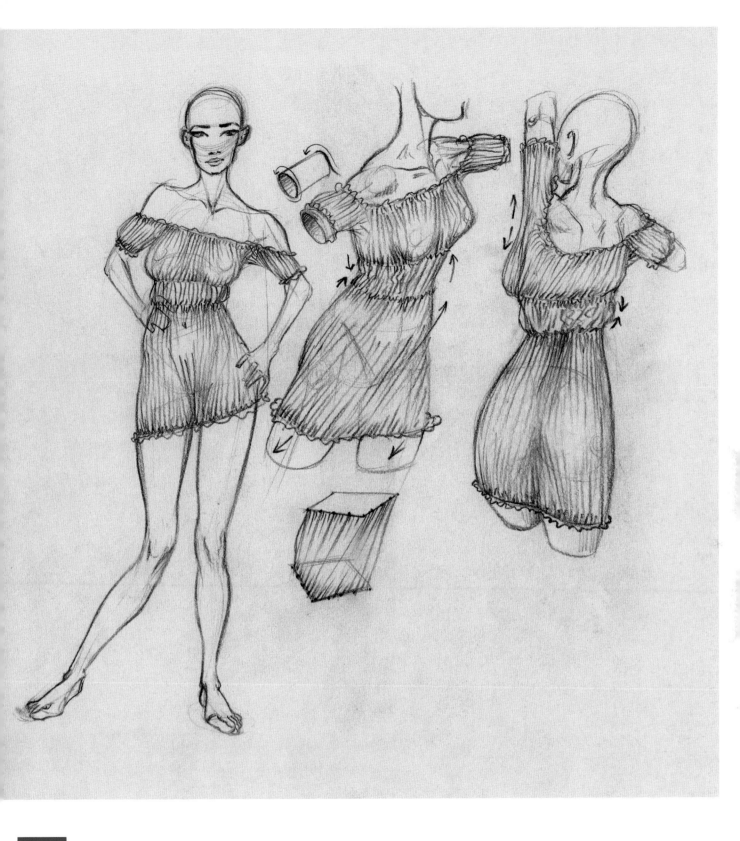

**Do not forget to imagine
and rationalize the drawing
you are producing as
if it were subjected to
real volumes, forces and
materials.**

Fig. 224 ▶

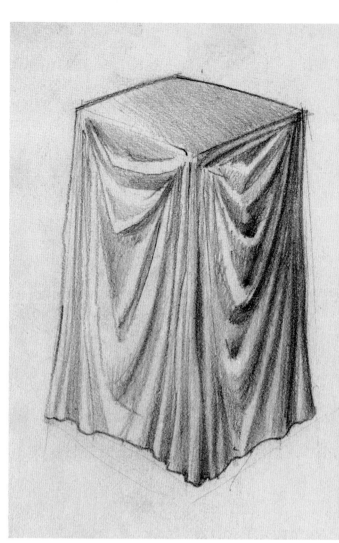

Different rigidities of a fabric and its representations, with values of light and shadow that add the illusion of lighting.
Note the relationship between the trimmed lines and the well-defined planes in the fabrics that indicate greater rigidity.

Fig. 225

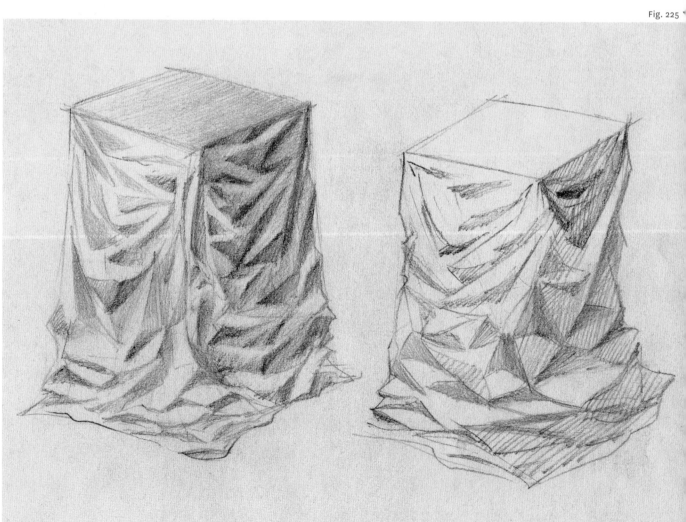

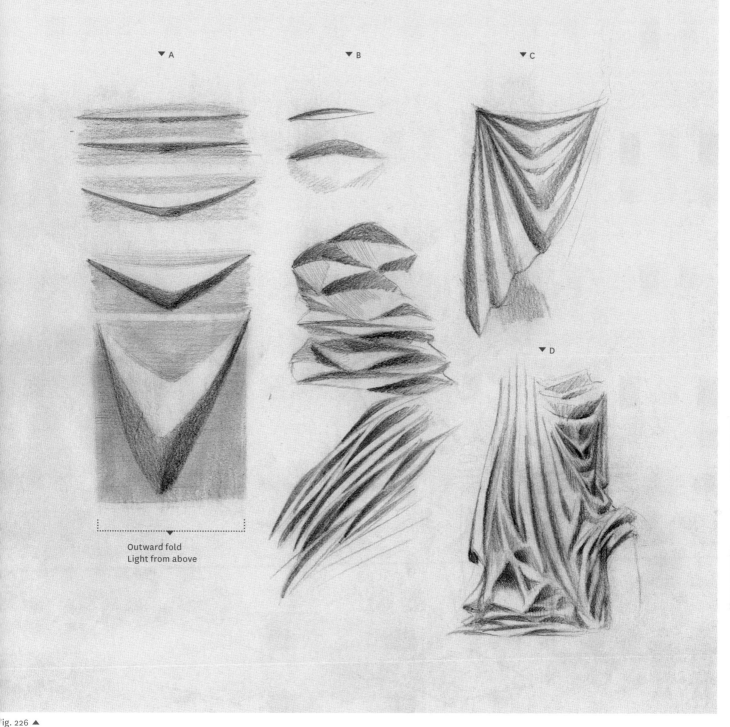

A | Outward fold
Light from above

Fig. 226 ▲

Plane forces

CHIAROSCURO IN FOLDS

Creases and folds in fabric also have a volume to them. Earlier in this chapter we only discussed the linear representation of a fold, and the devices and rationale for drawing them; the volume can be represented using planes with a variable or uniform value (shades of grey).

A | Traction in a fabric provides a convex or concave surface, depending on the point from where you look at it, forming a tubular configuration–with two vertices at the traction points–that arcs downwards due to the action of gravity. If the light goes in a vertical direction from above to below, it will illuminate the upward face of the fold (in the case of a convex surface, that facing outward).

B | Compression in a fabric causes it to curve inward concavely, as a result of which what we see is an irregular diamond that under the same lighting is illuminated in the opposite way to the previous case, with the light downward and the shadow upward. These rhombuses are irregular and may have different configurations depending on the characteristics of the material that the lines represent.

C | Light from top to bottom and from right to left in folds due to traction and gravity.

D | Frontal light from above.

Fig. 227 ▶

Shadows in frills and folds

1› compressed fabric, linear shadow

2› looser fabric, shadow as wide and soft line

3› loose fabric, shadow as plane with light and shadow value close to that of the fabric and with a gentle gradient

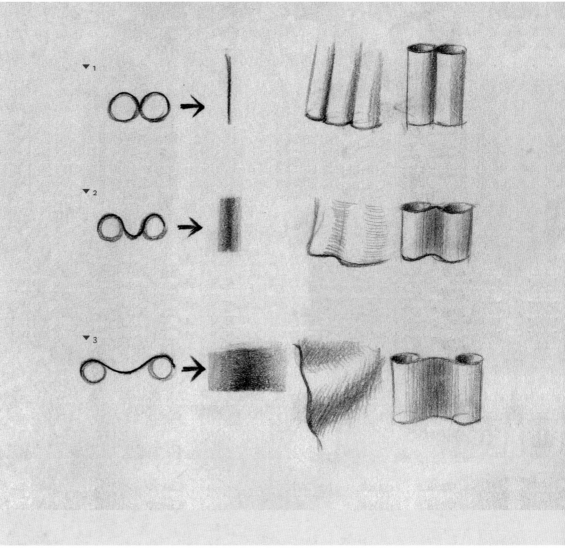

Fig. 228 ▶

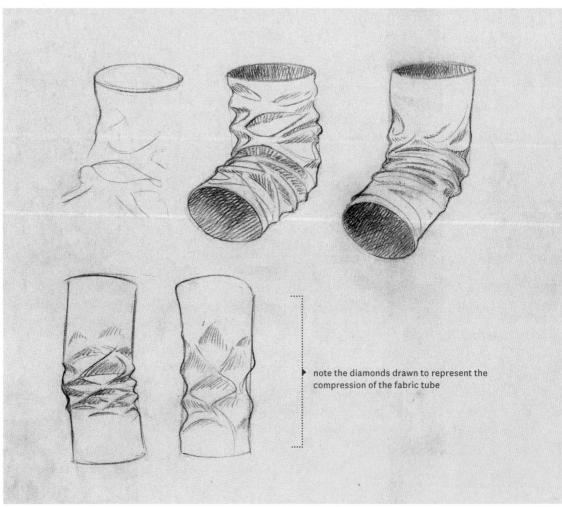

note the diamonds drawn to represent the compression of the fabric tube

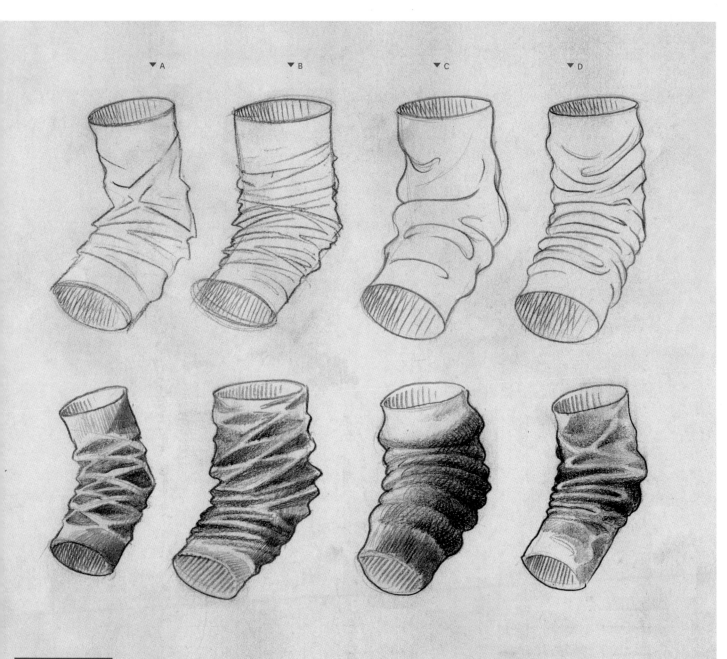

Combine folds with consecutive cylinders and shade them accordingly; note how the shadow is increasingly soft in relation to the opening of the curves.

Fig. 229 ▲

Lines becoming planes:
The same lines in greater quantity.
Changes in the thickness or strength of the fabric.

In these drawings we can see two important things:

1 | That a lower number of lines of the same type is interpreted as a thinner version of the same fabric that is therefore weaker. That is, if we want to suggest a difference in thickness, we have to reduce or increase the number of lines but not their rhythm. By doing this we do not change the material characteristics of the fabric, but only its thickness.

2 | In representing fabrics with light and shadow values that simulate lighting, the value planes will follow the lead of the lines that create the fold, meaning that planes with a well-defined outline and clear edges correspond to rigid lines, while gradated planes with less-defined edges correspond to sinuous and continuous lines.

Signs are interpreted in many ways (polysemy), and a drawing is also a type of sign. When drawing the behaviour of fabric we delimit this polysemy for clear communication, but you can not override the various interpretations that the viewer can make.

A | Moderately thick woven fabric.
B | Thin woven fabric.
C | Thick knitted fabric.
D | Thinner knitted fabric.

161

Fig. 230 ▶

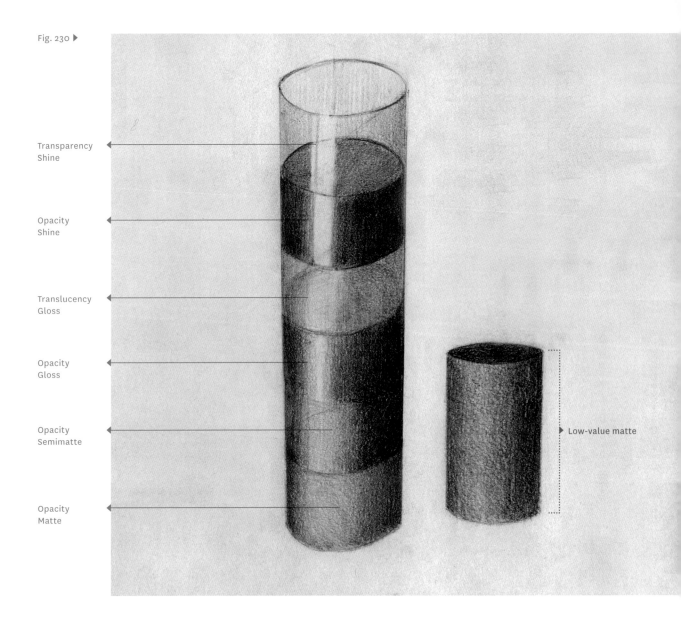

Transparency
Shine

Opacity
Shine

Translucency
Gloss

Opacity
Gloss

Opacity
Semimatte

Opacity
Matte

Low-value matte

APPEARANCE OF MATERIALS

We will term "appearance" the visual properties that an object has in relation to light, without taking into account the phenomenon of colour, which has a complexity that exceeds the aim of this book.

Therefore, we will consider:

A | Transparency or **opacity**.
B | Translucency.
C | Shine.
D | Brightness or **value**.

Every material behaves differently under light and our eyes perceive this behaviour as a particular sensory reaction. What we will attempt to do here is to simulate the appearance of a material with our visual resources, essentially using graphite pencil. The goal is once again to link visual sensory reactions with visual resources that allow us to recreate a real situation without it *existing* (we might think of drawing as a sort of dream).

Let us briefly look at the different characteristics of appearance:

Transparency

A material or object is transparent if it allows light to pass through it. Transparency comes about through the nature of the material or because, in a knitted item, for example, the threads separate, allowing light to pass through.
Examples of transparency are air, glass, water, some plastics, netting, and so forth.

Opacity

Unlike transparency, opacity is the property of a material or article that is *impermeable* to light.
For example, wood, iron, closed or very compact netting, and so forth.

Translucency

The translucency of a material or object relates to the irregular passage of light through it; it is *permeable*, but in an irregular or diffuse way, and does not allow you to clearly see an object placed behind it –as do transparent materials or objects– though it does not prevent you from seeing it –as does an opaque item.
Examples of translucent items are alabaster, very thin marble slabs and other minerals like jade, white polycarbonate used in advertising displays, and so forth.

Shine

A material or an object's surface is shiny when it reflects the light that hits its surface regularly or without scattering. There are materials which themselves are shiny such as mica, and others that can be shined through resources for their surface finish such as buffing, as well as polish or varnish, which achieve the same result but by adding another material that fills the porosity of the surface of the object being polished, or that covers it with a shiny material in the case of varnish.
The opposite of shine is matte, and there is a gradation from very shiny materials to matte ones:
metal, enamel, glass, resin, pearl, gloss, wax, oil, water, horn, earth, and so on.
If we can represent such phenomena we can give the illusion of the material in our drawings just by representing its visual appearance.

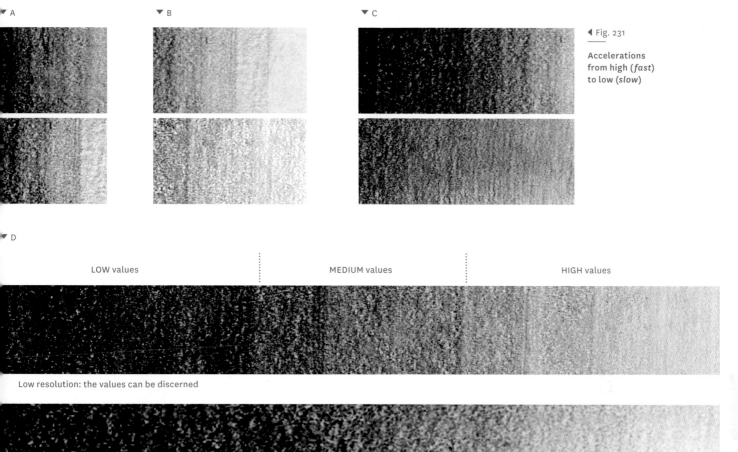

▼ A ▼ B ▼ C

◀ Fig. 231

Accelerations
from high (*fast*)
to low (*slow*)

▼ D

LOW values MEDIUM values HIGH values

Low resolution: the values can be discerned

High resolution: the change in values is less easy to perceive

Let's clarify some technical concepts that we will use in our work.

VALUE

The degree of brightness a colour possesses.

When a great amount of light is reflected by the object we see high values, and low values when there is less light, with there also being intermediate values between these points.

RESOLUTION

Resolution is the technical ability to express the quantity and quality of colour and value. It is linked with the concept of resolution in printing, photography and digital imaging, and other means of image reproduction.

In drawing, resolution is achieved by the skill of the artist with a particular technology and the combination of pigment, medium and instrument.

VALUE ACCELERATION

This is a concept from physics applied to drawing and representation.

Acceleration is the progression of speed that an object can develop within a given distance or time, and a high acceleration has an inverse relationship between maximum speed and minimum distance or time, and vice versa; in drawing, acceleration is the progression (or gradation) of values within a given distance. Maximum acceleration is when values change in short stretches and minimum acceleration is when values change in very long stretches. The quantity of values in the gradation depends on the resolution. These gradients and accelerations can span the entire range of values between black and white, joining them together as a progression; or there is also the possibility that gradations manifest themselves within this range without actually reaching all of the values (high, medium or low gradations).

CONTRAST

In representation, this is the difference of values within an illuminated object. Contrast indicates the amount and type of lighting, as well as its material or apparent look.

This difference can be very noticeable–in which case we talk about a "high contrast" –or very subtle– "low contrast" –with "medium contrast" being located in between the two.

It must be pointed out that low-resolution techniques do not allow us to easily work with low accelerations.

Shine is related to the surface finish of the object and its reflection of light.

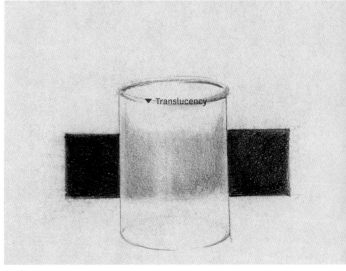

▲ Fig. 232

Fig. 233 ▼

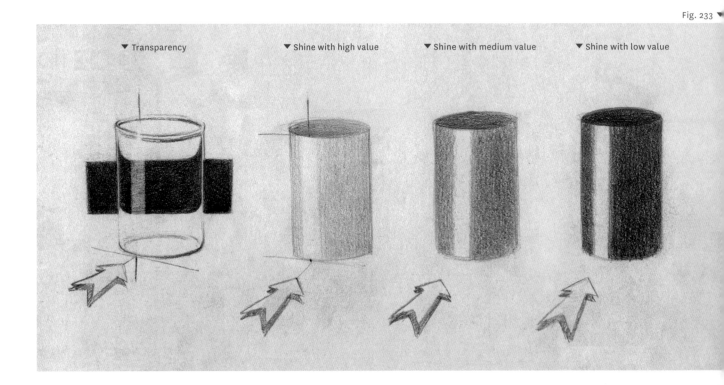

▼ Transparency ▼ Shine with high value ▼ Shine with medium value ▼ Shine with low value

Now, the problem we face is linking visual language with the visual properties of the materials to build a simple representational code.

Representing shine

Objects with a very smooth, specular finish, such as chrome, have a very pronounced contrast because light is reflected without being dispersed. Therefore, the value acceleration is maximum, that is, there are no intermediate values between the highest and the lowest, with the two being placed next to each other.

Matte objects

Because of their homogeneous and dispersive reflection, objects with a matte appearance do not have a pronounced contrast, as a result of which they have very subtle gradients with low acceleration, so that in extreme cases their surface is only expressed as a uniform value.

Glossy

As we decrease the value acceleration, increasing the resolution of our technique and decreasing the contrast, we achieve intermediate levels of shine, that is, different material qualities, from shiny materials or objects to matte ones.

Matte materials or surfaces exhibit a low and regular level of reflection of the light that hits them.

Broadly speaking, in the textile field shiny materials such as metal are, for example, meshes made from silvery metallic thread and sequins; vitreous ones are smooth patent leather or vinyl; satin ones are silk and other artificial fabrics; waxy ones are mercerized cotton; and finally matte ones are cotton, velvet and suede. We might informally say that transparency and opacity are internal characteristics of the material or object, while shine and matte are properties of their surface, and that the perceived behaviour of the material in response to light gives us an idea of the material properties of the object.

▼ A

▼ C

▼ B

▼ D

Fig. 235 ▶

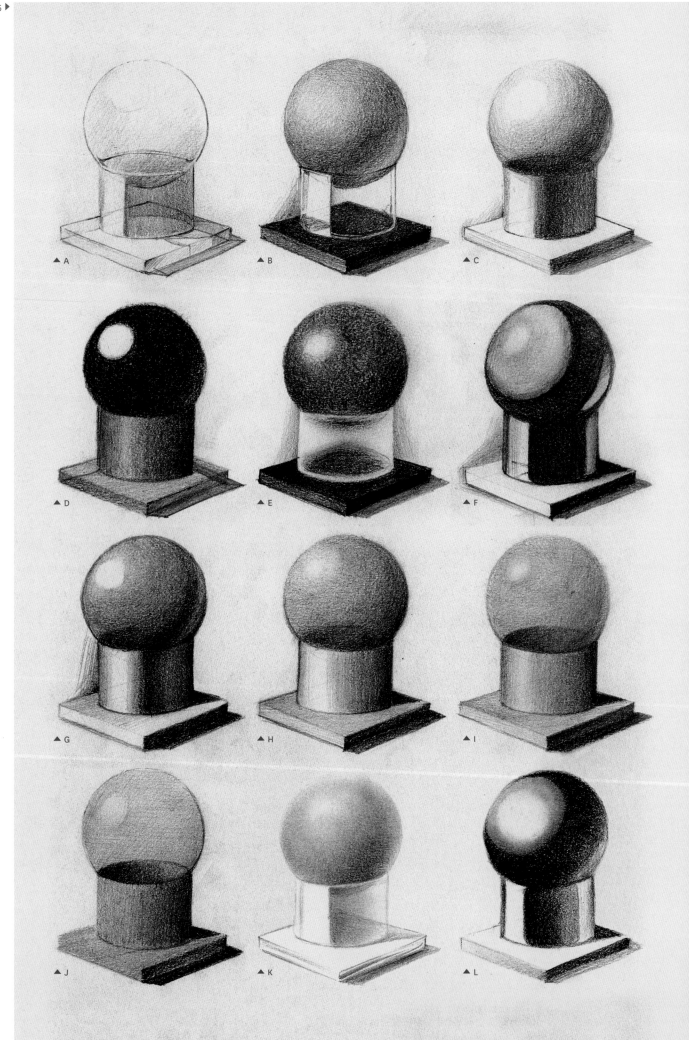

▲ A ▲ B ▲ C

▲ D ▲ E ▲ F

▲ G ▲ H ▲ I

▲ J ▲ K ▲ L

It is important to understand that what you see is not what you think it is, but simply tricks of the pencil.

Here are some examples to illustrate these concepts.

A | **Base**: transparent, a characteristic represented in the drawing by the internal construction of the block.
Cylinder: transparent and shiny coloured glass, the effect of which is created by the delineation of the base block in the area occupied by the cylinder, except for the white part of the surface, which simulates shine; the colour comes from the incorporation of a lower value than that of the context (homogeneous white).
Sphere: transparent and matte, through the delineation of the cylinder within the circle area of the sphere, which has no shine.

B | **Base**: opaque, matte and dark. Represented by the low values that cover the construction of the drawn volume.
Cylinder: transparent and shiny, simulated by the white surface for reflection and the black area for transparency.
Sphere: semimatte, oily-type shine, created by acceleration from white low to grey high, low-value base and use of high resolution.

C | **Base**: white, opaque and matte, shaded strips at edges.
Cylinder: opaque, glossy shine, created by high contrast, high value acceleration and increased resolution.
Sphere: transparent and glossy, an effect created by a medium contrast, medium acceleration and shading in the area corresponding to the cylinder.

D | **Base**: transparent, coloured and matte. Use of low-contrast values and medium values for shade; the structure of the block has been drawn.
Cylinder: semimatte shine. The values used in this gradient are low, medium and high, with average acceleration in medium to low contrast.
Sphere: dark, shiny and opaque. Low value and very high acceleration for the light and low acceleration for the reflected light.

E | **Base**: same as in B.
Cylinder: colourless and translucent. The effect is achieved from the softening at the edges of the areas belonging to the other bodies, blurring the base and sphere within the cylinder area.
Sphere: shiny with coarse surface. Surface texturing and high acceleration of high and medium values.

F | **Base**: shiny, opaque and light.
Cylinder: shiny, opaque and dark.
Sphere: shiny, opaque and dark.

G to J | Gradual increase in the transparency of the sphere while maintaining the same shine.

K | **Base**: smooth and shiny (although without reflection). Representation through contrast.
Cylinder: bright and transparent and somewhat translucent. White shine, pronounced contrast, visibility of background lines and continuity of the other objects.
Sphere: semimatte and opaque. Gradient with very high resolution and low acceleration of tone.

L | **Base**: semishiny (smooth, brushed surface). High contrast.
Cylinder: dark and shiny like the sphere. Representation through high contrast and predominance of low values.

167

▲ Fig. 236

Textures and pencil work

The term pencil work refers here to grouped strokes that make up a sense of visual texture and evoke a possible tactile association.

Generally we use our pencil unconsciously, without realizing the enormous and varied possibilities of strokes and effects we can get from it; to discover them it would be a good idea for us to dwell on the variables that the pencil offers.

› **From pressure:** rapid pencil strokes create a difference in pressure between their beginning and end, with greater intensity in the beginning that tapers as the line progresses towards the end.

With greater control the effect can be varied. We can make strokes that begin gently and end strongly, or that vary in intensity in a regular or irregular way over the path of the stroke.

› **From shape:** we always use a pencil with a sharp tip and get the same regular line. If we vary the tip we see that the line is modulated and produces thick and fine strokes according to the position of the pencil.

› **From hardness:** we can vary the intensity of the stroke or the pencil work if we use pencils of different hardness. Pencil work with a high value is obtained with hard pencils (HB); medium value from medium pencils (2, 3, 4B), and low value from softer pencils (5, 6, 8B). We can also experiment with different effects using various types of grease pencils or chalk.

› **From grip:** holding a pencil with all five fingers results in thicker strokes without having to vary the tip; there are many other ways to hold a pencil, and each one provides different visual possibilities.

▲ Fig. 237

Everything said here can be applied to other forms of visual representation; we are learning to use the resources of graphite pencils, but we can learn the artistic possibilities of other techniques, though we must always take into account the differences between each medium. Techniques requiring an applicator tool, a pigment with a base (watercolours, acrylics, oils) and a support medium obviously provide more alternatives; but, in short, exploration, practice and reflection on each technique will greatly help us to grow.

You can use a pencil in many different ways to find new ways to simulate effects.

▲ Fig. 238

Pencil work for texture

There are enormous possibilities for systematic variation in pencil work, as you'll discover when you start to play methodically with pencil and paper.

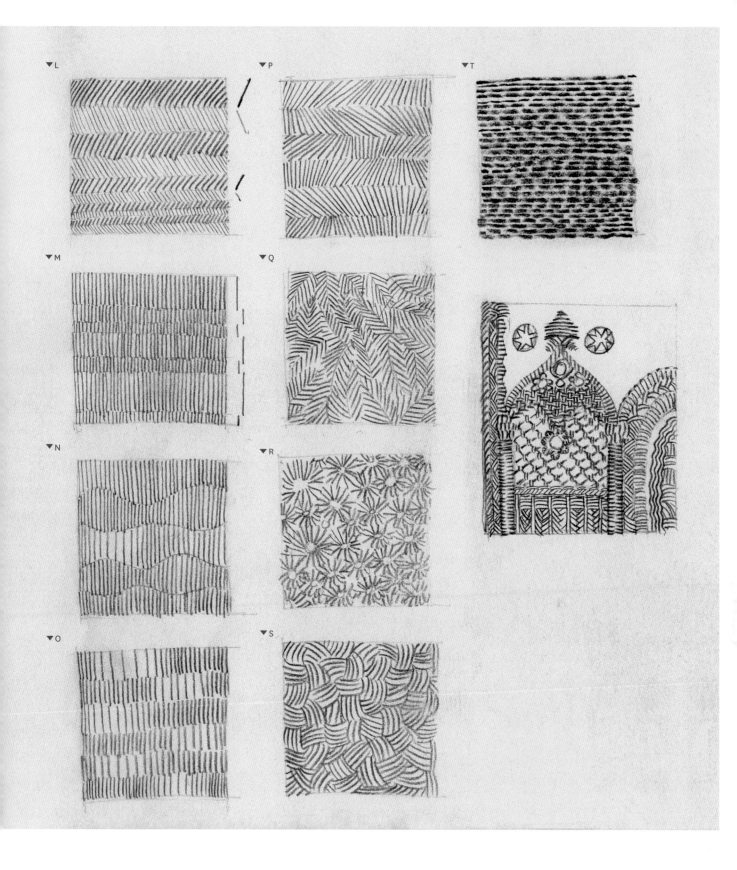

Let's consider the morphological variations in pencil work in these examples.

A | Regular pencil work with no pressure change.
B | Regular with pressure variation.
C | Regular with pressure variation and reversal of direction.
D | Regular with no pressure variation and variation in size.
E | Regular, constant pressure and variation in position.
F | Regular, variation in pressure and position.
G | Regular with variation in tip.
H | Regular, with variation in shape and position.
I | Irregular with variation in size and intensity.
J | Overlay of pencil work in layers.
K | Alternating rows varying position.

L | Alternating rows varying position.
M | Variation in scales by rows.
N | Regular stroke with irregular sections.
O | Variation in position and size of the pencil work by rows. Irregular sections.
P | Regular sections, gradual variation in position.
Q | "Fishbone," irregular sections.
R | Centripetal strokes in irregular sections of points.
S | Constant intensity, variable shape, size and position.
T | Horizontal lines with pressure variation.

Fig. 239 ▶

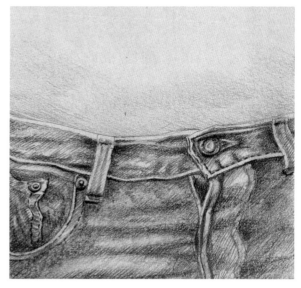

Fig. 240 ▶

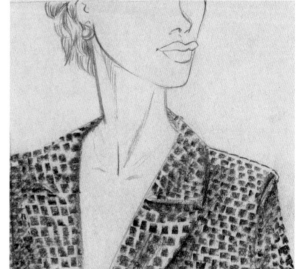

Simulating texture with pencil work

Note that despite producing a complex result, the strokes used in pencil work are simple. And that's the idea: to create effect, the illusion of material properties, through only the arrangement of lines.

Pencil work is reinforced with the addition of chiaroscuro, which adds a sense of volume.

Fig. 241 ▶

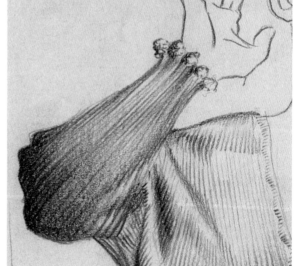

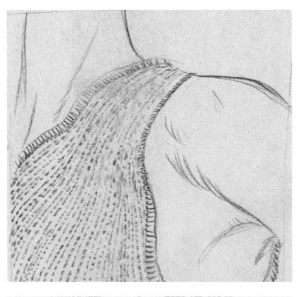

◀ Fig. 242

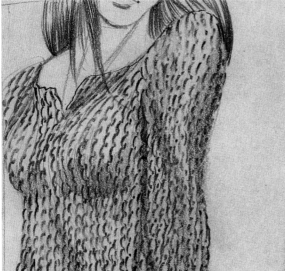

◀ Fig. 243

◀ Fig. 244

*The lines overlap so
that they synthesize the
visual effect of the actual
texture.*

We will now see a selection of finished figures,
with the incorporation of poses, attitude,
characterization, styling, material properties,
techniques, and so forth.

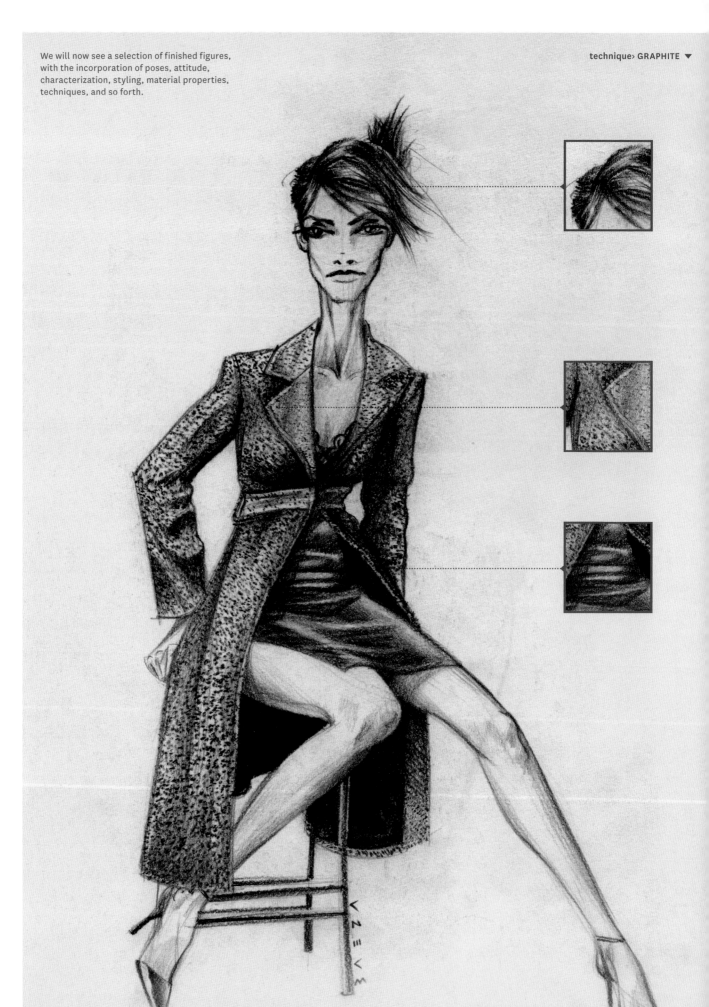

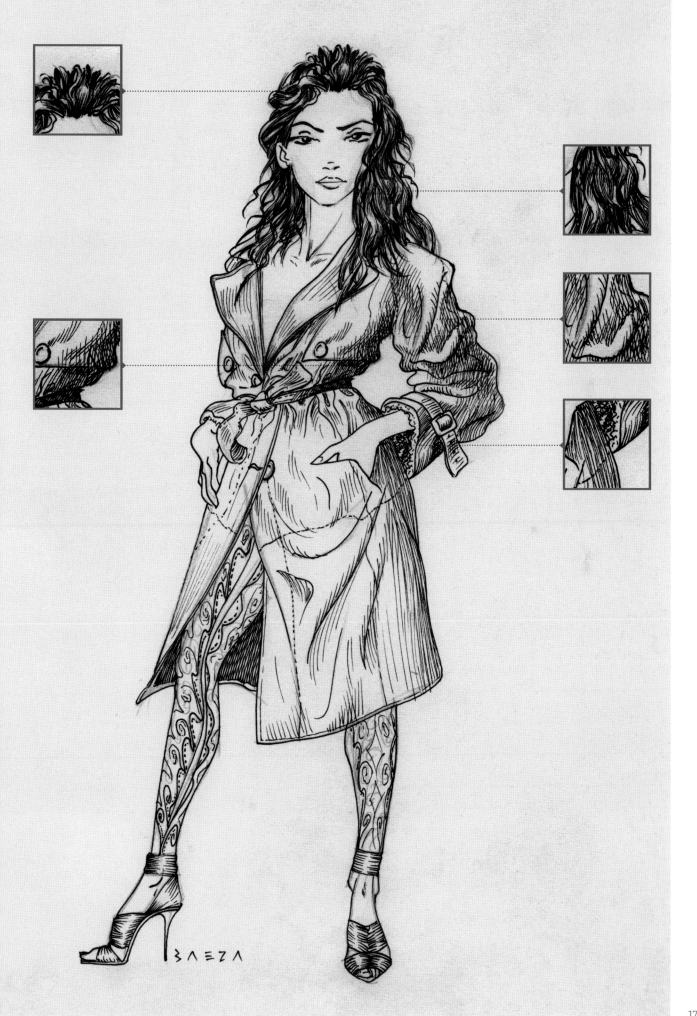

Regular and modulated line,
caricatured styling, synthesis
of lines and regular planes

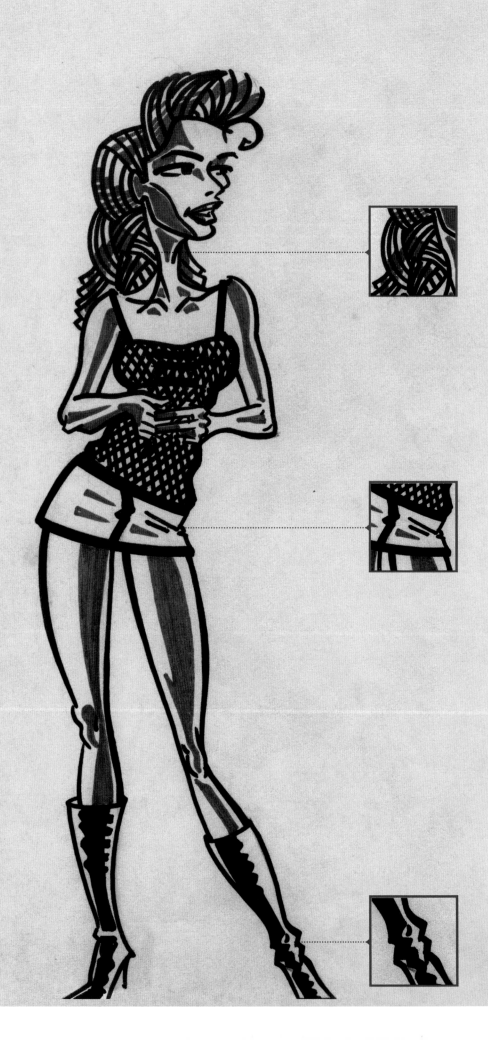

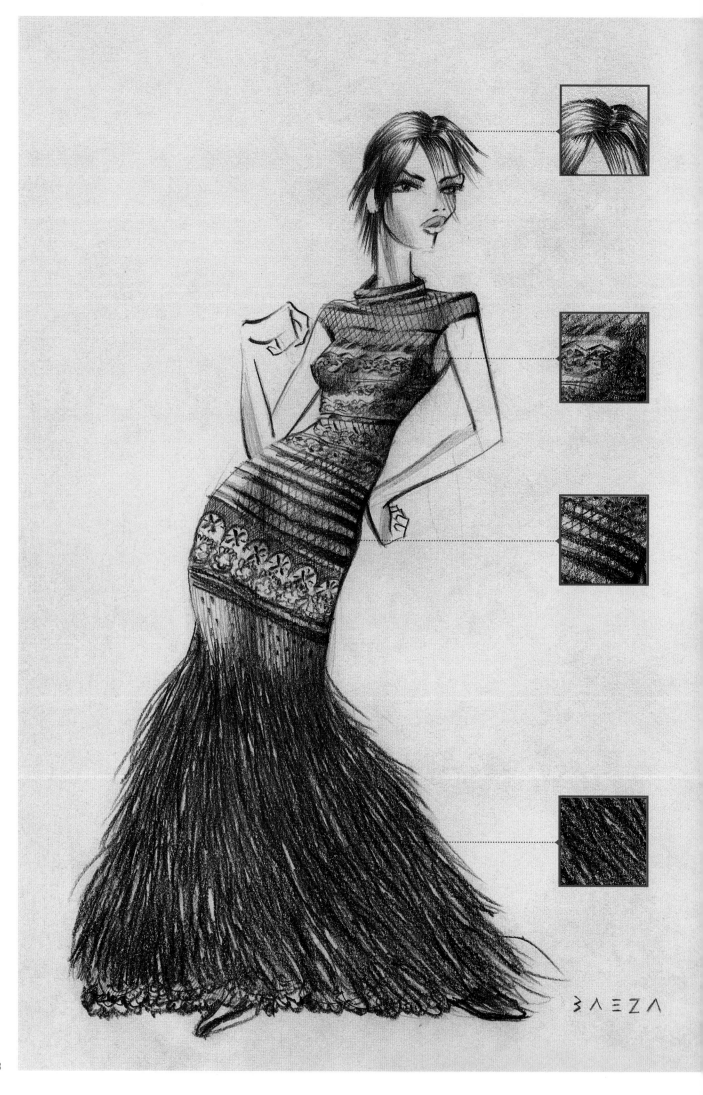

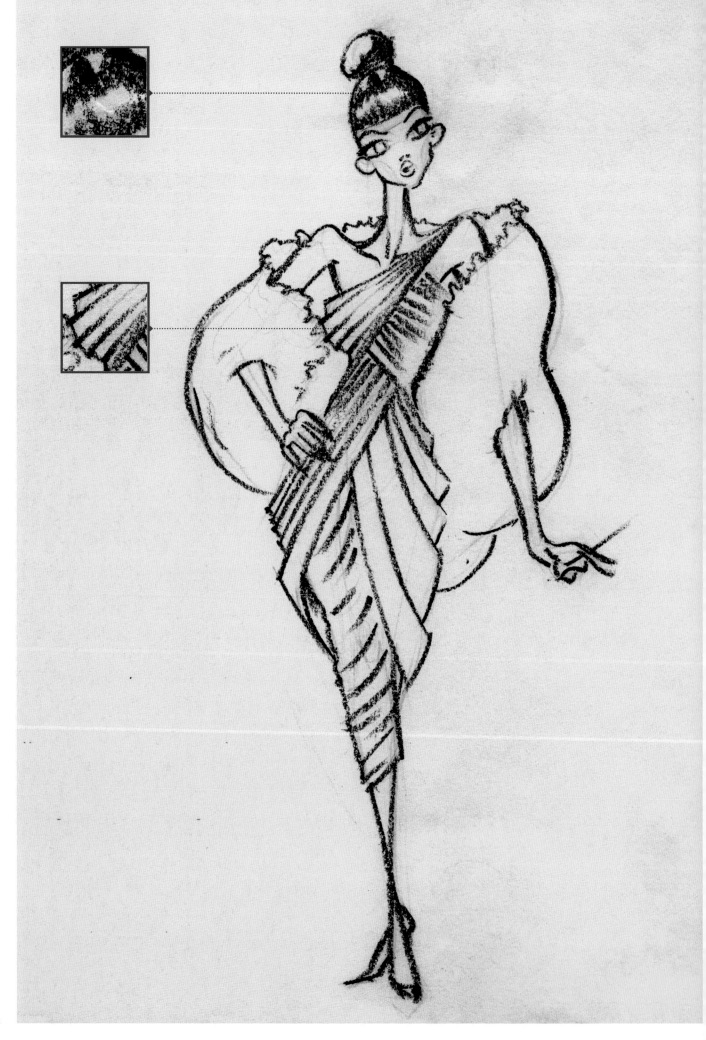

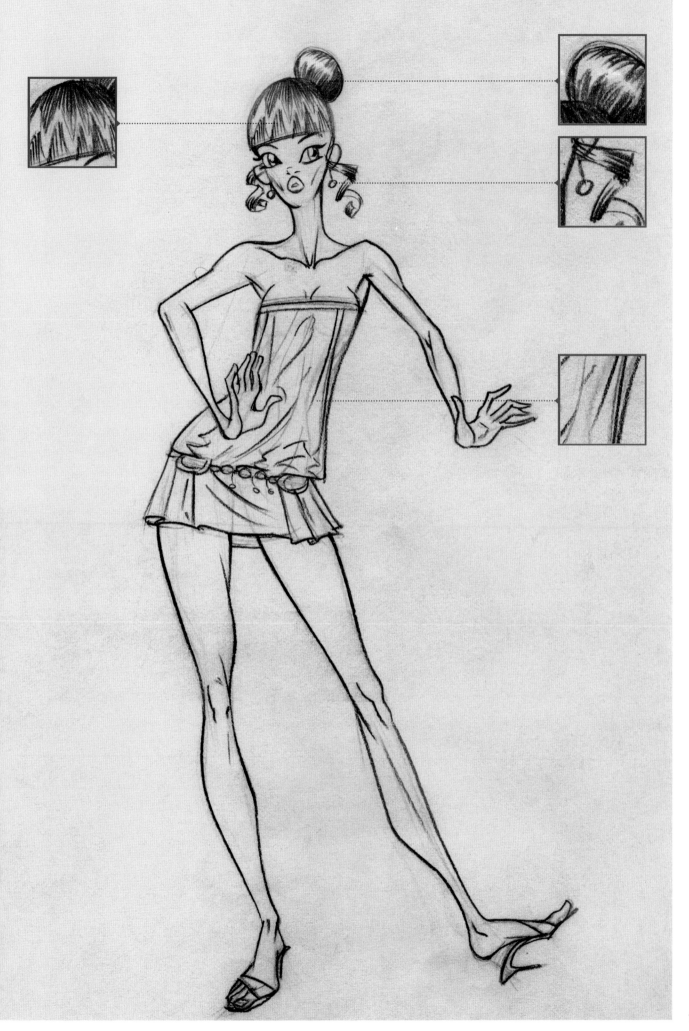

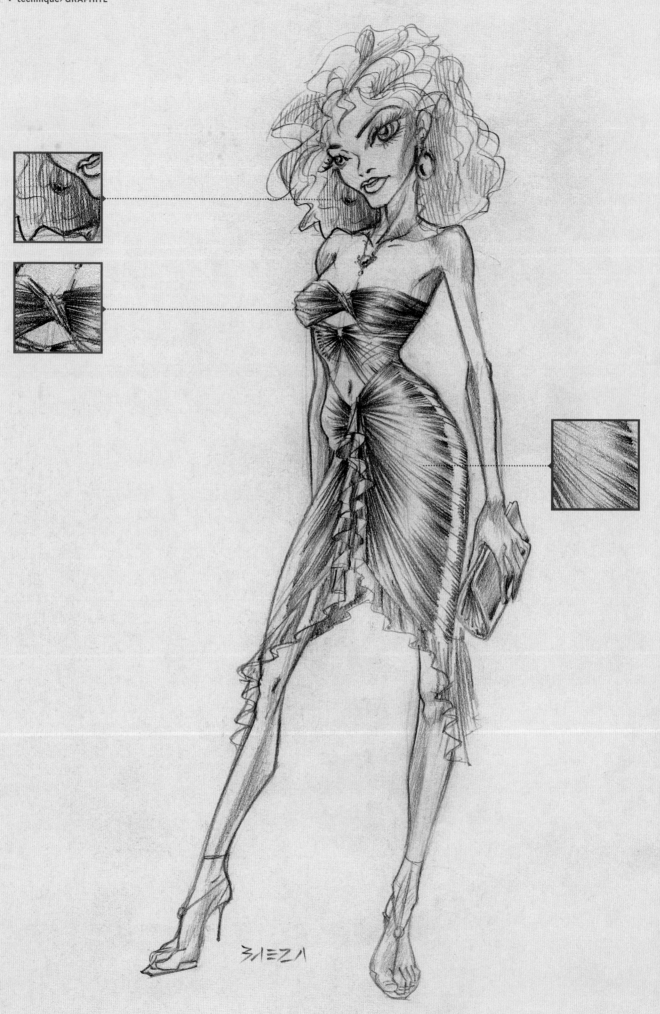

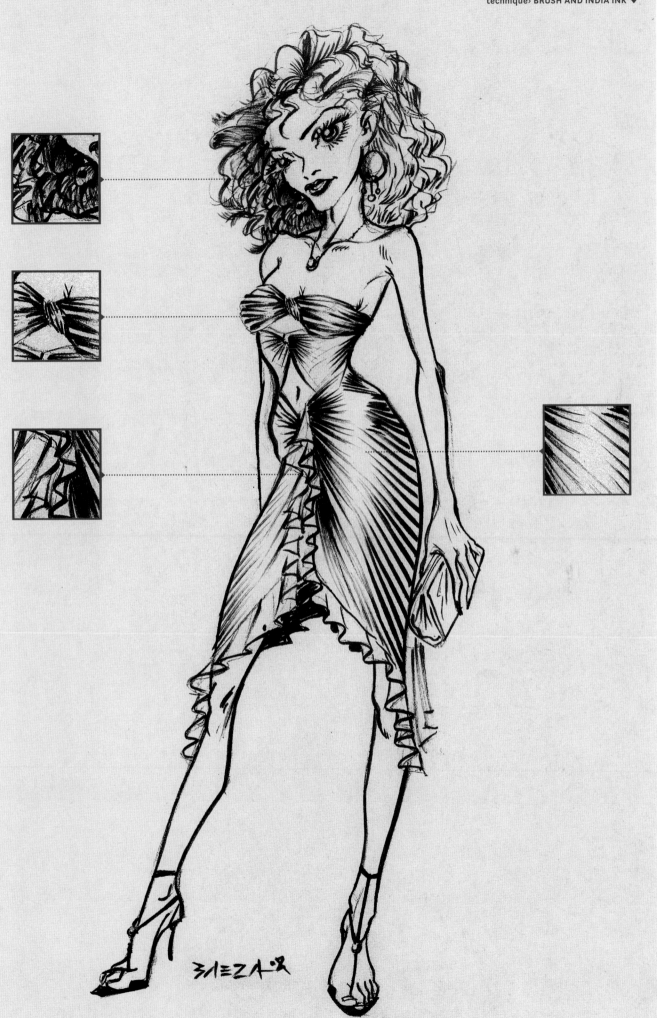

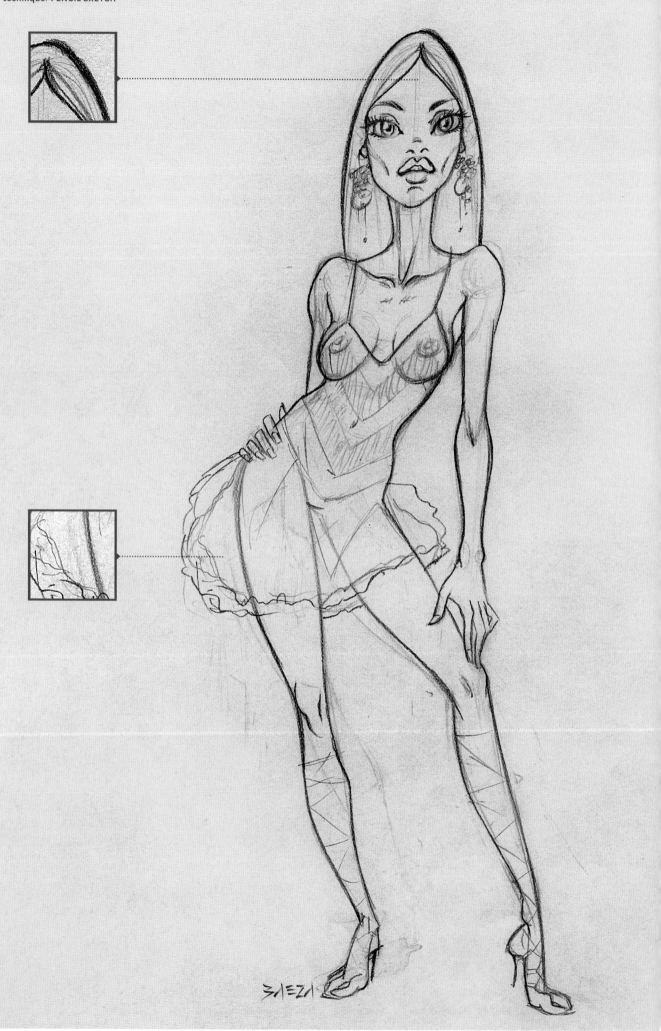

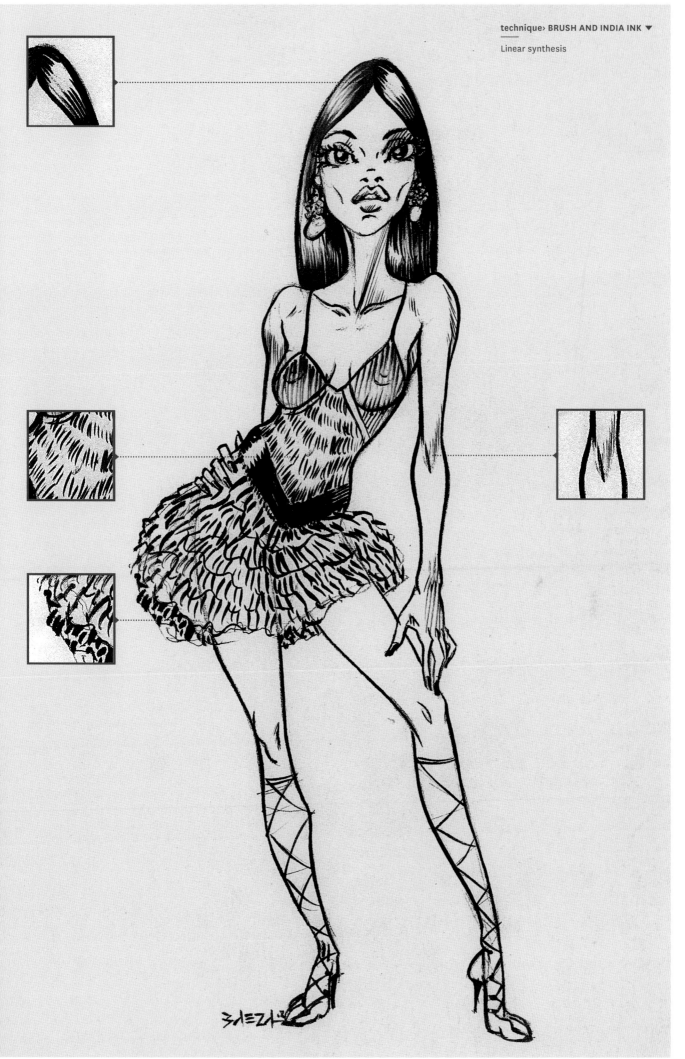

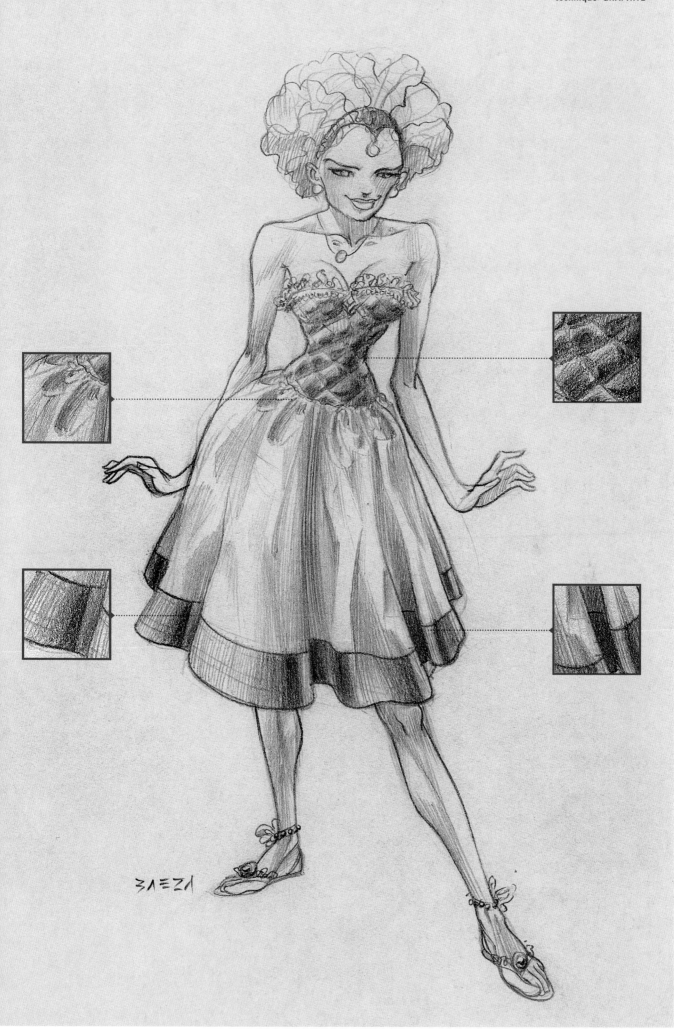

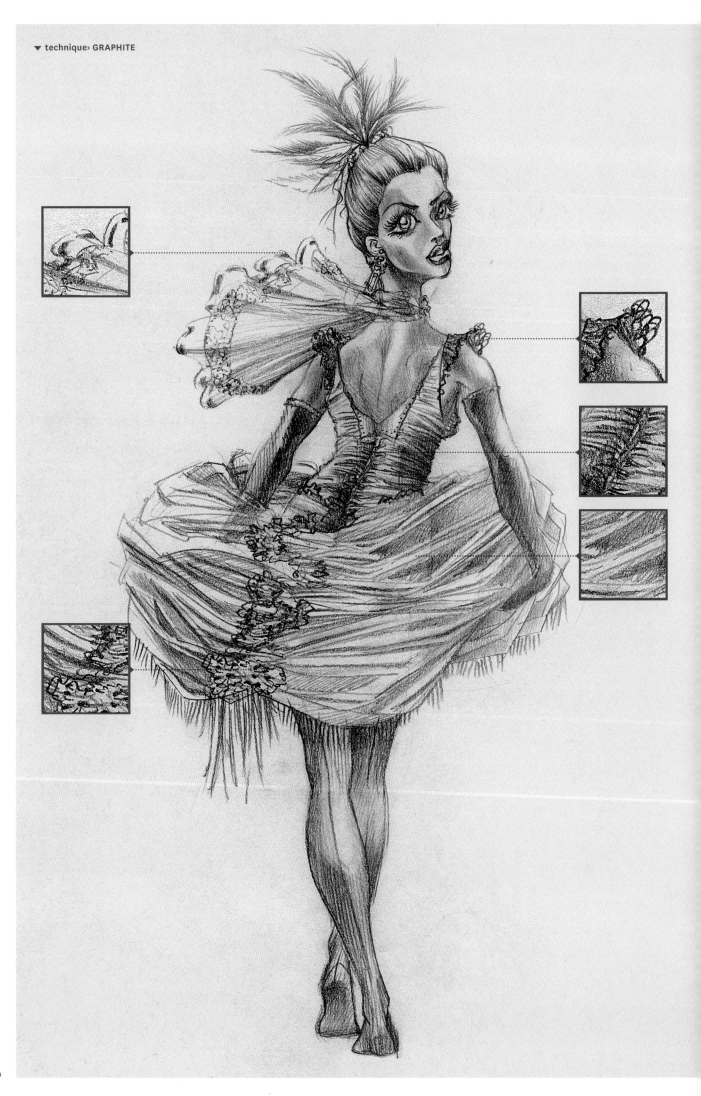

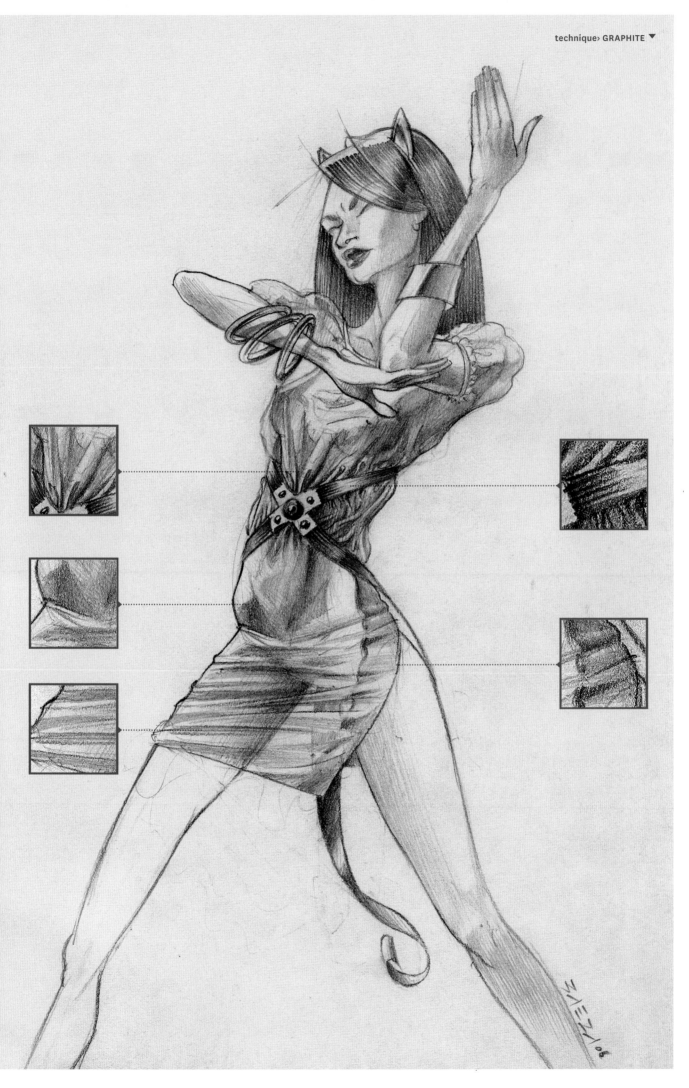

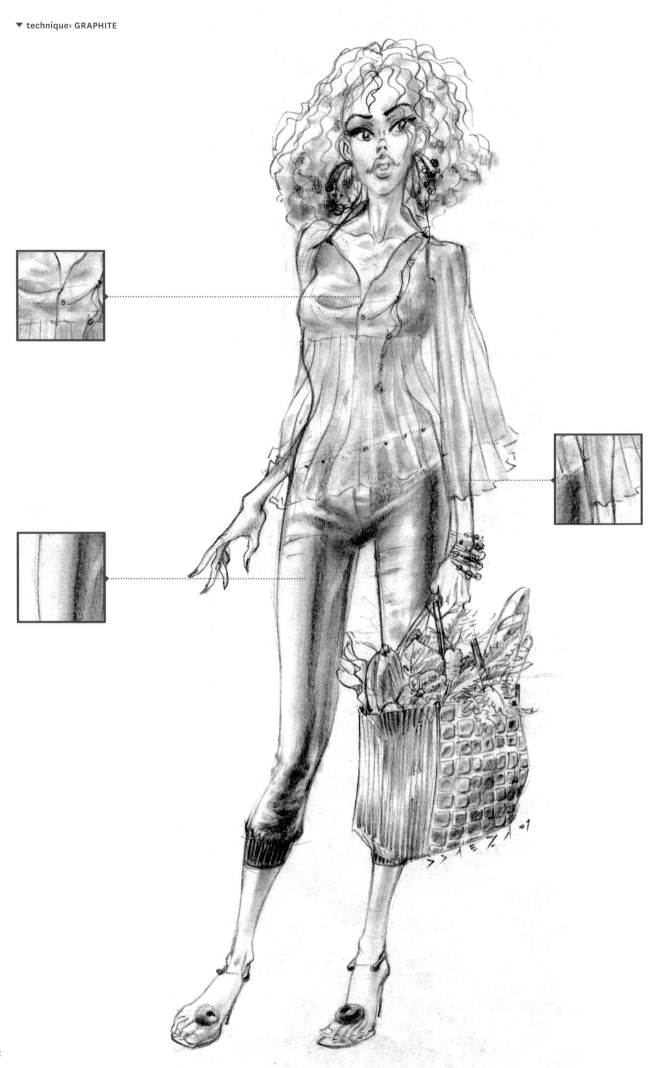

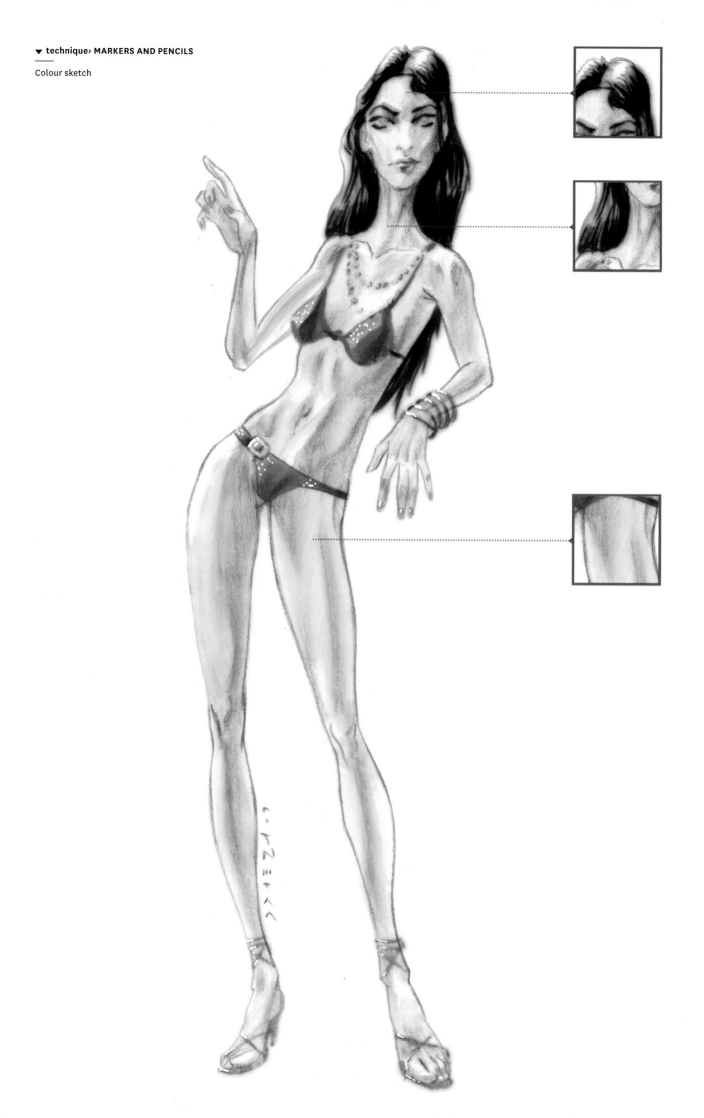

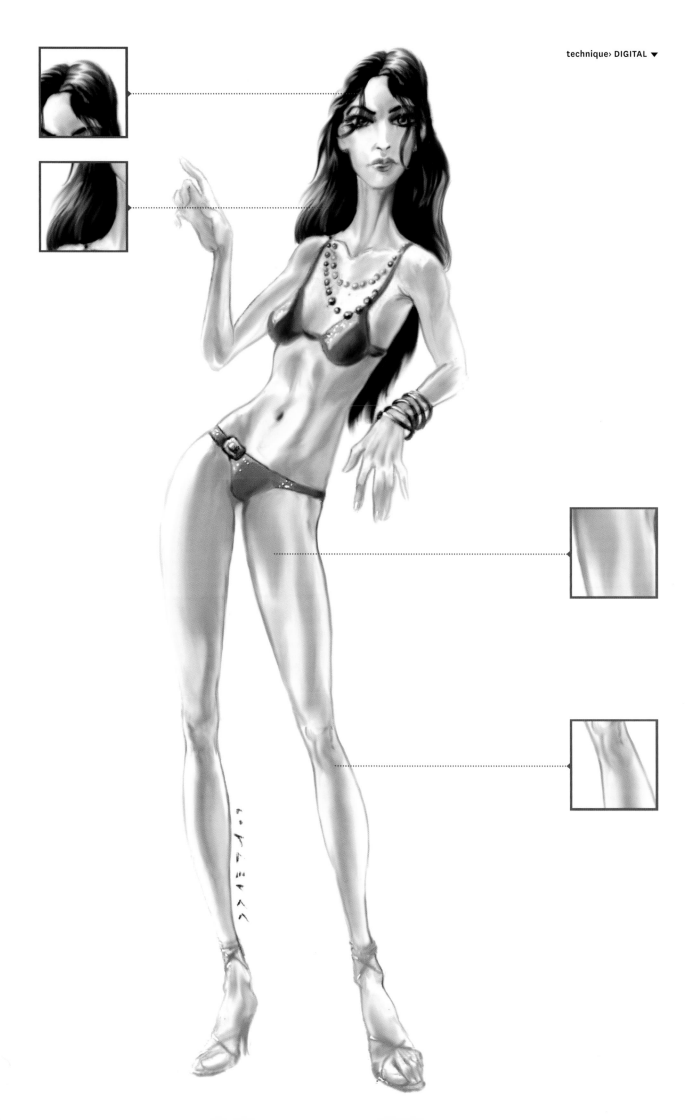

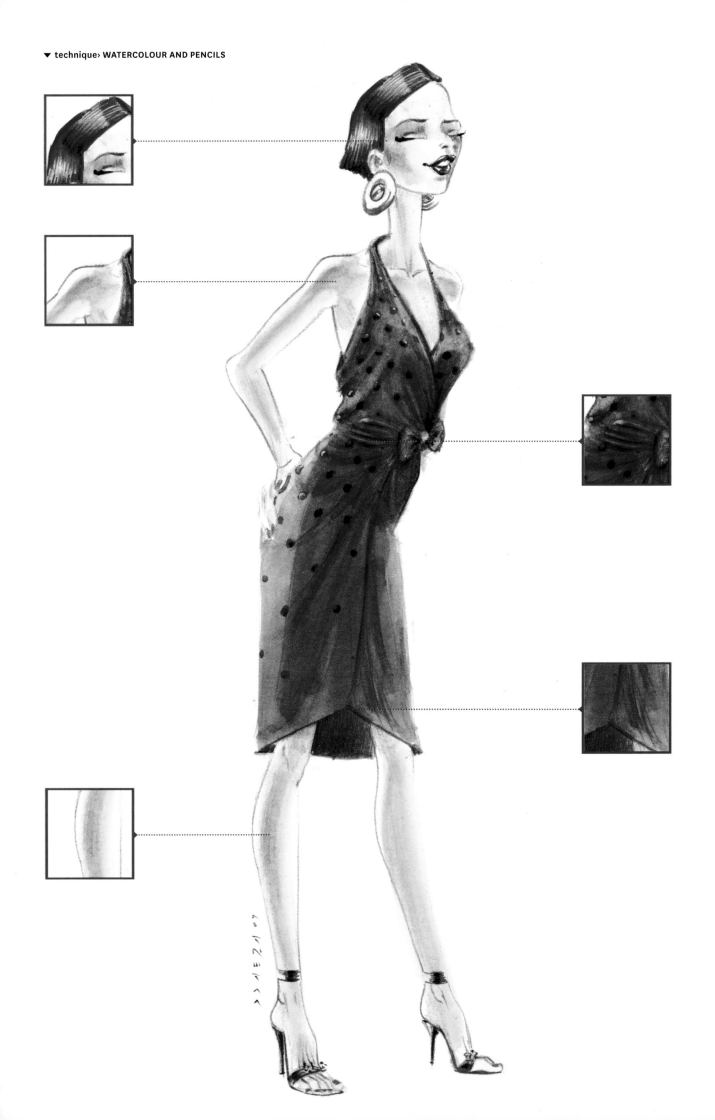

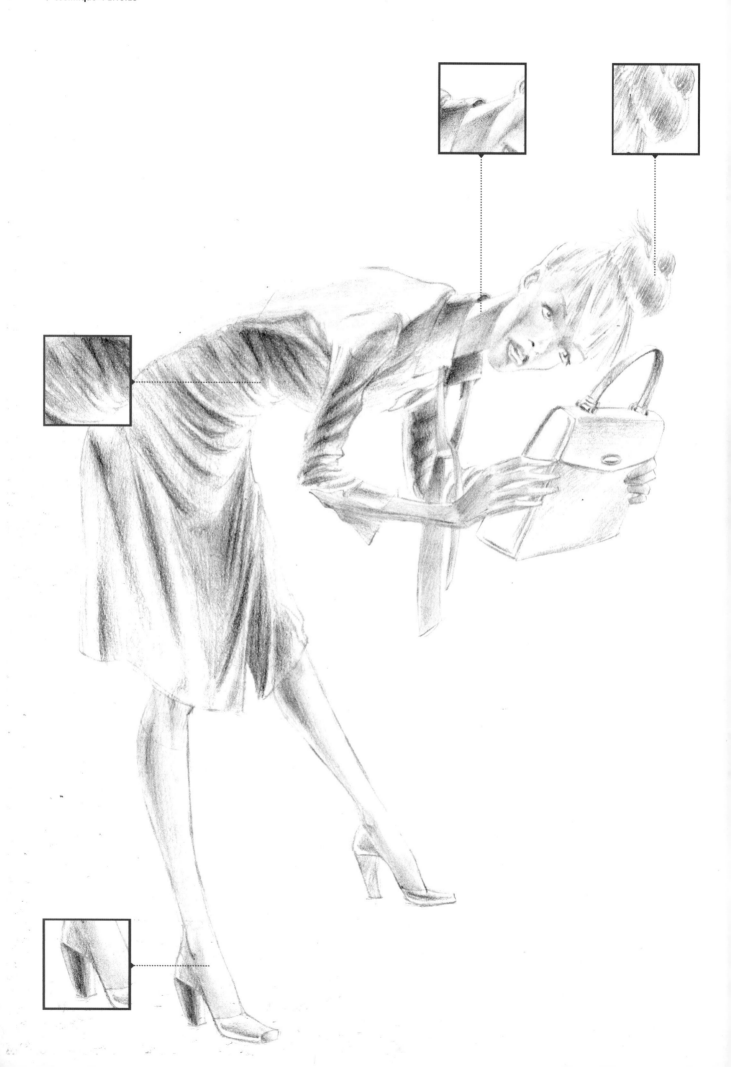

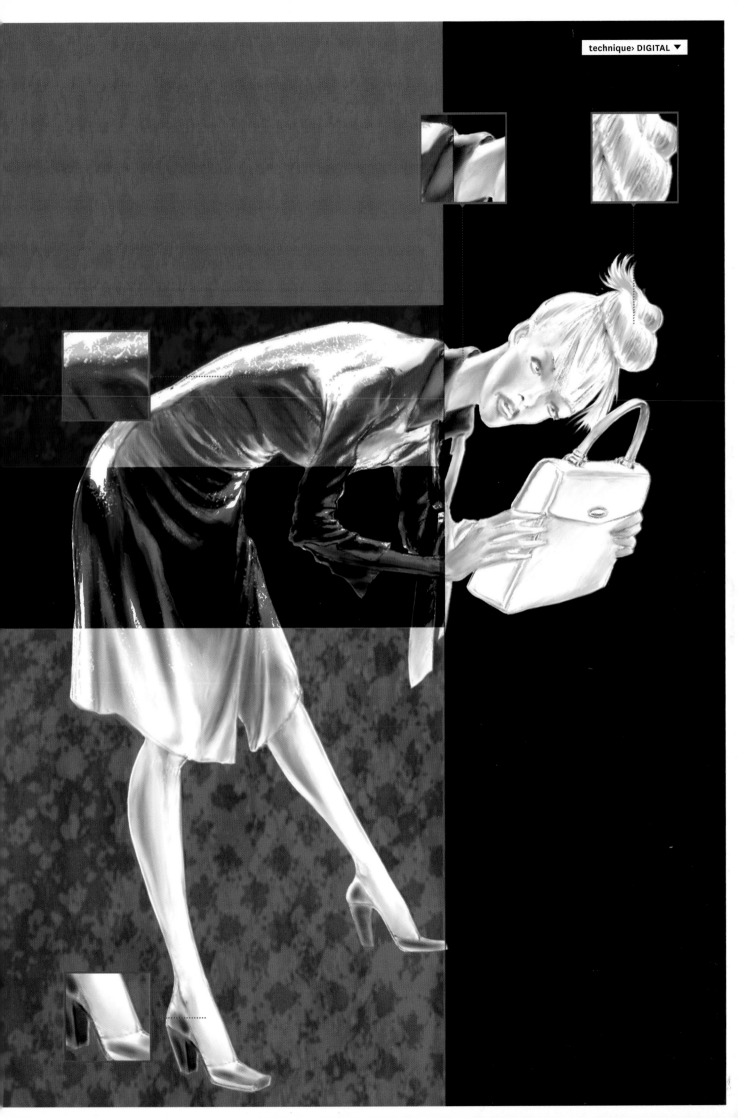

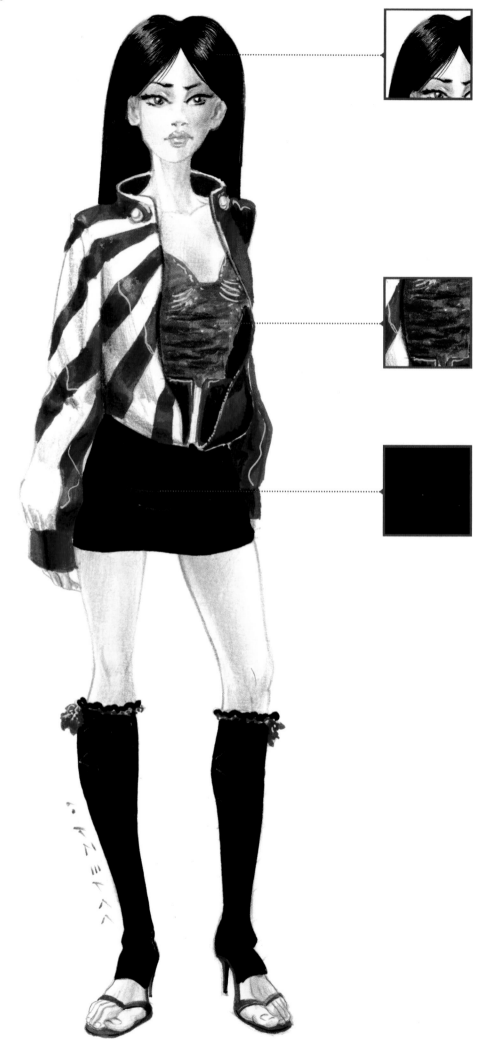

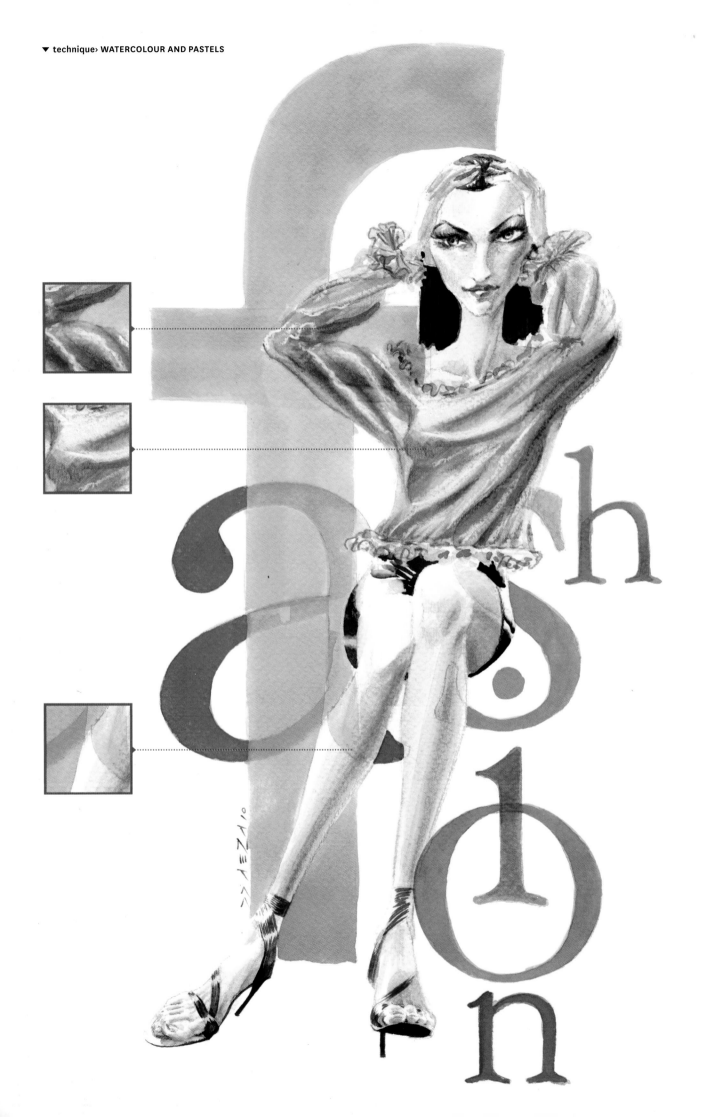

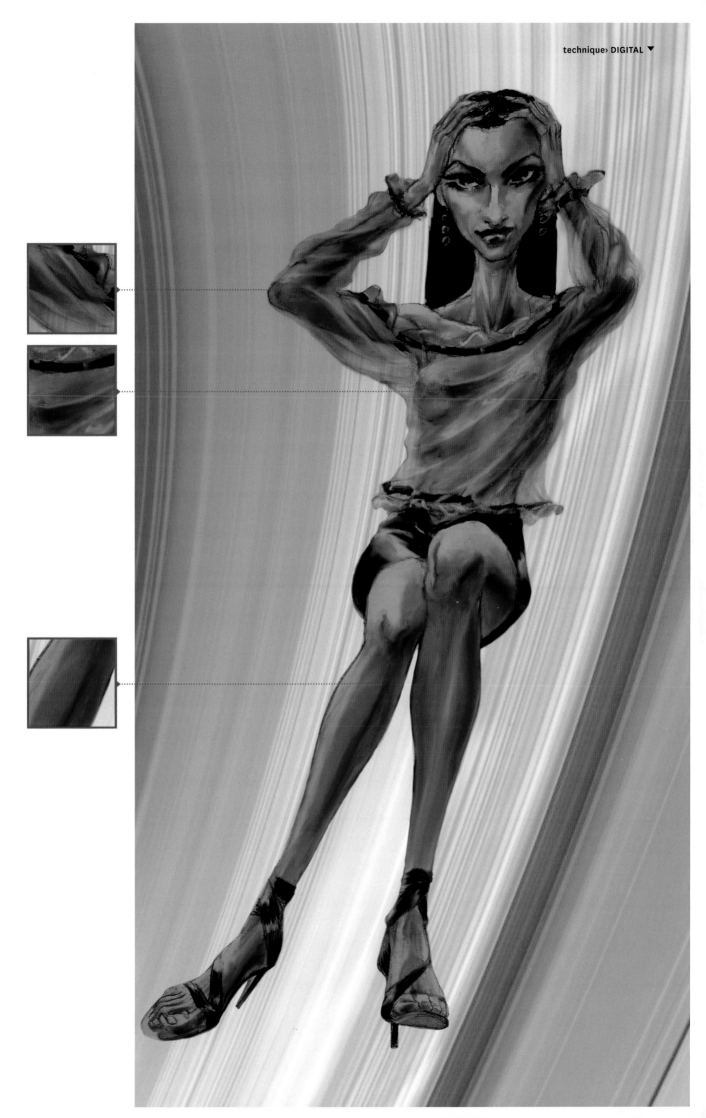

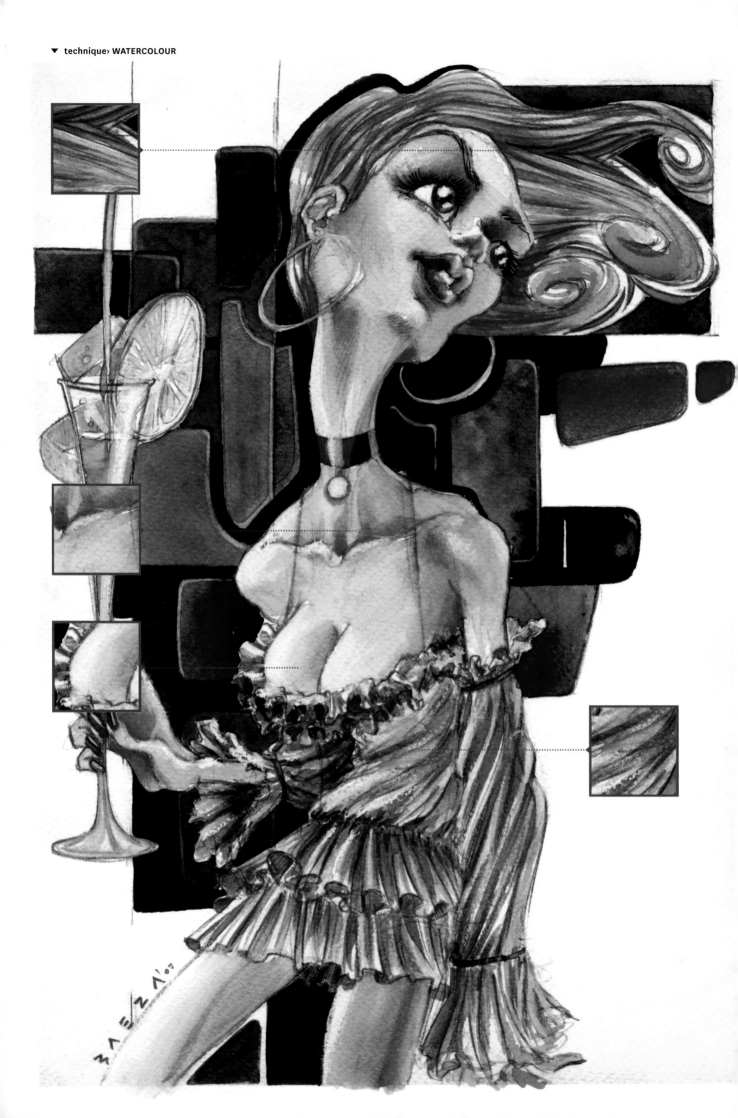

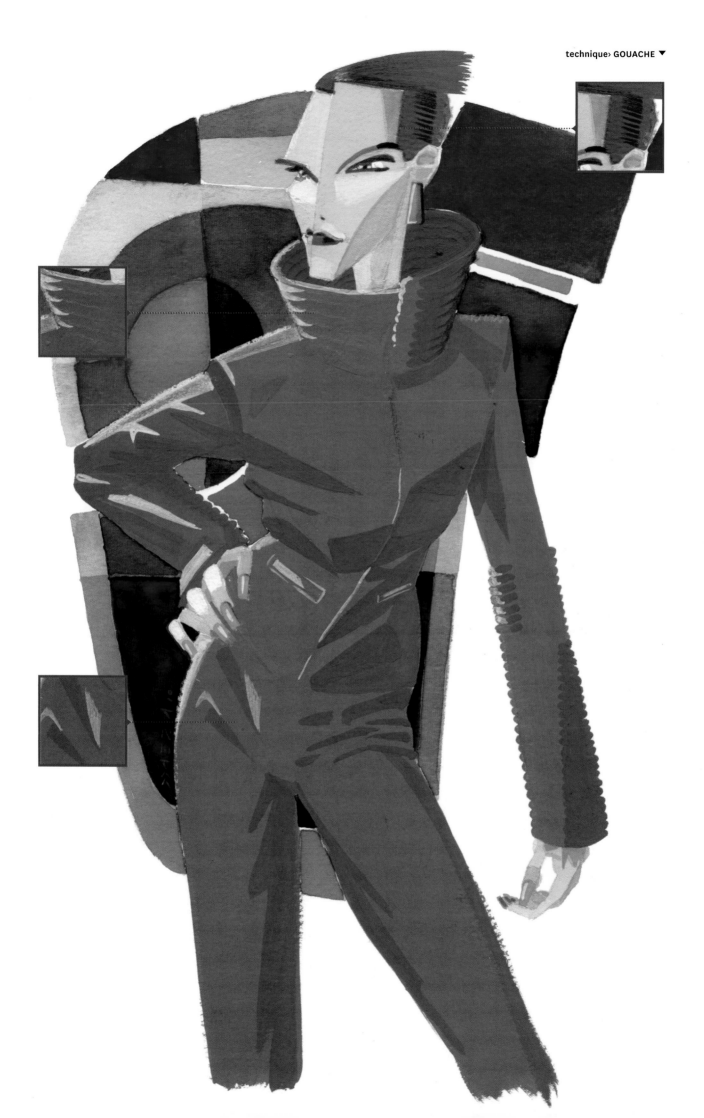

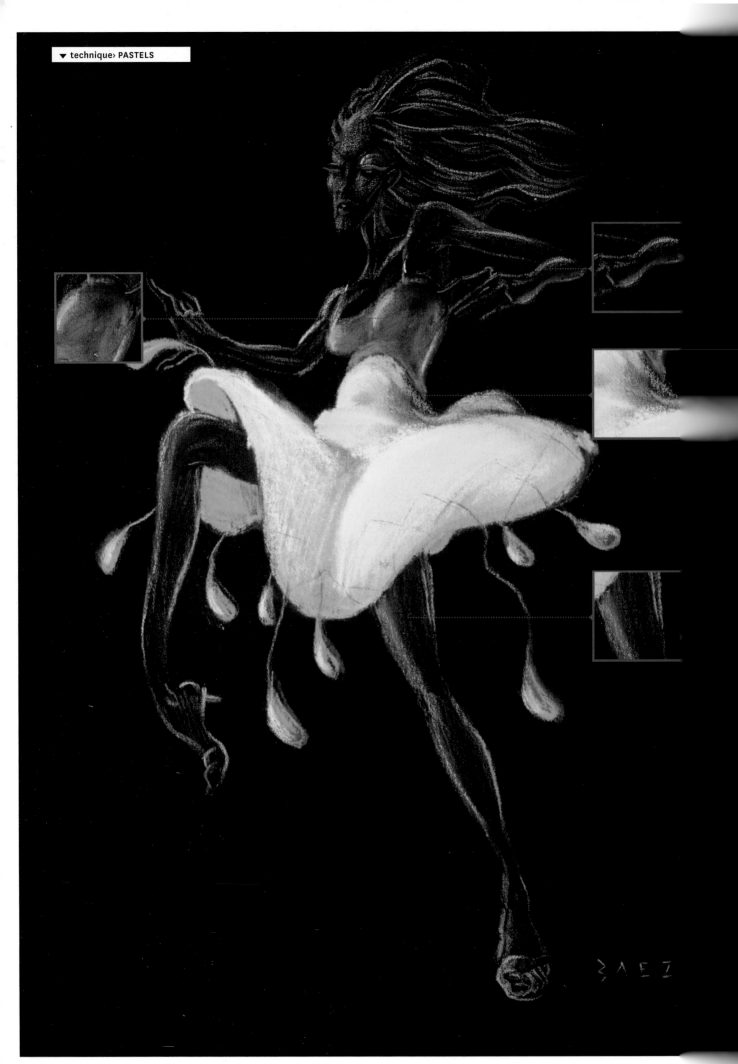

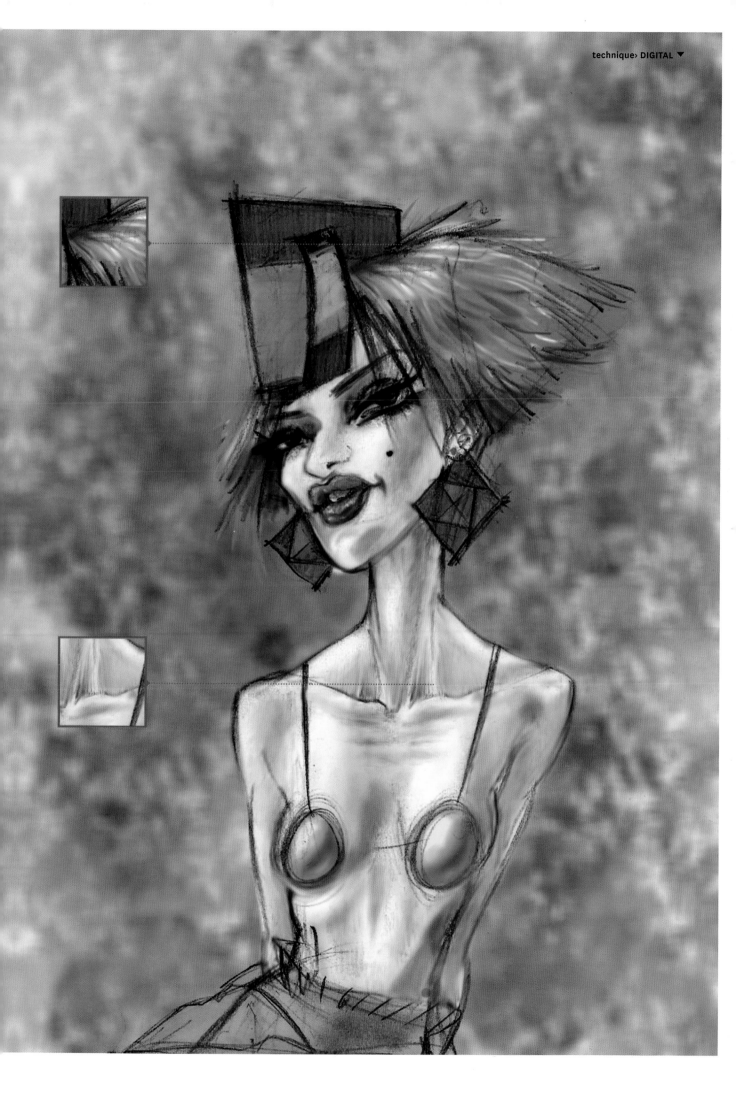